Moving Sounds

This book is part of the Peter Lang Media and Communication list.
Every volume is peer reviewed and meets
the highest quality standards for content and production.

PETER LANG
New York • Bern • Berlin
Brussels • Vienna • Oxford • Warsaw

Moving Sounds

A Cultural History of the Car Radio

Edited by Phylis Johnson and Ian Punnett

PETER LANG
New York • Bern • Berlin
Brussels • Vienna • Oxford • Warsaw

Library of Congress Cataloging-in-Publication Data

Names: Johnson, Phylis, editor. | Punnett, Ian, editor.
Title: Moving sounds: a cultural history of the car radio /
edited by Phylis Johnson and Ian Punnett.
Description: New York: Peter Lang, 2019.
Includes bibliographical references and index.
Identifiers: LCCN 2018028647 | ISBN 978-1-4331-5797-4 (hardback: alk. paper)
ISBN 978-1-4331-6121-6 (paperback: alk. paper) | ISBN 978-1-4539-0985-0 (ebook pdf)
ISBN 978-1-4331-5983-1 (epub) | ISBN 978-1-4331-5984-8 (mobi)
Subjects: LCSH: Automobiles—Social aspects.
Automobiles—Radio Equipment—Social aspects.
Transportation—Social aspects. | Material culture.
Classification: LCC GN441.M68 2018 | DDC 302.23/44—dc23
LC record available at https://lccn.loc.gov/2018028647
DOI 10.3726/978-1-4539-0985-0

Bibliographic information published by **Die Deutsche Nationalbibliothek**.
Die Deutsche Nationalbibliothek lists this publication in the "Deutsche
Nationalbibliografie"; detailed bibliographic data are available
on the Internet at http://dnb.d-nb.de/.

The paper in this book meets the guidelines for permanence and durability
of the Committee on Production Guidelines for Book Longevity
of the Council of Library Resources.

Printed in the United States of America

Dedicated to my road warrior, Julianna West Johnson.
Happy 21st birthday!

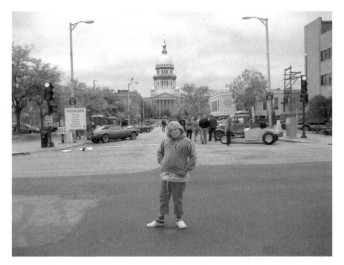

Julie, 7, at her first Route 66 Festival in 2006, Springfield, Illinois. Photo by P. Johnson.

Being born in 1936, as a kid I remember my father's radio was always tuned to sports activities—fights, baseball, or football—while riding hither and yon. During the 1940s and 1950s, music was my request when on the road. The best use of a car radio for me as an adult was the commute hour going to San Jose State where I worked. The car radio became "extended family" for me. Don Sherwood in San Francisco billed himself as the "World's Greatest Disc Jockey." Sitting at a stop light, you could tell who was listening to Don by watching people laugh. These days, my dial is set only to "On Broadway" on Sirius/XM.

My husband was much more of a car radio buff. He did not have a car radio until high school when he got his first car. A friend convinced him to install a cheap radio (he thinks Motorola) that never worked. To this day, the first thing my husband does when getting into the car is turn on news or sports.

Actually dialing a radio knob is now an old memory. Going into a car wash sometimes, you'll end up with your push buttons set on a different station—what a big surprise! Changing other peoples' radio settings in their car used to be a great way of pissing people off.

—Phyllis Mueller, age 82
March 3, 2018

CONTENTS

FIGURES

MOVING FOREWORD

Why This Book Matters

Robin Bertolucci

As our culture sits idling, waiting for the shift to autonomous vehicles, what an interesting time to reflect back on in-car radio listening. As a large-market radio programmer, I don't program exclusively for in-car listening, but for all listeners wherever they are, whatever they're doing. Radio does do different things at different times of the day for different reasons, however. For example, in the morning you need to know what's going on—what did I miss while I was asleep? Radio's mission is to get the listener up to speed and ready for his or her day. No one wants to be that person that walks into the office and says, "Huh, what happened?"

Where I live and work in Los Angeles, drive time starts weekday mornings by 5 a.m. and can go until 10 a.m—or later—while afternoon drive can mean anything from 2 p.m. until 8 p.m. It seems like there's always a crowd on the freeways, whatever the time of day! Even still, every time of the day has its own energy and its own needs. Midday radio has a completely different energy than mornings. When the midday shows start, the average listener probably already knows the big stuff that went on so there is more time for side stories, a deeper dive on info, new perspectives and entertainment. Afternoon drive feels very different than mornings, too. PM drive can be a way to blow off steam, get away, decompress, or focus on a particular issue. So, every

"daypart" has its own rhythm and style based on what the majority of people out there are doing at that hour, yet, because the morning and afternoon commutes bring the highest number of ears to radio, morning and afternoon drive radio remain synonymous with peak listening times. But soon, our rush hour experience could become something altogether new. When our in-car radio choices are no longer limited by the responsibility of operating the autonomously driven vehicle we are in, we'll be able to not only listen to the radio, but also read, watch, and interact—Apple has even patented a virtual reality headset so that future passengers will be able to transport themselves beyond their cars during their commutes.

This is only a suggestion of what the future might look like. As this book illustrates, so much has changed already for radio in general and specifically people listening to it in their cars. We've gone from the days of cars with just AM radios to AM/FM, and on to HD channels, satellite radio, apps, streaming audio, and in-car wifi hotspots. We are no longer limited by what radio signals are in our particular geographic region, we can now listen to virtually anything from anywhere.

As a program director, even in this wildly competitive landscape, I have to believe that great content will always win. History shows that audio connects us in ways that other media do not. Audio is captivating and liberating at the same time. Audio engages us but simultaneously frees the listener to do other activities such as drive, work or work out. Radio is not just a connection with other people but with the community. You are not sitting in that car alone when you are connected to people that you "know" on the radio and that makes the medium so powerful and connective.

Down the road, it's only my guess, but what will have the greatest value to the radio listener will be hearing content based on great stories because, since the beginning of time, human beings have connected to each other through storytelling. It's what we do. We are communal and we need to tell and hear stories. Radio, really, is just another in a long line of story-delivery mechanisms, a great device to share audio content over a large area but ultimately the device itself is irrelevant; the content is truly what matters.

Looking forward, I would guess that all audio content products such as terrestrial radio, satellites, podcasts, and streams will continue to get more and more diverse, fragmented, and/or focused. Whereas radio traditionally has been BROAD-casting to the largest groups possible, we may see many more radio NARROW-casters following the podcast model. The power of podcasts is not simply about driving a massive audience—although they can—it's about

targeting a specific segment of the population that is really into "that thing." For instance, what bicycle advertiser wouldn't want to buy spots in a podcast produced for 1000 highly passionate cyclists who own bikes over $4000 and race them on the weekends? Meaningful content can be derived just as much from the interests of small but passionate tribes as larger ones.

In the end, forward thinking suggests that with all these changes, in-car radio listening may take unpredictable forms, but always continue in some fashion. In many American cities like Los Angeles, despite so many attempts to get people out of their single-occupant vehicles and into public transportation, it has not yet been feasible or desirable for everybody to give up the ease and flexibility of a car, so drive time terrestrial radio still dominates—for now. Until the shift to autonomous vehicles goes into high gear, or large stations start thinking smaller, as makers of live audio content, it remains the obligation of everybody on the air to remember the listener stuck in their car, probably alone, and bring the creative energy needed to breakthrough to them. That personal relationship may never change.

Which is why those of us taking radio into the future always benefit from discussions of radio's past—and why this book matters.

PREFACE

How to Use This Book

Phylis Johnson and Ian Punnett

Moving Sounds: A Cultural History of the Car Radio explores the unique animating symbiosis that develops whenever previously unrelated technologies become intertwined and form a mutually invigorating relationship. When "car" and "radio" became permanently inculcated, it changed how both cars and radio were designed and experienced. If such a place existed where cars never had radios, and people never listened to radios in their cars, the form and function of both would be very different. This examination of "car radio," therefore, attempts to tease out not only the various aspects of the impact that this blending of these two technologies had on one another, but also how American culture was changed by car radio, and how car radio was influenced by American culture.

These confluences happen constantly. Similar—if, perhaps, shorter—conversations could be held about the historical intersections of, say, "cars" and "pizza," or "baseball" and "radio," but each of those relationships might be more transient, and have fewer cultural implications than this study. Indeed, the editors and authors of *Moving Sounds* are convinced that this interrogation only has captured a few initial dimensions of "car radio," but from a number of cultural perspectives sufficient enough to generate fruitful conversation.

Toward that end, *Moving Sounds* can be read from front to back like any book, or *a la carte*, to the reader's preference. It might be most helpful to read the first two chapters to get a solid grounding on the topic before going freestyle because each chapter begins, roughly, at a different point further up in the timeline. After introducing a few of the meta-concepts in Chapter One, Chapter Two starts the discussion of the cultural history of car radio in the late 19th century before moving forward, while Chapter Three begins a few decades later in the early 20th century and pulls at a separate thread as the conversation progresses. By Chapter Five, the new line of thought begins in the late 1950s, and so on, until the end of the book where the chapters become much more future-focused and theoretical. Should the reader become confused about a term, or a concept, the index will be a handy GPS.

It must be stated that, as a cultural history, this book only speaks about the technical aspects of cars and radios with broad strokes; the actual electronic and engineering interplay in car radio would make a worthy discourse as well but it is beyond the scope of this investigation. Many of the illustrations and photographs do provide important clues to the direction that scholarship could take an interested reader.

Regardless of the path the reader does take, however, *Moving Sounds* ends where history has concluded and the future has begun. Going forward, seemingly there will always be some interface between audio and movement—history indicates humans enjoy traveling with tailored entertainment and/or information as companions—but exactly what form that function will take is anybody's guess. At very least, after reading *Moving Sounds*, the reader may be better able to make an *educated* guess.

A FEW WORDS AND ACKNOWLEDGMENTS

Phylis Johnson

The idea to write this book came to me around 2005. Having lived close to Route 66, I was already fascinated with road culture when I decided to attend my first International Route 66 Mother Road Festival in 2006 in Springfield, Illinois. That was Julie's (my youngest daughter) first car show; I actually found my old blog entry:

> September 2006: Great times in Springfield. Chris and Julie tagged along as I sought answers for my burning questions about the beginnings of the car radio in the early 1920s and 1930s, the romance between the car radio and the driver, the sense of freedom that music and the road give us, etc. I met some really cool folks—intelligent and knowledgeable. The more I find out, the more I realize I have only begun this project. Ultimately I will complete my book and hopefully accompany it with a soundscape that resonates road culture. What would Thoreau have thought—he was awed by the sounds of the train and its signaling of unrestrained technology.

Julie also went with me to "The Birthplace of Route 66 Festival" in Springfield, Missouri and again 10 years later, this time as a high school senior. You might say, the whole concept of the Mother Road has been around our house for more than a decade now. She grew up to her own mother's odd fascination with car culture, and specifically how it intersects with the radio and the road.

As a typical American family, I went on my share of car trips across the U.S with my parents and brother, and then with my own kids, Nick, Jenny, and Julie through the years. All in all, during my life, I have mostly travelled across the Northeastern, Central, and Southwestern states. I find myself now with my kids raised taking a job in the North Bay area, and learning about and experiencing car culture first hand from a left coast perspective. Maybe it took this relocation to finish this book. Having been born and raised on the East Coast, living and working in the Midwest and South for significant years, my life's work has taken me to the last stretch of Route 66.

It has been a long adventure, and I have met some wonderful scholars along the way. Each of the authors selected for this book have a passion for radio, and understand the significance of the relationship between the road, radio and car. It is a love story for the radio station explorers, who understand what it means to listen to car radio (in all its forms) on the highway, and sometimes just sitting in the driveway outside your house. Your car can be that place of solitude or celebration, and the radio has always been there to help me feel that moment. I wait until the song has finished, and the talk show concludes, and then I transition back into my daily routine. Only the car brings me the personal space that I need to catch my breath, and regroup before the next challenge. I remember the first time that I ever voice-tracked a radio show on a sister station that I had agreed to help with for a time. I actually listened to myself that Sunday, as I drove around during my on-air shift completing errands. It was odd for me to hear my show en route. I am not so much a fan of voice tracking, but it did provide me with a rare opportunity.

So many changes have happened since I began my radio career in the late 1970s. Having done my share of radio remotes, I understand the importance of encouraging the driver/listener to take the nearest exit to help populate our radio event. "You're going to miss this super Saturday sale, and for the next three people who come up to me in the next 15 minutes, and say I heard you say so on the radio, I will give you a pair of tickets to *such and such concert or event, or whatever!*" And what do you know, someone always showed up to claim the tickets—and they typically got out of their car with friends or family and walked around the event! I did my share of car dealership remotes, more than I can count. We blasted our radio station from the station van, and then added some of the dealership's cars to the mix to increase the sonic impact so much so I had to find a space on the lot where I wouldn't get microphone feedback when I did my live breaks.

That's live radio, and to help engage your listeners to feel like they are actually there, or want to be there, is an art. For in-car listeners to take the initiative and redirect their plans because of something they heard you say while they were tuned to your show on the car radio, that is a wonderful feeling. Most people plug into a variety of options, but for the local feel of a town, it is still the car radio—you can learn a lot about a city from the local stations' commercials and promos. If you haven't for a while, turn on your radio in the car, and let it direct you to your next exit and event.

Special thanks to so many people, but I will highlight those not anticipating any sort of accolades.

Dr. Michael C. Keith for getting me started with my first book, and for your support on this idea! You are the quintessential radio scholar, and you have proven yourself to be a notable fiction writer in the past decade. I will always look at your work with amazement. I know that you truly understand the meaning of the road and the radio, and particularly how they complement one another. You have spent your whole life, cultivating your writing, always in search of that 'Next Better Place' to take your readers. Your passion for radio underscores your gift for storytelling.

Unique thanks to my friends who helped me experience and photograph Route 66 in the virtual realm, namely Belinda. Thanks to Donald Pettit for helping me secure photos for this project.

I would like to thank my co-editor and co-author Dr. Ian Punnett for helping me finally finish this long overdue book, by adding a well-needed editorial discipline to my routine. Frankly, trying to juggle administrative duties and scholarship is not an easy task, but one that Ian has made profoundly fun through his keen ability to focus on what is essential and how to integrate a good sense of humor into the process. He was my managing editor when I served at the editor of the *Journal of Radio and Audio Media* for a three-year term. Aside from having major radio chops, he is an excellent writer and editor, someone that you would want to include on any creative team!

Ian is the reason that this book is finished, and I am thankful to his wife and family for lending him to this project for the past several months. I also have grown to appreciate his mother-in-law, Mary Gray Kaye, who is a wonderful copy-editor, and has become equally invaluable to this project. Major thanks to our photography editor, Garr, for illuminating our text with the right professional mix of visuals!

Others to thank include my former colleagues at Southern Illinois University, Carbondale, for being around to discuss this project in its early days.

XXII MOVING SOUNDS: A CULTURAL HISTORY OF THE CAR RADIO

I would like to thank my current colleagues at San Jose State University, and especially Dean Mary Schutten for providing me the time to complete this book. It has definitely evolved since my inception of the idea, and it has become increasingly more personal to me through the years. There are as many unanswered, as answered, questions, in this book. My journey has only touched upon some stories that speak to the relationship between the car, road, and radio. I welcome those interested to pick up where we left off on this adventure.

Thank you to Chris Johnson for your support and insights, especially for driving me out to my first Route 66 show, and for your support of my work for all those years.

Thanks to Nick and his wife Jenn Nfj for moving me out to California.

Thanks to my new friend Grayson, who shares my condo and my appreciation of a good meal, unfortunately it is mine. He is not much of a car lover, and is happy just to stay home and watch life go by looking out the window. Thanks to Juan for watching Grayson when I have to travel!

Thanks to all those who helped in the making of this book! It takes a team! And thanks to all those at San Jose who understand that I truly miss my Midwestern homeland. Ultimately, Route 66 led me to California, the end of the road—and the beginning of a new adventure.

Sincerely,
Phylis West Johnson

· 1 ·

MOVING SOUNDS

An Introduction

Phylis Johnson and Ian Punnett

I heard [Sam Cooke's] "You Send Me" on the radio while we were driving through the South one night. We had to stop the car. We got out and danced around the car out on the highway.

—Aretha Franklin (cited in Graff, 2016)

The mass production of the automobile in American life invited writers, musicians, and roadside scholars to re-conceptualize what borders meant—be they geographical or philosophical. Whether it was a virtual image of "the road" played out in the theater of the mind of the would-be traveler or an effort to discover what one might find about oneself or learn from others along an actual freeway, the Great American Road Trip was soon an invitation extended to anybody with a set of keys and an imagination. Cotton Seiler, author of *Republic of Drivers: A Cultural History of Automobility in America* (2008), speaks to self-determination and liberation as part of the excitement and driving force fueling a mobile society across the nation. The stories would offer different lessons across racial, gender, and class lines too. In commentary for his alumni magazine, Seiler (2005) alludes to rocker Chuck Berry's Top Ten Billboard hit "No Particular Place to Go" (1964) as a cultural metaphor of a particular era, a time when the road spoke to the heart of the driver (and passengers on occasion) as one's wheels imprinted memories across new highways for those coming of age.

In doing so, Seiler's commentary reflects on times that uniquely captivate Americans. Berry's lyrics begin mundanely enough—"Riding along in my automobile"—but before the song is over, the blacktop of a half century has spoken. In the process, the listener places him- or herself near the Brown-Eyed Handsome Man at the wheel, admiring his carefree humor and optimism. Every time that Berry sings out, "Cruisin' and playin' the radio, with no particular place to go," the convergence and juxtaposition of these two distinct cultures—car and radio—is reinforced. Regardless of the distance of the trip, the radio provides a customized soundtrack for the journey. So intertwined are the histories of radios and cars that it would be difficult to determine whether the radio has had a bigger impact on the design, performance, and experience of car driving more than cars have had on the design, the performance and the experience of radio listening. Either way, car radios have contributed to the moving soundscape of America and beyond, to wherever the car might take one.

Moving Sounds is the first book-length study exploring the relationship between the car and the radio. While much scholarship has been devoted to the general history of radio, radio's unique relationship with the open road has been largely overlooked. John Alfred Heitmann (2009) confirms this gap in his book, The Automobile and American Life, when he states that the radio "transformed the car into a home-like environment," similar to the effect that "integrated heating/cooling systems" had when pioneered by Packard in the 1930s (p. 99). Within a controlled interior environment, drivers and passengers could converse with each other and listen to the radio without interference from wind and traffic. Heitmann addresses the need for a cultural text that explores the relationship between the car and radio by explaining, "Surprisingly, perhaps, there is not one scholarly essay that explores how the two dynamic technologies of radio and automobiles were brought together beginning in the 1920s" (p. 99). Heitmann goes on to note an advertisement circa 1930 that appealed to listeners who were away "from home and radio" (p. 99). The ad reminds the devoted listener that they can tune into their favorite shows in the "comfort" of the automobile, a second home by extension. A similarly themed, 1934 audio commercial for Philco asserted, "You wouldn't be without a radio at home—why be without one in your car?" (pp. 99–100).

The nascent interconnectivity between the early car and radio developers, and what they did to help each other, is another aspect of cultural history that is explored in Moving Sounds. For example, Powel Crosley had made his fortune as a radio dealer and station owner of Cincinnati's WLW before

developing his own compact automobile in the late 1930s. *Moving Sounds* uncovers many of these tidbit treasures that will help the reader better understand why the car and radio have become closely aligned to American road culture in general.

Seiler also calls attention to other road poets such as Jack Kerouac who focused on the new-found individualism being tested on the expanding U.S. highway system. Sunrise to sunset to sunrise, car and radio brought the world closer to the driver as he or she passed through varied landscapes, distant cities and dusty towns, stations often distinguished by the regional accents of announcers as the radio signals faded in and out. Even in unfamiliar territory, disc jockeys and radio hosts became dashboard buddies. Whether or not the automobile was an upgrade on the horse for those chasing age-old dreams of freedom just over the horizon can be debated, but at least this metal horse could talk.

But while highway travel may elicit romantic metaphors of westward expansion to many, long-distance drives are just as often products of economic realities. Songs of the road may be told and retold by musicians, historians, and philosophers; they are also narratives captured in piles of wrinkled receipts for weary salesman hitting the bricks on a per diem. Early on, the car radio kept the driver company while the driver was on company business. Competing with the wind from an open window or mechanical groans from within the depth of the urban horse as it accelerated onward for hours and days with only necessary stops for water and fuel, long before cell phones and tape decks, sometimes the car radio provided the only other human voice to be heard against the backdrop of rubber on the blacktop. As Heitmann (2009) points out, car radio and car driver can become so connected that fiddling with radio knobs risks a deadly distraction—some states even attempted to prohibit vehicle registration for cars with radios (p. 100). Such criticism was prescient given the growing number of mobile options for in-car listening and their impact on road safety today.

Indeed, as the reader will discover, this recursive relationship in the repetition of history is common regarding car radio discussions. *Moving Sounds* both accelerates the cultural conversation into the future and circles back to the past by exploring the evolution of the original car radio into today's multi-platform, mobile in-dash audio entertainment system; where the two differ, and how some things have remained the same. Understanding car radio in a more complete context reveals a story intertwined within literature, film, music, and oral history. The invited researchers and essayists provide social

commentary as well on timeless American themes such as technological convergence, leisure and labor, individualism vs. alienation, and all from various perspectives.

Designed as a social history, therefore, *Moving Sounds* is an account of car radio's role in American life since its inception in the late 1920s. It is a book intended as a road map for car radio's critical moments, plotting the course through so-called glory days (war years, economic hardships, good times, social unrest, and material excesses in America) to the present challenges terrestrial radio faces with audio technologies such as satellite and web radio, digital recording options, and streaming services.

But *Moving Sounds* will even go the extra mile into deep space and within virtual worlds where automobile owners, for example, can time travel to fictitious drive-ins or take a spin across a reconstructed Route 66 in online platforms such as Second Life, in which millions engage in role play and social and creative activities parallel to "reality." In this way, through one's imagination and the cyber interpretations of perceived good times embodied in a corporate dome comparable to that portrayed in Peter Weir's *The Truman Show* (1998), a "radio listener" in Second Life can lose him- or herself in some iteration of a past reality—however constructed—and of the ideals of freedom and independence of that iconic period in the radio-human symbiosis that is car radio history.

Which is why the car radio should be conceptualized as more than a nostalgic discussion centered on technology that has overstayed its welcome in the listener's "home away from home." Because it is perpetually morphing, car radio continues to thrive amidst many competing personalized options. The car, in and of itself, is still very much a personal space to many and America continues to tune into the world through car audio even if radio's proto-tech has been displaced. This is because sound is still a significant force in everyday life, and a "listening culture" built around podcasts and net-native, non-broadcast, specialty programming has reinterpreted the acoustic car experience but not eliminated it. The sphere of in-car listening has always been controlled by the driver—one could always look out the window at the passing landscape as an internal soundscape influenced the visual experience—but today it's only more so.

Similarly, with the advent of battery-powered transistor radios, a driver had always been able to listen to his or her favorite station walking up to the car, get inside, and tune into that same broadcast in a seamless multi-platform experience, but the programming options were limited to what was available

on the AM or FM radio bands. As of this printing, the full all-you-can-hear buffet of audio's mobility arguably has been perfected. Today, inside and outside of the car, audio programming has never been more varied, mobile, or seamless. Due to satellite, Bluetooth, cellular, and Wi-Fi coverage, a typical listener can listen to almost anything almost anywhere. Despite unlimited customizable options, however, the average audio day for many may be more about creating and recreating "your" world wherever you go, and less about letting the world in through the radio. Perhaps the so many choices can be overwhelming. At one time, fewer options meant that somethings were forced into a listener's experience—but in hindsight, that should not necessarily be seen as a bad thing.

For example, in the heyday of AM radio "Top 40" stations, the format was designed to play the bestselling 45 rpm records in a given region regardless of genre. As a result, a popular Rock, Country, R&B, or even an "Easy Listening" song could end up with mainstream exposure to disparate listener groups even if an average Top 40 fan might not love every genre. During this period when fewer licensed radio signals meant increased competition for the audience, however, radio stations fought hard to create attractive content worthy of the largest audiences possible—and in-car radio listening was often a driving force that shaped the scope and presentation of some of the biggest radio legacies. This is a key point that *Moving Sounds* emphasizes across the readings: Then and now, the relevance of the content ultimately determines when, where, and how we listen in the car, or anywhere.

Arbitron, the largest radio listening measuring service, and its other research partners, have kept an ear on in-car listening over the years with special reports regarding the relationship between driving and listening dating back to the late 1990s. Arbitron started with its first quantitative work on the mobile audience of Los Angeles, and subsequent reports into similar listening patterns in Mexico and the United Kingdom. After assessing 287 markets, Arbitron indicated that regardless of city size, the primary location of radio listening remains the automobile. Arbitron studies have remained consistent on this over time: Americans continue to tune into the car radio in large numbers despite the proliferation of mobile and satellite options (Arbitron, 2003, 2009, 2013b).

Furthermore, Americans spend more than 17 listening hours in cars during a typical week—with men consuming in-car AM/FM radio approximately one half-hour more than women on weekdays—2.5 hours for men compared to nearly 2 hours for women—with weekends being equal (Arbitron, 2003,

2009). Ninety-three percent of listeners turned to AM/FM in 2009, and that accumulated to 20 hours of potential in-car listening, with 200 plus miles weekly. In *The Infinite Dial*, Arbitron (2013a) reported that 58% of in-car radio listeners tuned specifically to AM/FM band stations, more than other audio sources such as satellite radio, mobile/online stations, and CDs. AM/FM radio also remains the primary source of new music for most listeners, followed by friends, family, and YouTube (p. 59).

In a 2013 report, *The Connected Car*, Arbitron acknowledges radio's future was changing but was far from dismal: "Despite the advertising of several 'new' in-car audio choices over the years such as 8-tracks, cassettes, compact discs, and even the auxiliary jack, radio continues to be the 'King of In-Car Media'" (Arbitron, 2013b, p. 1). At the 2013 National Association of Broadcasters/ Radio Advertising Broadcasters (NAB/RAB) Show, research trends for in-car listening pointed toward an increase in infotainment within the dashboard, connecting the listeners to traffic and mapping services and streaming audio, with most consumers not being impacted yet.

It is in this spirit of objective assessment that in the pages ahead, the authors hope to convey passion for radio, through all its eras, all its forms, and the lessons that it has communicated across its airwaves, without giving in to undue romanticism. Unlike the future of automobiles, however, *Moving Sounds* will not be a "driverless" experience for the reader. In every chapter the voice of the authors will be heard over the car radio.

Conceptual Framework

Moving Sounds gives account of the people and places that helped to position the car and the radio as interdependent consumer adoptions that were greater together than the sum of their parts. The authors then steer the book through key intersections in U.S. cultural history as radio makers, programmers, the Federal Communications Commission, and the automobile industry became corporate partners spanning more than eight decades of growth.

What this means simply is that traditional broadcasting has ruled the roadways for the better part of a century but the incorporation of mobile devices and satellite radio also have become important cultural options, and perhaps even innovations that will end up strengthening radio's role on the road. The United States is the primary focus of this book, in which the relationship of the automobile, radio and road culture, is primarily explored within the broader scope of the cultural history of car radio.

It should be noted that much of the technical and social history regarding the car radio is archived by automobile museums and collections. No books—trade or academic—have told the story of the car radio as a cultural history and few scholarly journal articles specifically address the significant relationships between automobiles and radio in the United States. Bailey (1989), Belasco (1997), Flink (1990), Gunnell and Sieber (1992), Bull and Back (2003), Hinckley (2005), and other academic works do offer glimpses into American car culture. Unique primary sources, including past and present audience studies (of which an early example is "Radio Takes to the Road," NBC 1936), contemporary newspaper and magazine articles, and other publications have helped the authors to reconstruct the historical and cultural events surrounding the birth and evolution of the car radio.

Ultimately, Moving Sounds is designed to offer hitherto unrevealed cultural perspectives and insights into car radio, as it was shaped and is still being reshaped by American ideals and tribulations. It is intended to engage media scholars and students and contribute to the cultural studies of sociology, anthropology, marketing, and communication, but none of the authors presume to have written the definitive work on the subject. For example, while Moving Sounds considers questions of race, gender, materialism, and alienation, these are conversations that are just being started and it is our hope that other scholars will contribute to and/or build on this cultural history in years ahead, just as we have pull on threads from an investigation of American mobility initially popularized by Vance Packard's A Nation of Strangers (1972).

In the best case scenario, the work that has begun here will result in greater attention in the other industries as well, such as the "Car Radiorama 2005" in Pennsylvania that celebrated vintage Crosley products. This book, consequently, fits nicely within university media studies and business school industry studies classes, and more specifically the growing field of radio and sound studies. It likely serves as reference for those studying and teaching in the fields of American studies, sociology, advertising, and marketing. The cultural studies theme presented here is to catch the eye (and ear) of both radio enthusiasts and those fascinated by road culture. The authors fill a significant historical and cultural void in American and media studies, one which is inclusive of the prominent role of women and minorities in mobile listening history. This retrospect is timely, as analysts of radio and automobile industries ponder the cultural and economic impact of new technologies in listening.

Moving forward, reader feedback will be an essential part of the Moving Sounds mosaic, a hoped-for audio portrait of America that includes echoes of

Big Bands, big hair, Beach Boys, Motown, Vietnam Protests, and the Civil Rights Movement to the rise of talk radio conservatism and today's I-generation hooked on the portability of iPods and MP3s. Thus, *Moving Sounds* invites the reader on a trek across time and space as the authors take turns behind the wheel.

"So don't touch that dial. We will be right back."

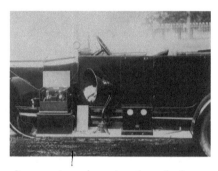

Figure 1.1. The first car radios were just adaptations from the home consoles.

Figure 1.2. Music for the traveler.

References

Arbitron (2009). *The Arbitron national in-car study.* Retrieved from http://www.arbitron.com/downloads/InCarStudy2009.pdf

Arbitron/Edison Media Research. (2003). *The national in-car study: The power of outdoor advertising.* Retrieved from http://www.arbitron.com/downloads/Incarstudy_summary_outdoor.pdf

Arbitron/Edison Media Research. (2013a). *AM/FM radio has far more frequent usage than other in-car audio options* (p. 30). Retrieved from http://www.edisonresearch.com/wp-content/uploads/2014/03/The-Infinite-Dial-2014-from-Edison-Research-and-Triton-Digital.pdf

Arbitron/Strategy Analytics/Jacobs. (2013b). Radio and the connected car. Retrieved from http://www.arbitron.com/downloads/connected_car_exec_summary.pdf

Bailey, B. L. (1989). *From front porch to back seat.* Baltimore, MD: Johns Hopkins University Press.

Belasco, W. J. (Ed.). (1997). *Americans on the road: From autocamp to motel, 1910–1945.* Baltimore, MD: Johns Hopkins University Press.

Bull, M., & Back L. (Eds.). (2003). *The auditory culture reader.* Sensory formations series. Oxford/New York, NY: Berg.

Car Radio. (n.d.). Last 100 years: Parts. *Car Radio4U*, accessed October 19, 2013. Retrieved from http:// www.carhistory4u.com/the-last-100-years/parts-of-the-car

Flink, J. J. (1990). *The automobile age.* Cambridge, MA: The MIT Press.

Graff, G. (2016, March 25). *Aretha Franklin on celebrating six decades as the queen of soul: "Our generation—The artists were stronger."* Retrieved from https://www.billboard.com/articles/news/magazine-feature/7285247/aretha-franklin-celebrating-six-decades-as-the-queen-of-soul

Gunnell, J., & Sieber, M. (Eds.). (1992). *The fabulous 50's: The cars, the culture.* Iola, WI: Krause Publications.

Heitmann, J. A. (2009). *The automobile and American life.* Jefferson, NC: McFarland.

Hinckley, J., & Robinson, J. G. (2005). *The big book of car culture: The armchair guide to automotive Americana.* Minneapolis, MN: Motorbooks.

Packard, V. (1972). *A nation of strangers.* New York, NY: David McKay.

Seiler, C. (2005, Summer). Song of the road automobility connects many aspects of American culture. [Commentary]. *Dickinson Magazine*, pp. 25–26.

Seiler, C. (2008). *Republic of drivers: A cultural history of automobility in America.* Chicago, IL: University of Chicago Press.

· 2 ·

THE ROAD TRIP IN THE MAKING

Phylis Johnson

There was no definitive event that ignited the spark between car, driver, radio, and the road. The modern automobile made its official appearance around 1886 but did not go into mass production until 1913 with Henry Ford's Model-T in Detroit. Similarly, there are many who had contributed to radio's arrival such as Nikola Tesla, Guglielmo Marconi, and David Sarnoff. Radio, as we might recognize it today, began in its rough form in 1910 with accolades to Charles Herrold broadcasting in California while amateurs across the United States were still building their own receivers (Greb & Adams, 2003). A photo in the Herrold biography (p. 117) captures the inventor's practice of broadcasting live "radio concerts" from his car when driving downtown San Jose in the early 1920s.

Radio through the years continued to evolve, with a waring waging among the inventors. When the smoke cleared in 1937, *Time Magazine* featured car radio on its cover, in what appeared an attempt to declare the uncontested winner of the automotive radio war. It shared one of many stories that exemplified the frustration of inventors and listeners of these early models. The article, "Radio Boom," opens with one such instance. According to Time, the first car radio on record was built in 1922 by William Lear of Quincy, Ill. That's when a Midwestern physician bought a car radio from Lear for his road

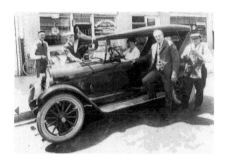

Figure 2.1. Charles Herrold broadcasting his radio concerts live in San Jose, CA. Photo courtesy of Greb & Adams's 2003 biography of the inventor.

trip to Los Angeles, and neither there or back was he able to tune in anything only to find out "the power plug had been installed backwards." There were so many trials and tribulations along the way. Authoritative scholarship regarding the history of car radio is lacking. Ultimately, *Time* acknowledges 1930 as the turning point for car radio; sales nearly tripled in 1931, and continued to escalate dramatically at lower price tags.

As a result, this chapter will not quibble over who should get credit as the "inventor" of the first car radio because that may depend on whom you ask or how car radio is defined. Yet, we will call attention to some of the major players. Across the world, the race had begun, with make shift radio fittings reported from England, Australia and the United States, with the latter initially taking the lead (*Car history*, 2018). For example, as early as 1901 in the United Kingdom, Guglielmo Marconi installed a radio unit within a steam-powered vehicle, but its antennae was so large that it had to be lowered before the vehicle could move. It transmitted data, but no sound (Car *history*, 2018). In another instance, Lee de Forest demonstrated a wireless radio in an automobile at the 1904 World's Fair in St. Louis, but without any radio stations yet, static was the only "show" on the programming schedule (*Wireless Telegraphy*, 1904).

In 1919, Westinghouse announced improvements to its portable battery for car radios, and a few years later Chevrolet Sedans would be fitted with Westinghouse receivers for an additional two hundred dollars above the price of the automobile (*Car history*, 2018). For many, these options would be too expensive, still too bulky, and without regulation.

With that in mind, experimentation continued, with several leading to success. In 1922, George Frost, president of the "Albert Grannis Lane Manual

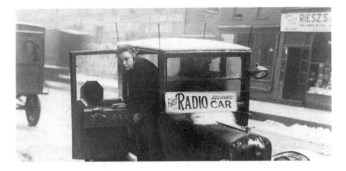

Figure 2.2. George Frost, 18, claims the first radio equipped car in 1922.

Training High School Radio Club" in Chicago (known today as "Lane Tech"), had installed a battery powered radio in his Model T Ford (Erb, 2007); this happened about the same time that a "Marconiphone" radio was displayed in a Daimler Motor Company car at the Olympia Motorshow in England (Erb, 2013), and R. E. Leppert, Jr., 17, of Harrison, New York, was featured in July 1922's *Radio Broadcast* in his refurbished Ford Classic car that he found alongside the road in a ditch. Shown in a photo, Leppert and his younger sister are seated proudly in the convertible demonstrating their huge car radio unit protruding above the dashboard complete with an elaborate antenna that he designed and built himself (Evans, 1922).

Figure 2.3. Leppert and his sister display a do-it-yourself car radio.

As the twenties came to an end, Philco bought the Automobile Radio Corp. (ARC), which had been purchased by the U. S. Heinaphone Corp. (owned originally by William M. Heina). ARC Chief Engineer A. A. Leonard discovered a way to "eliminate ignition interference" (Gottlieb, 1972, p. 39). The ARC even threw a big reception at Hotel Roosevelt in New York City, inviting the top auto makers. "You have to remember that America was

having a love affair with not only the automobile but also with the radio" (Gottlieb, 1972, p. 39). Famed newspaper columnist Arthur Brisbane was there to report on the party (1972).

About this time, the president of the National Association of Radio forecast "Receivers will become stock equipment for automobiles ... in the same way that bumpers and headlights are now" (Balk, 2006, p. 69). The gathering became a turning point for those in the car radio business; finally some serious attention was coming their way. A number of those companies had already begun to include space in their designs for car radio batteries and to equip new cars with antennas. As quickly as start-ups formed they were sold to larger companies, who profited from the experimentation of those who preceded them. That became the case for ARC as well (Gottlieb, 1972).

According to historian Rob Siegel (2017), bragging rights among firsts should be given to the Heinaphone Company. Its owner William Heina was "granted the first patent for the installation of radios in cars, " Transitones, the name of his brand which had improved upon the car radio. At that point, in 1927, it was the Automobile Radio Corporation (ARC) that purchased Heinaphone. In either case, Philco (Philadelphia Storage Battery Company) eventually landed ARC, and that worked well because it was mainly a supplier of batteries for electric vehicles. Transitone radios were successful enough to produced for many years (Siegel, 2017). In 1930, General Motors "produced its own car radios and equipped Cadillacs with roof antennas, while Chrysler advertised luxury cars' factory-wired for immediate installation of Transitone ..." (Balk, 2006, p. 69).

Alongside the car radio innovations, serious commercial production of radios, radio stations, and radio programming developed and grew concurrently with new car technologies. Before stand-alone antennae, early radio stations transmitted over telephone wires, similar to how the telegraph operated. Telephone/radio lines tended to be strung across roadways which favored car rooftop antennas, but reception was still spotty. Sometimes the car served as a mobile soundscape; roll down the windows, turn up the radio, and park near a favorite picnic area.

However, while radio listening was getting traction *inside* the car, car tires were still routinely getting stuck in the mud of unpaved country roads. Washington lobbyists had begun pushing for wider, longer, better roads that would connect major U.S. cities as early as 1916; Congressional legislation was enacted in 1925 to construct a national highway system. In the summer of 1926, a more-or-less contiguous highway from Chicago to Los Angeles—an

assimilation of former wagon trails, private routes, and existing highways that crossed through Illinois, Missouri, Kansas, Oklahoma, Texas, New Mexico, and Arizona before ending in California—was assigned its name: Route 66. Within a year, the nearly 2,500 mile-long Route 66's iconic road signs were in place and the country would never be the same socially or commercially. By the 1930s, Route 66 was "the Mother Road," the Main Street of America.

As the nation's newly codified highways lured people into their cars to explore the American West, the United States, and Canada began to formally organize the airwaves that commercial broadcasting business applications sought to exploit. For example, as early as 1916, David Sarnoff, who worked for radio innovator Guglielmo Marconi at the time, developed a plan for wireless broadcasting that would introduce music, sports, and other programming across the U.S., connecting rural communities to culture and entertainment. While other industry leaders mostly saw the highest purpose of a radio signal was only to connect a point on a map to another point on a map, Sarnoff saw the potential of one *person* connecting to the masses.

Post–World War I, a plethora of radio makers and radio transmitters—people "using vacuum tubes to build transmission facilities in sheds, garages, and attics" (Cowan, 1997, p. 284)—grew across North America. Sarnoff imagined a relay of radio telephone transmitters with a range of up to 50 miles would be installed at pivotal locations. The programming would be embodied in what Sarnoff referred to as a "radio music box" (Cowan, 1997, p. 283). Unfortunately, Sarnoff had other pressing financial issues that would distract him from his vision for a while.

In 1919, Westinghouse Electric Corporation's Frank Conrad set up an experimental radio station in his garage in Wilkinsburg, Pennsylvania. Although Westinghouse had been a manufacturing company focused on metropolitan electric infrastructure, Conrad's garage station eventually would evolve into one of the country's first professional radio stations, KDKA, broadcasting from atop the Westinghouse Company building in Pittsburg on November 2, 1920. The difference maker was the quality of Conrad's vacuum tubes, allowing his transmissions to be heard clearly for miles (Cowan, 1997, p. 285). Such sky-reaching antennas would foreshadow all future mobile listening.

The original home radios—mostly wood consoles that looked more like stylish furniture intended for family gatherings in the living room—were portable at least in the sense that one could pick them up, put them on the front passenger seat or backseat, and power the unit off the car battery. Maybe it

was just boredom that drove people to carry their 40 to 50 pound radio sets into their cars. Engines were so loud and mufflers so ineffective that radio signals were best heard with the car engine off—an incentive which may have drained a few car batteries in the middle of nowhere. As car radio popularity increased, people used just about anything and everything to strengthen radio signals on the road including umbrellas or the fashioning homemade car-length antennas (Hall, 1922; "Mobile," 1922).

By the mid-1920s, battery powered-radios expanded broadcast opportunities for music, religious sermons, news, and sports. Some people created their own drive-in radio theaters, bringing family and friends together for an evening show in an open yard (Lenthall, 2017). By 1930, approximately 7 percent of African-Americans owned a radio. The national average, in comparison, for White America was nearly 6.5 times greater (Lenthall, 2017, p. 58). That meant it was common for families and neighbors, and even whole towns in the rural areas of Arkansas, and Southern states like Mississippi, to listen together, and or to use the family car to broadcast outside of the home. Some people reported walking several miles to hear radio, others told stories of how they strung wires from homes to cars or to other homes to increase radio's reception (p. 59). Through the twenties, group listening continued as a widespread phenomenon, and that would change as the nation pulled out of the depression. The next decade, car radio would transform the automobile into a listening space, and it would be improved in appearance and design, taking up less interior space (Lenthall, 2017, p. 59).

Regardless of how cumbersome the radio units were within the automobile, consumer adoption of in-car radio listening came years before specially designed in-car radios were manufactured for purchase. The first car radio sets were only slightly better, even with professional installation (Lenthall, 2017). Magazine and newspaper ads and flyers of the era reveal a glimpse into the public excitement about the "over the road" portability of this new medium. Automobile dealers advertised car radio sets as attractive extras when buying new cars. One such was Chevrolet's "The Radio Sedan," a high-end option for car consumers that cost $200 on top of the price of the vehicle (Flammang, 1994, p. 97; "The Chevrolet," 2013).

Despite the effort required, evidence exists that instead of waiting for radio stations to come to in-car radio aficionados, many drivers strapped in their radios and went directly toward the signals. *The Popular Science Monthly*'s 1922 *The Standard Radio Guide* issued a U.S. broadcasting map, including a listing of the top stations (Davis, n.d.). In 1923, *Radio Age* published a map

that speculated radio's growth across the U.S., with highways as future indicators of station location (Lesh, 1923, pp. 11, 13; "Tune Up and Listen In," 1922, p. 4). Many radio stations even began to build transmitters along roadways to aid with car reception.

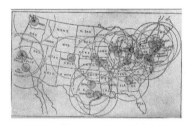

Figure 2.4. Standard Radio Guide's U.S.'s broadcasting map of U.S. stations to tune in for highway listening.

In an edition of *Radio World* dated October 28, 1922, a photo captures the fervor of the toddling in-car radio era. The headline states, "The 'Dashboard Special' Makes 40,000 Mile Tour, Equipped with Radio" (Butman, 1922; Erb, 2007). The caption describes how J. C. Davenport and his wife had taken their new car radio set, "the Dashboard Special," on a 40,000 mile trek. The photo displays the car's interior during a stop in New York City; the automobile windows are open as the couple blares music from a local radio station to encircling crowds of passers-by.

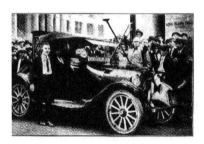

Figure 2.5. Car radio installed for a 40K mile trek in 1922, *Radio World*, October 28, 1922.

Despite all the complications and expense, the public could sense that magic was in the air. Besides big local stations, coast to coast radio networks such as the National Broadcasting Corporation (1926) and Sarnoff's Columbia Broadcasting System (1927) packaged and delivered a national culture of music, news, and advertising commerce that was redefining America. By the

decade's end, radio had become a star vehicle of its own rivaling theater and movies by introducing new celebrities into popular culture. The decade of the 1920s in America is remembered as an era of excess, rapid technological change, and an empowered consumer that was connecting through cars and radios, although not necessarily car radios yet. The 1920s had come in roaring with people seeking live music venues and good times wherever they could be had, but it ended in economic upheaval after the stock market crash on October 29th, 1929.

Almost because of the Great Depression of the 1930s, radio came into its own as many Americans escaped economic woes with this new-found form of "free" entertainment. In John Steinbeck's *The Grapes of Wrath* (1939)—a novel about displaced Oklahomans migrating to California—character Connie Rivers aspires to be a radio announcer while he listens to a dusty, "cathedral" receiver that had been loaded manually into a run-down automobile. American roads were filled with dreamers; Connie Rivers symbolized all those that imagined their voices would be one day broadcast through those speakers bumping along the roadways. As cars became the homes of nomads, westward pioneers, and explorers; as radio receivers became more compact and took up less space in the car; as radio stations began to broadcast to wider areas with predictable schedules, the practice of listening to the radio while driving was normalized.

A consequence of dedicated amateur and commercial innovative car radio enthusiasts, the story of the car radio is now more than a century old. Until the ubiquity of mobile phones, car radio was the ultimate, most common inter-connective technology and traveling companion on the road. In fact, radio could be viewed as an early version of social media in that when one turned on the car radio, one tuned into the community, and the communities though which one traveled. What people took from the car radio experience was individualistic in one sense, but also a collective bond in another, as commuters were becoming constant mass media consumers in their homes, their places of work, and now the spaces in between while the commercial radio experiment rolled on.

"Freedom Machines"

The thirties became a pivotal year for the rise of African-American radio personalities in urban areas in medium and large cities. Talented broadcasters like Jack L. Cooper, Eddie Honesty, Bass Harris, Hal Jackson, among

others emerged on the scene, challenging cultural stereotypes (Barlow, 1999, pp. 94–95), and local programming. With limited resources, Black Radio would rise to fill a community void for many African-Americans. It would become a way to unify listeners about issues and concerns, and it would take a civic spokesperson like Jack L. Cooper to lead the way for others across the U.S. As host of WSBC's The All-Negro Hour in Chicago, Cooper became one of the first, if not the first, on-air African-American ambassadors of Black Radio. He had been a journalist and columnist for the *Chicago Defender*, and conversationalist and entertainer at heart. He understood radio, and the audience loved him. He was intelligent, innovative and as "well-spoken as his white competitors in the industry" (Barlow, 1999, p. 51). He had no idea how much he would radically change radio, and provide a well-needed forum for Black America in the coming years. By the 1930s, African-Americans, who could afford one that is, found the automobile as a safe haven away from public transportation and Jim Crow laws. Even so, African-American motorists faced numerous challenges (Seiler, 2007, p. 115).

> … [S]ervice station bathrooms and roadside rest areas were usually closed to them. Black motorists also found it difficult to find places to stay: most roadside motels-north and south-refused to admit blacks. Diners and fine restaurants alike regularly turned away black customers. (Sugrue, 2005, n.p.)

By the 1930s, however, black motorists could consult travel guides. One of the first of the genre was the *Negro Motorist Green Book* published in 1936 (Seiler, 2007, pp. 115–116). "Black newspapers also ran advertisements for 'race' hotels, restaurants, and resorts where black customers were welcome" (Sugrue, 2005). Yet, it would years before the first black-owned auto dealers, for even if one had the financial means, it would be nearly impossible to locate a white dealership that would sell a vehicle to African-Americans (Sugrue, 2005). By 1950, Black radio would become far more powerful than ever anticipated under the reign of Al Benson, who capitalized on the popularity of rhythm & blues, and understood that the African-American voice was missing from politics. He was at "the forefront of the struggle against racial discrimination" (Barlow, 1999, p. 102). He was quick to broadcast commentary against violence to African-Americans, as well as to gather resources for those in need in the community (p. 102). He was described as "flamboyant" in appearance and style, arriving in his "white Cadillac convertible" driven by a chauffeur, and often greeted by more than a hundred thousand fans at his hosted concert events (Barlow, 1999, p. 102). He earned the top spot

and commanded top dollar for its ability to draw listeners to the dial and his remotes (Barlow, 1999). Surely, his car radio would be blasting the top R&B hits as he headed for his daily shows, or his next appearance at some Chicago venue, where he would be greeted by adoring fans. The automobile was still out of price range for most African-Americans, who relied on public transportation for their travel needs. By the end of the decade, Berry Gordy would establish Motown Records.

There appeared a slight increase in car ownership among African Americans in the postwar era, but nothing in comparison to what was portrayed in the media at the time, such as:

> ... the plentiful images of joyous and footloose drivers in black publications and popular culture [that] suggested that auto-mobility had ceased to be an exclusively white prerogative ... these phenomena were held up by apologists as signs of African Americans' ascent into the middle class and of racism's decline. (Seiler, 2007, p. 114)

But the world had not changed that much. Seiler (2007) points to horrific cases, like that of Robert Mallard, in which an African American driver was beaten and murdered for seeming "too prosperous" and "not the right kind of negro"; "For black drivers, the road's only constant was uncertainty" (pp. 114–115). The car radio was a companion, a connection between the driver and the world, but it could do little to protect its occupants who listened within inside. Aside from the dangers that accompanied the road, they provide new-found freedom. *Washington Post* columnist Warren Brown, who wrote on automobile industry ("Real Wheels") since 1982, recently retired, with his last column in January 2018. Years earlier, when recalling his New Orleans childhood, he wrote, "freedom of mind, spirit, and movement came with my family's acquisition of personal cars. We in fact called them 'freedom machines'" (Seiler, 2007, p. 125).

Motorola—Let the Good Times Flow

Like with any invention, there were many people who had contributed along the way, and then even involved in taking the idea to the market, among them the most influential being Paul Galvin, who launched the company Motorola. He seized the opportunity to capitalize on the rising car radio market that lacked efficiency because radios had to be custom-fitted into automobiles. He brought his idea to a banker, who tested the car radio in his Studebaker, and the radio ended up causing a fire in his car (Gottlieb, 1972). Galvin still

ended up getting the loan. Before it became the name of the entire company, "Motorola" was originally the model name that Galvin had given to the first car radio itself, a portmanteau of the key two concepts in car radio, motors and entertainment (the suffix "-ola" borrowed from the old Victrola phonograph brand). Fitch (2008) notes Galvin wanted to capitalize on the good times that driving and listening might bring to the driver (Fitch, 2008). The radio cost $110, but a bit of promotional savvy would help overcome the steep price tag (2008).

The Lear/Galvin historical narrative is more complicated than can be presented here adequately, but the pivotal year according to Fitch (2008) was 1929 when Galvin's car radio went into assembly at the Galvin Manufacturing Corporation. William Lear sold Galvin the patent (U.S. patent 1,944,139). Fitch (2008) pointed out, even though Galvin now had "a workable product, the car radio was far from an overnight success." Lear was the co-founder of Quincy Radio Laboratory in Quincy, Illinois; it was there he worked with Elmer Wavering. *New York Times'* obituary acknowledges Wavering as the inventor (Salpukas, 1998). It is clear that Wavering was an ambitious young man, who spent hours tinkering with auto parts, and the car radio would have been the first of his many successes. He worked for Lear while in high school, and the two worked together to smooth out the kinks of the car radio, such as the vehicle had to be turned off to hear the radio over the automobile noise, and that it was difficult to pick up any stations unless they were nearby. Both men were brilliant, and went on to have long careers in the transportation and communications industries (Salpukas, 1998).

The *Chicago Tribune* (Jackson, 1998) affirms his partnership with Lear in the design of the car radio that would go on to make Motorola a household name. Lear and Wavering drove to meet Paul Galvin at a Chicago audio show. Brothers Paul and Joseph had recently launched Galvin Manufacturing Corporation, and it was known that they would be at that auto show. Paul Galvin met the two young men, and then following his business sense, he challenged them to create a marketable version before he headed off to his next automobile convention in Atlantic City. Both men would help Galvin toward that end, with Wavering eventually becoming part of Motorola, as an engineer. It was a fateful decision that would result in him becoming president of Motorola in the early 1960s. "By tinkering and absorbing engineering on his own, Mr. Wavering worked with Mr. Lear and built a car radio that could withstand the rigors of bumpy roads and severe climate changes" (Jackson, 1998, n.p.). Looking back today, it is clear that it took the efforts of all three men to revolutionize both the car and auto industries.

With assistance from Galvin's brother Joseph, Lear, and Elmer Wavering, Galvin had installed a Motorola into his Studebaker before making a publicity stunt out of an 850 mile road trip from Chicago to Atlantic City for the 1930 Radio Manufacturers Association Convention. To get the kind of press he wanted, the Motorola had to handle rough roads, neatly fit within the dashboard, and project a good sound (McClure, Stern, & Banks, 2006). Galvin parked his car on the pier, attracting attention as he tuned in and turned up the locally broadcast music loud enough to solidify his place in media, marketing, and automotive history, according to the *Automotive Hall of Fame* (2013).

Technology was shrinking in size and price, and it was all about improving radio on and off the road. Crosley "was the first to add push buttons to car radios, and the second to install radios in automobiles" (LaHurd, 2015, n.p.). In 1930, the Crosley Radio Corporation marketed its car radio brand—Roamio. "It wasn't the first. People had been installing radio sets—homemade jobs, largely—in cars since the early 1920s, and 'Motor Victrola', (Motorola) was already on the market when the Roamio appeared" (McClure et al., 2006, p. 242). Car radio "wasn't quite as big a market as had developed in the early radio boom, largely because radio and the automobile didn't fit together as smoothly as they would in the years to come" (pp. 242–243). Installation was still cumbersome and lengthy (around 3 hours), and three extra batteries were anchored under the car's back seat. There was an antenna that required lots of wire that was looped on or below the car roof, and then there was an awkward dashboard, in which the speakers sometimes had to be installed separately apart from the panel (p. 243).

As the 1930s approached, car radio performance had stabilized and manufacturing techniques were increasingly standardized. Police cars, taxis, fire trucks, airplanes, and boats were being fitted with mobile radio sets even if the price tag for these professional units still put it out of range for the masses. By now, automobile owners could now listen to the radio more easily while the motor was running, as long as a radio station transmitter was in close proximity.

The Rise of the Portables

In the early 1920s, sizes, styles, and production quality of portable radios were as varied as the home furniture models. According to Michael Brian Schiffer (1991), most portable radios never really caught on with the general public in part because they were poorly designed, powered by external rather than

internal batteries, and operated on household current. On top of reception limitations for many of the smaller units, portables were still cost prohibitive to most Americans. The expense of owning more than one radio at all is why some people continued to put their home radios in their vehicles and why the first auto radio tuners—if a consumer had one at all—were essentially battery-operated portable units that could be taken in or out of a vehicle. Even wealthy Ohio auto parts manufacturer Powel Crosley, Jr. was appalled at the $100 price tag of a portable radio that his son, Powel III, wanted as a present. As the corporate story goes, Crosley and son instead built their own portable radio as a father-son project and by 1925, the millionaire industrialist began to market the Crosley Pup for its reliability, streamlined attractive modern encasing, and its reasonable price, retail priced at under $10 (McClure et al., 2006, p. 191).

Although the improved car radio sets were still mostly modifications of home radios that were difficult to install with aerial wires all over the place, by the end of the 1920s, the needle was moving on the number of Americans who had car radios. As for portable radios in general, Schiffer (1991) suggests that the market for these units "killed itself in the late twenties" by not being targeted enough (p. 114). For example, some early portables were sold as "outdoor radios" ideal for summer listening; just bring along a blanket, picnic basket, and a large external battery (p. 111). Do-it-yourself plans were available for building a Dick Tracy-style "wrist-watch radio," or a "pocket receiver" which was also called a "pocket sportset" (p. 115), but regardless of how exciting the ads looked, most families lacked the extra funds. Manufacturers like Collins Radio Company, founded by Arthur Collins, which were not successful at car radio production, had found some success during WWI tailoring their products to the military (Braband, 1983). Schiffer (1991) refers to the combined amateur, professional, and military efforts to shrink a longer-lasting battery as a "cultural imperative":

> Another generation of young experimenters was building their own portables during the thirties. These unique sets—like those of the teens and twenties—perpetuated the belief that small, battery powered radios, easily carried about, would someday become a casual companion to people at work and play. (Schiffer, 1991, p. 114)

Perhaps because during the Great Depression radio programming had risen above its original role to provide entertainment into a crucial national service needed to fill informational needs and an emotional void of a country in shock, citizens became more inclined to bring radio with them wherever they

went—even if the aesthetics were over the top. For example, in the 1930s, Philco sold a portable radio that appeared similar to a mini suitcase, complete with handles and surface speakers that might resemble a "boom box"—minus a requisite large external battery.

A Nation Connected

As car radio entered the market, only a handful of the top automobile makers remained strong. Only a decade prior, the mass production had first introduced the automobile to the public. Families could now live further away from the city, and this would eventually create the idea of suburbia. The rise of the supermarket meant the decline of the corner store. San Francisco's Crystal Palace opened in 1923, and Piggly Wiggly had opened six years prior. There were even driven-in food markets (Hess, 1996; Leisure Life, 2016). A car was essential in this new mobility.

Employment in the automobile industry and its related firms continued to rise. As the automobile radically transformed America in every fundamental way, the radio made for some wonderful company along the way. (Hess, 1996; Leisure Life, 2016). In-car air conditioning was introduced in 1933 in New York (First Air Conditioned Auto, 1933), but it would be several years later that air conditioning would become an option in cars, soon keeping people in cars longer, and make the automobile a place to cool off, because most did not have or could not afford air conditioning in their homes when it first became available. As more reliable, less obtrusive radio models took to the road on a new national highway system that provided a concrete infrastructure to a recovering economy, radio as an industry grew into what we might call today "a social network." Fan communities grew around radio programming and in-person listening clubs dedicated to broadcast information and entertainment shows were established. People were moving away from rural areas to cities in record numbers to find work so coffee shops and restaurants bloomed along the highways and became community gatherings and connecting points for the temporarily or permanently displaced. At the start of the 1930s, 40% households had radios—doubling during the decade (Smith, 2014). Whereas radio's golden age kept radio listening mostly confined to the home, radio on the road would find its peak in the decades ahead. The automobile and the car radio were status symbols of the good life that remained out of reach for many Americans. In 1920, according to Rudi Volti (2006), only 30% of rural Americans living on farms had automobiles (p. 39). By the early

thirties, car radios were installed into more than 100,000 automobiles, and that became a small business enterprise as well for some Do-It-Yourself types in the midst of harsh economic times. Fitch (2008, n.p.) elaborates, "That joy was spreading; by 1934, total industry sales of car radios topped $1.35 million."

By comparison, Americans took to the road tuned to the radio much faster and bolder than other nations (*Car history*, 2018). The first British broadcast was in 1922 near the Marconi laboratories. The first official British Broadcast Company (BBC) broadcast was later that same year. The trajectory of England's first car radios, either as separately purchased sets or factory installed, are somewhat comparable to what transpired in America. In 1929, one sees a clip of an early car radio, as captured on film. The object is an unusually large car radio that has been situated in the automobile. There is a driver in the front seat and a passenger with headphones in the backseat. The passenger appears to be adjusting a makeshift car radio (*British Pathé*, 1929). Notably, in 1933, the British car manufacturer Crossley Motors (no relation to Powel Crosley, Jr.) was the first to install a car radio in the factory (Harding, 1972). BBC radio programming would also take a backseat, however, as UK listeners preferred listening to unregulated overseas shows with formats similar to American stations, which is considered the beginning of Britain's love of pirate radio broadcast from ships in international waters that lasted almost until the 1970s (Barker, 2009).

Meanwhile in the former colonies, Winberry (2005) describes the impact of Route 66 as the highway that would change America, "the hopes, dreams and aspirations of people looking for a better life" (p. 28). As it rose quickly in the American consciousness, Route 66 was more than a road, it was a collection of "people, places, food, buildings, and entertainment that conjure fond memories" (Winberry, 2005, p. 28). Route 66, of course, is not the only U.S. highway of legendary status, but the Mother Road did provide the setting for many of the first romantic sparks between car and radio. A recent report in an alumni magazine published by Dickinson College determined that approximately 80% of Route 66 is still drivable in its original layout.

Radio's Futurama

As conceded at the start of this chapter, although there was no definitive event that cemented the relationship between car, driver, radio, and the road, once connected, there would be no turning back. People created cars and radios, people put radios in cars, car builders and radio programmers then perfected the symbiosis, and so it was almost inevitable that in turn people

would enjoy listening to songs about people on the road. The new auto travel culture inspired musicians to write songs about the road life that then could be listened to on the road.

American singer-songwriter Woody Guthrie, known for his advocacy of migrant workers during the Great Depression, influenced generations of musicians such as and Peter Seeger, Bob Dylan, Jack Elliott, Bruce Springsteen, and John Mellencamp with his moving Dust Bowl ballads. "Crossroads Blues" (Robert Johnson, 1936), "Route 66" (Nat 'King' Cole, 1946), "Wide Open Road" (Johnny Cash, 1954), and "I've Been Everywhere" (Hank Snow, 1962) are also some of the more famous some road songs of the 20th century. When Dylan controversially pivoted from acoustic folk songs to a rocking electric guitar, the title track from his next album was *Highway 61 Revisited*.

Radio, of course, can always take people further than cars because it offers a mind's theater-on-wheels fueled by personal and cultural imagination. Behind the wheel, people sing, dance, and argue back to talk radio programs as though they are in a solitary bubble. While the argument or their imagined singing career may not be going anywhere, at least the car is. Car radio sounded the call for freedom across the open road where a man or woman could be anybody he or she wanted to be—for the length of the car ride, at least. Perhaps this is what public intellectual Marshall McLuhan hinted at in *Understanding Media: The Extensions of Man* (1964) when he discussed how technology would provide opportunities beyond human reach, extending physicality toward potential.

Indeed, connection comes in concentric circles radiating outward from the driver's seat. Radio stations functioned as reflectors and producers of local culture as well network affiliates that connects passengers to a broader national pop culture conversation. With a car radio, the listener can tune into society and/or drop out of it for a while. The family car could bring the family together for summer and holiday vacations, and also serve as an escape pod from domestic duties waiting in the driveway.

Jim Hinckley (2005) in *The Big Book of Car Culture: The Armchair Guide to Automotive America*, makes a reference to Highway U.S. 100 which covets Willapa Bay's shoreline in Washington. The road meanders across the countryside and arrives in Grays Harbor. Two steel bridges catch one's attention, and "at the foot of the biggest one, there is a small building with a booth on the second story that leans out over the highway" (p. 269). Hinckley (2005) explains, "At one time, this was a radio station, and the disc jockey played records, gave weather reports, and waved to tourists from the windows of his booth" (p. 269). Radio stations positioned along roads vanished over time

even though they were sometimes the lone human connection along "long stretches of desolate highways" (p. 269). With prominent, frequently well-labeled transmitters nearby, a driver could easily identify and tune in the signal. Over time, however, the giant antennae became hidden from view, separated from radio stations that provided the juice, often consolidating many radio stations on a single tower that had been relocated away from sight.

One year after Orson Welles' *The War of the Worlds* (1938) unwittingly duped many listeners to jump into their cars to escape a fictional Martian invasion, industrial designer Norman Bel Geddes, on behalf of General Motors, was commissioned to create the Futurama exhibit/ride at the 1939 New York World's Fair. The exhibit's concept proposed a speculative system of free-flowing highways across all terrain with predictions that Americans would be connected via the automobile and highway (Walker, 2016). It would appear we are connected not only by physical highways, but Super Highways via the Internet. In 1972, Vance Packard's *Nation of Strangers* would address the ills of mobility in U.S. culture, including the rise of individuality and alienation, at the cost of the loss of community.

Other stories that speak to the interconnectivity of the car, driver, radio, and the road are still being told while others will be uncovered one day on yellowing documents in the shoeboxes of history. One great lesson that every student should remember is that then, like today, technology has always been fluid and transforming and only a handful of people are mindful enough to document the changing times. Inventors have left notes, but few coherent narratives that explain the beginning, the middle, and the end, of how we started there but ended up here. The early history of the car radio is still a work in progress. As you will see in the next few chapters, with the advent of transistor technology, car radio's signal and sound would strengthen while its size would shrink, and allow drivers to hear for longer distances than previously, without worry of their radios or batteries overheating. Progressively, the love affair with the car, radio and road would deepen, as some of the former distractions and frustrations dissipated leaving driver to enjoy the ride.

References

The Automotive Hall of Fame (2013). Paul Galvin. The Automotive Hall of Fame. Retrieved from http://www.automotivehalloffame.org/inductee/paul-galvin/774/

Balk, A. (2006). The rise of radio, from Marconi through the Golden age. Jefferson, NC: MacFarland.

Barker, V. (2009, November 13). The real story behind Britain's rock 'N' roll pirates. All things considered. Washington DC: National Public Radio Corporation. Retrieved from https://www.npr.org/templates/story/story.php?storyId=120358447

Barlow, W. (1999). Voice over: The making of black radio. Philadelphia, PA: Temple University.

Berkowitz, J. (2010, October). The history of car radios: Car tunes: Life before satellite radio. Car and driver. Retrieved from http://www.caranddriver.com/features/the-history-of-car-radios

Braband, K. C. (1983). The first 50 years: A history of Collins Radio Company and the Collins Divisions of Rockwell International. Cedar Rapids, IA: Rockwell International. Also refer to: https://www.k4vrc.com/uploads/7/8/8/6/78865320/collins_history_presentation_tvarc_9-21_[w3my_russ].pdf

British Pathé, 1929. Car Radio. British Pathé, NewsArchive. Film ID: 1036.02. London, UK. Retrieved from https://www.britishpathe.com/video/car-radio/query/Car+Radio

Butman, C. H. (1922, October 28). Secret lines of communication. Radio World. Retrieved from https://www.radiomuseum.org/forumdata/upload/Car_Radio_1922_Radio_World11.png

Car History 4U. (2018). Car radio. History of the car radio in motor cars/automobiles. Retrieved from http://www.carhistory4u.com:80/the-last-100-years/parts-of-the-car/car-radio

Cowan, R. S. (1997). A social history of American technology. New York: Oxford University Press.

The Chevrolet, from 1916–1934 (2013). Welcome to John's old car and truck pictures, memory lane. Retrieved from http://oldcarandtruckpictures.com/Chevrolet/

Cross, A. (2013, July 29). A brief history of the car radio, 1904-present. A Journal of Musical Things. Retrieved from http://ajournalofmusicalthings.com/a-brief-history-of-the-car-radio-1904-present/

Davis, G. (n.d.). Route 66 and radio history timeline. Grand Canyon Tube Radio. Williams, AZ: Music Gateway Corporation. Retrieved from http:// www.grandcanyontuberadio.com/research/radio66history.html

English, B. (2013, July 27). Classic cars, auto radios: Tuned in, turned on to classic radios. The Globe and Mail (Toronto, Canada). Retrieved from https://www.theglobeandmail.com/globe-drive/reviews/classics/tuned-in-turned-on-to-classic-radios/article13432272/

Erb, E. (2007, March 13). History and development of early car radios. Forum. RadioMuseum. Retrieved from https://www.radiomuseum.org/forum/first_car_radios_history_and_development_of_early_car_radios.html

Evans, P. W. (1922, July). Our amateur radio reserve. Radio World, pp. 243–246. New York: Doubleday. Retrieved from http://americanradiohistory.com/Archive-Radio-World/20s/22/Radio-World-1922-June-10.pdf

First Air Conditioned Auto (1933, November). Popular Science 123 (5), 30.

Fitch, C. S. (2008, February 1). Radio has a special place in the car. Radio World Online. Retrieved from https://www.radioworld.com/miscellaneous/radio-has-a-special-place-in-the-car

Flammang, J. (Ed). (1994). Chronicle of the American automobile over 100 Years of auto history. Lincolnwood, IL: Publications International.

Gottlieb, R. J. (1972, June-July). Getting radio on the road. Special Interest Autos. Hemmings Daily. Retrieved from https://www.hemmings.com/blog/2007/08/26/sia-flashback-getting-radio-on-the-road/

Greb, G., & Adams, M. (2003). *Charles Herrold: Inventor of radio broadcasting.* Jefferson, NC: McFarland.

Guinness book of car facts and feats. New York: Bantam Books.

Hall, W. (1922, June). The Pacific Coast is "on the air." *Radio Broadcast,* pp. 157–161. New York: Doubleday.

Harding, A. (1972). *Car facts and feats: A Guinness record of everyday motoring and automotive achievement.* New York: Doubleday.

Hattwick, R. (2014, October 24). Paul Galvin—Motorola. The American National Business Hall of Fame. Retrieved from http://anbhf.org/laureates/paul-galvin-2/

Hess, K. (1996, June 9). The growth of automotive transportation. Retrieved from http://www.klhess.com/car_essy.html

Hinckley, J. (2005). *The book of car culture: The armchair guide to automotive Americana.* Minneapolis, MN: Motorbooks.

Jackson, B. (1998, November 22). Elmer H. Wavering, 91, A pioneer in electronics. *Chicago Tribune.* Retrieved from http://articles.chicagotribune.com/1998-11-22/news/9811220128_1_automotive-electronics-wavering-motorola

LaHurd, J. (2015, November 15). Powel Crosley Jr. remembered as a visionary. *Herald-Tribune.* Retrieved from http://www.heraldtribune.com/news/20151115/powel-crosley-jr-remembered-as-a-visionary

Langley, R. (1973). *Radio collector's guide 1921–1932.* Palos Verdes Peninsula, CA: Vintage Radio.

Leisure Life. (2016, March 22). The automobile—effects/impact on society and changes in cars made by generation. *Axle Addict.* Retrieved from https://axleaddict.com/auto-industry/Affects-of-the-Automobile-on-Society-and-Changes-Made-by-Generation

Lenthall, B. (2017). *Radio's America: The great depression and the rise of modern mass culture.* Chicago, IL: University of Chicago Press.

Lesh, L. J. (1923, April). The super-radio survey. [map]. *Radio Age,* pp. 11–13.

McClure, R., Stern, D., & Banks, M. A. (2006). *Crosley: Two brothers and a business empire that transformed the nation.* Cincinnati, OH: Clerisy Press.

McLuhan, M. (1994). *Understanding media: The extensions of man.* Cambridge, MA: The MIT Press. First edition, 1964.

Mobile Phone. (1922). Pale of future [Video]. Smithsonian Magazine Blog. Retrieved from http://blogs.smithsonianmag.com/paleofuture/2012/01/a-mobile-phone-from-1922-not-quite

Pearne, F. P. (1922, September). Novice gets good results with Armstrong Super-regenerative circuit. [Photo: Auto-Man Solved The Circuit]. *Radio Broadcast,* pp. 2–3, 22.

Petrakis, H. M. (1965). *The founder's touch: The life of Paul Galvin of Motorola.* Chicago, IL: Motorola University Press.

Oakley, H. (2014, January 9). Elmer H. Wavering: Quincy native father of modern automotive electronics. *Herald-Whig.* Retrieved February 24, from http://www.whig.com/story/24411717/quincy-native-father-of-modern-automotive-electronics#

Ramirez, R. (2013, May 31). Auto radio. *Philco Auto Radios.* Retrieved August 10, from 2013, from http://www.philcoradio.com/autorad/autorad.htm

Salpukas, A. (1998, November 27). Elmer Wavering, 91, pioneer of auto electronics, is dead. *New York Times*. Retrieved from http://www.nytimes.com/1998/11/27/business/elmer-wavering-91-pioneer-of-auto-electronics-is-dead.html

Savage, M., & Brand, C. (2007, May 3). *Wireless on wheels – A brief history of car radio*. DX International Radio. Retrieved from http://dxinternational.blogspot.com/2007/05/wireless-on-wheels-brief-history-of-car.html

Schiffer, M. B. (1991). *The portable radio in American Life*. Tucson, AZ: The University of Arizona Press.

Seiler, C. (2007). *Republic of drivers: A cultural history of automobility in America*. Chicago, IL: University of Chicago Press.

Siegel, R. (2017, December 11). History of obsolete car radio, part 1: Early radio. *Hagerty* Group. Articles-history of early radio. Retrieved from https://www.hagerty.com/articles-videos/articles/2017/12/11/history-of-early-radio

Smith, S. (2014, November 10). Radio: The internet of the 1930s. American Radio Works. St. Paul, MN: American Public Radio. Retrieved from http://www.americanradioworks.org/segments/radio-the-internet-of-the-1930s/

Strohl, D. (2007, August 26). SIA flashback—getting radio on the road. The Hemmings Daily. Retrieved from https://www.hemmings.com/blog/2007/08/26/sia-flashback-getting-radio-on-the-road/

Sugrue, T. (2005). Driving while Black: The car and race relations in modern America. Automobile in American life and society. Retrieved from http://www.autolife.umd.umich.edu/Race/R_Casestudy/R_Casestudy.htm

Tune Up and Listen In. (1922, May). Midwest broadcasts. [Map]. *Radio Age*, p. 4.

Volti, R. (2006). *Cars and Culture: The Life Story of a Technology*. Baltimore, MD: Johns Hopkins University Press.

Walker, N. R. (2016, Fall). American crossroads: General Motors' midcentury campaign to promote modernist urban design in hometown U.S.A. *Buildings & Landscapes Journal of the Vernacular Architecture Forum*, 23(2), 89–115.

Winberry, J. (2005, Summer). Getting his kicks: Optometrist has an eye for the ultimate road trip. *Dickinson Magazine*, pp. 27–30.

Wireless telegraphy at the St. Louis exposition. (1904, September). *The Electrical Age*, pp. 161–167. Retrieved from http://earlyradiohistory.us/1904sl.htm

· 3 ·

ON WOMEN AND RADIO

Women in the Driver's Seat

Donna Halper

In 1914, Evelyn Marie Stuart, a regular contributor to the *Fine Arts Journal*, a woman who normally evaluated artworks, attended in Chicago what today would be called an "auto show." And while there were no Rembrandts or Monets at this exhibit, Stuart was impressed by the stylishness of the new vehicles. For the wealthy man, she wrote, there were "wonderful, roomy limousines" with exteriors that seemed to glitter and shine thanks to their "deep varnishes," cars whose equally luxurious interiors featured "tufted ... upholstery as soft as the favorite arm-chair of a British earl" (Stuart, 1914, p. 148). Even the less expensive vehicles, she noted, demonstrated "unpretentious dignity and good taste" (Stuart, 1914, p. 152). Most of the illustrations in the article either showed men or just showed the car itself, but one photograph displayed a stylish young woman at the wheel of a model that was said to exemplify "elegant beauty and refinement" (Stuart, 1914, p. 151).

To Stuart, the automobile was a marvel of modernity, although a dedicated reader still might question its presence in *Fine Arts Journal*. No doubt, there is an aesthetic to automobile design, but Stuart spoke just as much about function as form. "A car ... makes for sociability, civic pride, a greater appreciation of nature ... through more time spent in the fresh air," and automobiles facilitated neighborliness, Stuart said, since now "neighbors and friends are never more than a few minutes away" (Stuart, 1914, p. 148).

To read Evelyn Marie Stuart's article is to witness how America was still figuring out what to make of this new national obsession—starting with an agreed-upon vocabulary. Only a few years earlier in 1899, *Scientific American* encouraged readers to suggest what these new driving machines should be called; the editors ultimately rejected the many suggestions, noting they tended to be both "weird" and "amusing" but not very practical (Hornberger, 1930, p. 274). By 1900, "automobile" had managed to become the preferred lingo, with the shortened version, "auto," not long after that ("Bewitching," 1904, p. 9). "Car" also seemed to be in circulation by 1902, but since it was originally associated with the trolley lines as in "street car" shortened from "carriage," the shift in meaning to a *personal* car was more gradual ("Causes for Stops," 1902, p. 15).

The next semantic evolution in car culture pertained to what word should be used to designate the people who were behind the steering wheels of these automobiles. In most newspapers, "motoring" had become the verb of choice to describe driving around in one's automobile, so it followed that the person who motored was called a "motorist" ("Many Uses," 1902, p. 21). Not surprisingly, at least early on, any mention of a motorist would have had gender implications because men—especially upper-class white men—tended to be the only ones with enough money to buy a car. This is also understandable considering early automobiles required a crank to start the engine and that some degree of physical exertion was needed to operate and maintain the car over unpaved streets (e.g., Parlin & Bremier, 2017, para. 16). On the other hand, when the motorist was a woman, "automobile girl" and "motor girl" became *terms of art* in keeping with the custom of that era that called adult females "girls" as a compliment to imply a woman was still youthful ("Automotive girl," 2011). Stylish "motor girls" were popping up everywhere.

As early as the late 1890s in Newport, Rhode Island, where many of the East Coast elite spent their summers, motoring became a new craze with such society women as Mrs. Herman (Tessie) Oelrichs, Mrs. Oliver H. P. (Alva) Belmont, and Mrs. Stuyvesant (Marian) Fish making the local news for learning to drive and even having an "automobile parade" in September 1899 ("First Automobile," 1899, p. 6). According to newspaper reports, the women gave demonstrations of "skillful automobile driving," after which, the parade commenced. "The carriages were superbly decorated with flowers and ribbons," the society reporter commented (p. 6).

On the so-called "Women's Page" of many daily newspapers, in fact, the big stories were not just that socialites were riding in beautiful automobiles, it was *what they were wearing* for the occasion. Then as now, celebrities influenced

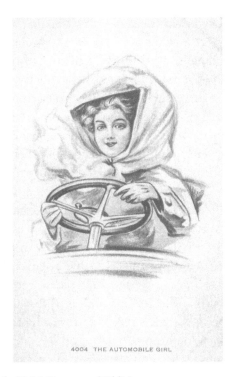

4004 THE AUTOMOBILE GIRL

Figure 3.1. "Automobile Girl." Courtesy of OldMotor.com.

fashion, and as automobiles became more popular, designers were busy creating the "proper" garments for the well-dressed woman to wear, whether as the passenger or the driver. For example, when syndicated columnist Ellen Osborn covered the Newport "automobile parade," she noted some women had a special "driving dress" of "attractive, elegant white taffeta or white silk," while others preferred the "divided skirt" (a culotte-like garment also popular with women who rode horses), and many chose straw hats (Osborn, 1899, p. 11).

As to who was the first licensed motor girl in the United States, we may never know. In early January 1900, the *Denver Post* was among the many newspapers with a brief article claiming Miss Florence E. Woods was the first woman to receive her permit in New York, but she was licensed only to operate an automobile in Central Park. Some newspapers reported Woods was just 17, others said she was 20, but all agreed she was the daughter of Clinton E. Woods, the general manager of the Woods Auto-Vehicle Company of Chicago. About the same time down in Washington DC, Anne Rainsford French was said to be the first licensed female operator ("She's Now," 1900, p. 6). To support that claim, in a 1952 *Life* magazine profile, French was dubbed

"The First Woman Driver" in the United States. The author noted that her auto, the Locomobile, cost about $600 and went 9 miles an hour—the speed limit at that time (Lehmann, 1952, p. 86). The story also noted that when she married Walter Bush in 1903, her husband, believing that driving was a "man's job," refused to let her drive anymore. She seems to have gone along with his wishes (Lehmann, 1952, p. 95). Ultimately, the issue remains unsettled, however, because at least one other source suggests the first licensed female driver in the U.S. was Genevera Delphine Mudge in 1898 (Scharff, 1991, p. 37).

Either way, by 1914, when Evelyn Marie Stuart wrote her review of that Chicago auto show, women drivers were no longer a novelty. At a time when most women still could not vote, however, seeing a woman who could drive a car as fast and as ably as any man must have been exciting to watch. In popular culture, a woman driving became associated with female emancipation and autonomy—the "new womanhood." One popular silent film with this theme was called *Mabel at the Wheel* (1914) starring Charlie Chaplin and Mabel Normand, who was the co-director. "In this two-reel comedy, Mabel takes the wheel of her boyfriend's race car, thwarting the machinations of a villainous Chaplin and speeding to victory on her own" (Parchesky, 2006, p. 176). Although this movie was a farce, just a year after its release, 18-year-old Katherine Dahlgren, referred to as the "daring young woman driver" from Lenox (in western Massachusetts), won an auto race in Elgin, Illinois, in a car that could go 90 miles per hour ("Daring Girl," 1915, p. 18).

Before she was known for her bestselling etiquette manual, a divorced socialite named Emily Post wrote a series of articles for *Collier's* magazine about traveling long distances by auto. She and her son (who did the driving), along with a cousin, embarked upon a twenty-seven day trip to California, stopping along the way so Mrs. Post could offer her impressions of the cities they visited (as well as the hotels and restaurants in each one) (Post, 2004, pp. 3–4).

But it was not only wealthy women who valued mobility. By the mid-1910s, driving a car was quickly becoming a way for many middle-class women to experience some degree of independence. This was especially true for black women living in a segregated America. Since people of color were not always welcome on the public trolleys and trains, those African Americans who had access to a car gained the opportunity to travel in comfort and—more importantly—safety (Sanger, 1995, p. 712). Car ownership for any prosperous black woman—just like her white counterpart—was seen as a visible sign of social status. Well-known entrepreneur Madame C. J. Walker, for example, often used her car as part of doing business, driving to distant neighborhoods to demonstrate and

sell her hair-care products. She also used her car to show invited guests around Indianapolis, where her company headquarters was located ("A Grand Musicale," 1914, p. 8). When Madame Walker gave a dinner, if she knew there were people who wanted to attend but had no transportation, she would often send a car for them ("Madame C. J. Walker," 1916, pp. 1–4).

Rural women were another marginalized demographic who benefited from having access to an automobile. Cars offered these women the opportunity to go into town and run errands for the farm (Scharff, 1991, p. 142). Being able to drive also meant an isolated woman could visit the library, where there might be an educational program, such as a lecture (Stearns, 1913, p. 176).

And just as the automobile went from a fad for the wealthy to an important part of modern American life, so did the radio. To illustrate the improvements in radio receivers to the average consumer, the cover of the June 1923 issue of *Radio News* showed a young woman with her headphones on, happily tuning the dials on her radio set. That cover art conveyed a dual meaning: the radio was becoming pleasurable pastime for women and this particular receiver was so simple to operate suggesting that "even a woman could do it."

While not nearly as famous as the male pioneers of radio, some women also were involved in broadcasting from the beginning. For example, Marie (Mrs. Robert) Zimmerman put station WIAE on the air in Vinton, Iowa, the first woman to be granted a license by the government ("First Woman," 1922, p. 14). At least one woman, Eunice Randall of greater Boston's 1XE/WGI radio, was both an announcer and an engineer (Halper, 2015, pp. 6–7). Among her duties was reading news headlines, which included the reports of stolen automobiles so that the police could get help in finding the criminals or finding the cars (Halper 2015, p. xi). A closer look at the radio stations of the early 1920s shows that women did mostly clerical work, with some copywriting, sales, and performing, but little representation in management. Bertha Brainard, a celebrated theater critic, became the first female network executive when the National Broadcasting Company was created in 1926, but she was a rarity (Scully, 1927, p. 39, p. 122).

On the other end of the radio signal, however, women were increasingly the target demographic of early programming such as the daily visit from "radio homemakers," experts such as "Betty Crocker," the corporate symbol who was portrayed by an actress discussing Betty's latest recipes ("Betty Crocker," 1925, p. 3). Another radio homemaker was Ida Bailey Allen, the real author of more than 50 cookbooks, nicknamed "The Nation's Homemaker," but there were also local, non-network versions of these programs as

well. These "women's shows"—similar in premise to the "Women's Page" in a newspaper, but with less gossip—offered helpful hints about cooking interesting meals, raising obedient children, and stretching the household budget. Especially in rural America, the radio homemaker was a "cultural phenomenon: a local icon of the ideal woman and simultaneously, a powerful force in shaping listener's lives" (Smethers & Jolliffe, 1998, p. 138).

Of course, not all women in the 1920s were homemakers. This was the Jazz Age after all, the era of the cigarette-smoking, hard-drinking, high-hemmed "flappers" and many young women were attending college with the intent of becoming lawyers, doctors, or businesswomen. More than ever before, women thumbed their upturned noses at social convention and challenged the concept that a woman's true happiness could be found in being the ideal wife and mother. Many of these non-conventional women also enjoyed a higher profile as celebrity spokespeople, such as former Olympic gold-medalist turned professional golfer Mildred "Babe" Didrikson-Zaharias, one of the first female athletes to do paid endorsements. An experienced driver, "Babe" agreed in 1933 to make appearances at six automobile shows and do print ads for Dodge ("Babe Back," 1933, p. 11).

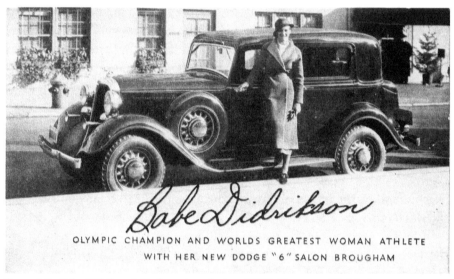

OLYMPIC CHAMPION AND WORLDS GREATEST WOMAN ATHLETE
WITH HER NEW DODGE "6" SALON BROUGHAM

Figure 3.2. Babe Didrikson's Dodge print ad, circa 1956). Courtesy of B. Mechum.

To advertisers of an expanding commercial medium, however, radio homemakers served the most useful purpose for the owners of stations and

their advertisers. As women's shows grew, female listeners became a powerful new block of mass consumers. Unlike newspapers or magazines, radio was a dynamic medium that "helped bring business and the home together. As [the Radio Homemakers] used radio to reach large audiences with ideas about homemaking as a vocation, they also told women that happiness and success could be gained by purchasing products" (Smulyan, 1993, p. 89). Commercial advertisers were not just seizing upon radio's ability to move household goods, they were indoctrinating a previously under-appreciated group of mass consumers.

The prevailing philosophy of mass marketing was that it offered "endless potential for growth and appealed to all Americans" (Cohen, 2004, p, 237). The subtext to the expansion of the American economy through the mass marketing of goods and services through radio advertising was that "it widened the target audience to include the preliterate as well as the illiterate. It was also inherently intrusive and inescapable—a valuable persuasive tool of which agencies were keen to make use" (Hutchings, 1996, p. 66). To the extent that the goal of every advertising agency is to reach to the largest group of potential consumers at the lowest possible price, women's shows became increasingly important as women's buying power increased.

Due to various shifts in the economy, during the 1940s, rudimentary home economics—the longstanding province of the woman of the house— had developed into a sophisticated extension of national economics when "women became responsible for much of the spending necessary to sustain their families, and they were taught to regard intelligent consumption as an essential part of their duty as good wives and mothers" (Graham, 1997, pp. 539–540). The most famous female industrial engineer and mother, Lillian Moller Gilbreth, the subject of the novelized biography *Cheaper by the Dozen* (1950), once endorsed IBM's design for a "household management desk that included a radio, telephone, clock, adding machine, typewriter, reference books, schedules, and some pull-out charts useful for completing household tasks" which spoke to the elevation of homemakers to "domestic engineers" (Graham, 2013, p. 364).

The relationship between the busy housewife and her ubiquitous radio may seem exaggerated, but extant radio sales pitches to national brands of the 1950s extol women as loyal daytime radio listeners, not "dial-twirlers," because radio "has become a companion medium that stays with the housewife as she performs her daily chores ... she has come to accept her favorite radio personalities as old friends to be relied upon and visited with again and

again" (Wang, 2002, p. 361). Up to this point, men dominated radio owner-ship, management, and on-air presentation, but women listeners were on a steady climb to drive programming as mass consumers.

The purchasing potential of female radio listeners had never been so pow-erful. The spending habits of U.S. women soon loomed over most terrestrial radio programming and marketing decisions because they controlled almost all household purchases (Nava, 1991, pp. 6–7). For example, lucrative medi-cal and pharmaceutical advertising tended to be female-focused since "women are more likely than men to be the principal brokers or arrangers of health care for their spouses as well as for their children" (Norcross, Ramirez & Palinkas, 1996, p. 475). Beginning with the new millennium, it became even more evident that "women choose how 88 percent of every disposable dollar is spent—including 53 percent of all stock purchases, 63 percent of personal computer buys, and 75 percent of all over-the-counter drug outlays" (Crawford, 2004, para. 2). A 2013 study by consultants Alan Burns and Asso-ciates of more than 2,000 female radio listeners (aged 15–54), indicates that women still rely on radio for companionship in significant numbers: 86.6% of the women surveyed said they had listened to a radio show on AM/FM sometime in the last week (Schmitt, 2013, para. 4).

But women are also bringing their vigorous buying power to various digital radio/audio platforms as well. According to researchers, about half of women surveyed said they had downloaded a radio app and/or listened to radio on a mobile device at least weekly—and that was only up to 2012 figures (Schmitt, 2013, para. 6). Several years later, Nielsen Media Research indicates listener-ship "remains steady and high, with more than 90% of listeners tuned to ter-restrial radio in a given week" (Pew Research Center, 2017, para. 2). Further, the report also notes that "radio listening in cars, like listening to AM/FM stations online or streaming other online audio, [has] continued its increase since 2010, when it was at just 6%." (Pew Research Center, 2017, para. 5; also Brenner 2015 for comparison data from 2010). To underscore how in-car lis-tening has changed, more than 40% of U.S. mobile phone users have listened to online radio in a car via phone (Pew Research Center, 2017, para. 5).

The migration has been steady to podcasting as well; women are almost equal to men—55% to 45%—in total podcast listeners ("Westwood One," 2017, p. 6). Wherever women go to listen to radio programming, advertisers follow.

Less than a century ago in an issue of *Literary Digest*, First Lady Eleanor Roosevelt, was photographed with her light blue Buick Roadster. Although she could have easily afforded a Cadillac or another luxury brand, the small,

economical Buick Roadster with a rumble seat in back symbolized her efforts to change the role of women in society through her weekly radio commentary, speaking out publicly, and driving herself to and from events to champion women in her own car (Bugbee, 1933, p. 22). Mrs. Roosevelt did her part: an hour before her husband's scheduled press conferences, she would hold her own—but only female journalists were allowed (Youngs, 2013, para. 2). Yet, social change rarely comes quickly. Despite major gains in broadcasting over the years, women are still vastly underrepresented at the management and executive levels in radio (Cramer, 2007, p. 62).

As at least one classic photo of Eleanor Roosevelt illustrates, nothing ever stopped First Lady Eleanor Roosevelt from finding her power—on the radio, in her car, or making her voice known. As this chapter has made clear, while few women have had the opportunity to own or program a radio station, the most important male media executives were forced to succumb to the pocketbook economics that changed broadcasting. While women may not be running the show yet, their prowess as mass consumers in a capitalist economy has already put them in the most powerful driver's seat of all.

Figure 3.3. Eleanor Roosevelt at the wheel, July 1933, Hotel Belle Plage, Matane, Quebec.

References

"Automobile girl." (2011, August 24). The old motor.com. Retrieved from http://theoldmotor. com/?p=15001

"A grand musicale." (1914, April 25). *Indianapolis Freeman*.

"Babe back in prints." (1933, March 6). *Portland Oregonian*.

"Betty Crocker talks for the housewife soon." (1925, August 30). *Springfield Republican*.

"Bewitching, instead of grotesque, is the new motor girl." (1904, June 26). *Cleveland Plain Dealer*.

Bugbee, E. (1933, September 16). A new interpretation of the First Lady's role. *Literary Digest*.

Brenner, J. (2015, April 27). Monthly online radio listeners have doubled since 2010. *Pew Research Center*. Retrieved from http://www.journalism.org/chart/monthly-online-radio-listeners-has-doubled-since-2010/

Caddell, A. (2015, September 18). Eleanor Roosevelt's road trip to Quebec. *Montreal Gazette*. Retrieved from http://montrealgazette.com/news/local-news/eleanor-roosevelts-road-trip-to-quebec

"Causes for stops in automobile run." (1902, December 21). *Springfield Republican*.

Cohen, L. (2004). A consumers' republic: The politics of mass consumption in postwar America. *Journal of Consumer Research, 31*(1), 236–239.

Cramer, J. (2007). Radio: The more things change … the more they stay the same. In P. J. Creedon & J. Cramer (Eds.), *Women in Mass Communication* (pp. 59–72). Thousand Oaks, CA: Sage Publication.

Crawford, K. (2004, September 22). Ads for women are "Miss Understood." *CNN.com*. Retrieved from http://money.cnn.com/2004/09/22/news/midcaps/advertising_women/index.htm

"Daring girl automobilist astounds the Berkshires." (1915, July 25) *Boston Globe*, p. 18.

"First automobile parade." (1899, September 8). *Boston Globe*.

"First radio broadcaster." (1922, October 20). *Lowell Sun*.

Graham, L. (1997). Beyond manipulation: Lillian Gilbreth's industrial psychology and the governmentality of women consumers. *The Sociological Quarterly, 38*(4), 539–565.

Graham, L. D. (2013). Lillian Gilbreth's psychologically enriched scientific management of women consumers. *Journal of Historical Research in Marketing, 5*(3), 35–369.

Halper, D. L. (2011). *Boston radio: 1920–2010*. Charleston, SC: Arcadia Press.

Halper, D. (2015). *Invisible stars: A social history of women in American broadcasting*, 2nd ed. New York, NY: Routledge.

Hornberger, T. (1930). The Automobile and American English. *American Speech, 5*(4), 271–278.

Hutchings, K. (1996). The battle for consumer power: Post-war women and advertising. *Journal of Australian Studies, 20* (50–51), 66–77.

Lehmann, M. (1952, September 8). The first woman driver. *Life Magazine*.

"Madame C. J. Walker leaves scene of her labor and success." (1916, February 12) *Indianapolis Freeman*.

"Many uses of automobiles." (1902, April 20). *New Orleans Times Picayune*.

Mechum B. (2014). Povich Rewind: Babe Didrikson Zaharias. Photo (circa 1956). Dodge Print Ad. *The Shirley Povich Center for sports Journalism*. Retrieved from http://povichcenter.org/babe-didrikson-zaharias/

Nava, M. (1991). Consumerism reconsidered: Buying and power. *Cultural Studies, 5*(2), 157–173.

Norcross, W., Ramirez, C., & Palinkas, L. A. (1996). The influence of women on the health care-seeking behavior of men. *Journal of Family Practice, 43*(5), 475–480.

Osborn, E. (1899, July 2). Ellen Osborn's fashion letter. *Duluth News-Tribune*.

Parlin, C. C., & Bremier, F. (2017, March 3). Selling cars to women. Originally, "Increasing ownership and use of motor cars by women,". *Special collectors' edition; Saturday Evening Post: Automobiles in America*, The early years. Retrieved from http://www.saturdayeveningpost. com/2017/03/13/archives/historical-retrospectives/selling-cars-women-1930s.html

Parchesky, J. (2006). Women in the driver's seat: The Auto-erotics of early women's films. *Film History: An International Journal, 18*(2), 174–184.

Pew Research Center. (2017, June 16). *Audio and podcasting face sheet*. Retrieved from http:// www.journalism.org/fact-sheet/audio-and-podcasting/

Post, E. (2004). *By motor to the golden gate*. Annotated and Edited by J. Lancaster. Jefferson, NC: McFarland.

Radio news. (1923, June). Cover image. MagazineArt.org. Archive. Retrieved from http://www. magazineart.org/main.php/v/technical/radionews/RadioNews1923-06.jpg.html

Sanger, C. (1995). Girls and the getaway: Cars, culture, and the predicament of gendered space. *University of Pennsylvania Law Review, 144*(2), 705–756.

Scharff, V. (1991). *Taking the wheel: Women and the coming of the motor age*. New York, NY: Free Press.

Schmitt, M. (2013). New study of women radio listeners spotlights migration to digital platforms. *Radio and Internet Newsletter*. Retrieved from http://drupal.kurthanson.com/ category/issue-title/rain-713-new-study-women-radio-listeners-spotlights-migration-digital-platforms

Scully, M. F. (1927). The girl boss of WJZ. *McClure's Magazine*.

"She's now an engineer." (1900, March 27). *St. Louis Republic*.

Smethers, J., & Jolliffe, L. (1998). Homemaking programs: The recipe for reaching women listeners on the Midwest's local radio. Journalism History, 24(4), 138–147.

Smulyan, S. (1993). Radio advertising to women in twenties America: "A latchkey to every home." *Historical Journal of Film, Radio & Television, 13*(3), 299–314.

Stearns, L. E. (1913). The Woman on the farm. *Bulletin of the American Library Association, 7*(4), 173–176.

Stuart, E. M. (1914). Echoes from an auto exhibition. *Fine Arts Journal, 30*(3), 147–156.

Wang, J. H. (2002). The case of the radio-active housewife. In M, Hilmes., & J. Loviglio (Eds.), Radio reader: Essays in the cultural history of radio (pp. 367–389). New York, NY: Routledge.

Westwood One. (2017). In the past week, approximately how many hours, if any, did you spend listening to podcasts? Westwood One, MARU/Vision Critical Nationwide Study. Retrieved from https://www.westwoodone.com/wp-content/uploads/2017/09/The-Podcast-Download-Fall-2017-Report_WWO.pdf

Youngs, B. (2013). Eleanor Roosevelt, Lorena Hickok, a Buick roadster, and a trip to Quebec. American Realities. Retrieved from http://www.americanrealities.com/untitled/ eleanor-roosevelt-lorena-hickok-a-buick-roadster-and-a-trip-to-quebec

· 4 ·

GOT JESUS IN MY CAR RADIO

Evangelism on the Road

Phylis Johnson

In the form of a prayer on its website, non-denominational Christian radio station KGRV-AM sent out an invitation to its listeners "that we may become a trusted friend." Through music, information, biblical teaching, and Christian-friendly news, KGRV hoped to strengthen its relationship with the community by caring for its spiritual and practical needs. Bonding with an audience as if it were a congregation is one of the reasons why Christian radio historically has been such a durable format (Barrington, 2011, para. 2; Lochte, 2005, p. 183) and perhaps why the Contemporary Christian Music (CCM) stations continue to grow in popularity.

According to Lochte (2005), Christian radio as a whole has boomed as "an alternative to music-as-usual," with a big growth spurt from 1973 to 2002 (p. 11). Between 2000 and 2005 alone, religiously formatted radio stations grew another 14 percent (Hangen, 2008, p. 145). (Also, see Radio Today, 2013, p. 4, para. 5.) As of 2017, there are more than 1,400 radio stations and 80 million listeners of Christian/Gospel music in the U.S (Gaille, 2017, para. 5).

While secular music stations may struggle to keep their popularity among teens and young adults as the demo ages upward, research suggests that CCM audiences were more committed to remain loyal to the format and the ideals that they represent (Lochte, 2005, p. 118). In this way, Christian radio is not

just an entertainment choice, it is a "modern, pop culture missionary" that could be beamed into territories that many missionaries dare not go themselves: "naval vessels, taverns, death row cells, houses of prostitution, across the Southern racial line, into the homes of upstanding members of other denominations, the car radios of late night truckers, and transistors on the beach" (Hangen, 2008, p. 143).

CCM can assume many musical and radio presentational styles, but there is continuity in its comforting message. From the overt "praise music" of Sandi Patti, the more subtle pop of Amy Grant, "'heavenly metal' of Bride, the alterno rock of Third Day, or whatever, contemporary Christian music has become essential listening for a great many of contemporary evangelicals, inextricably intertwined with their religious experiences" (Howard & Streck, 1999, p. 219). To serve the millions of Christian radio listeners, several Christian networks, such as Way-FM and Family Radio, provide more than music, they use pastoral outreach to frame their on-air perspectives and presentations, with the former catering to younger listeners and the latter to family audiences (Lochte, 2005, p. 168).

The Early History

Christian radio is almost as old as radio itself. Among other historic firsts, Pittsburgh's KDKA (see Chapter 2) became the first to broadcast a religious service when the Westinghouse company wanted to experiment with a remote broadcast outside of a radio studio. Nearby Calvary Episcopal Church got the honor because a Westinghouse engineer happened to be a member of the choir and could easily make the arrangements, but it was not an ordinary Sunday service (Graves, 2007, para. 4). On January 2, 1921—just two months after KDKA's first ever successful broadcast—"The junior pastor, Rev. Lewis B. Whittemore, preached because the senior pastor was leery of the new medium. The technicians (one being Jewish, the other Catholic) were outfitted with choir robes in order to keep them from distracting the congregation" (Graves, 2007, para. 4).

About that time, the Moody Bible Institute in Chicago launched WMBI, the oldest non-commercial Christian radio station in the U.S. Following KDKA's lead, Paul Radar, a pioneering Christian broadcaster in Chicago founded WJBT (Where Jesus Blesses Thousands), which, in turn, led to the growth of religious programming across the country, and, on September 21, 1944, the formation of the National Religious Broadcasters at a convention

in Chicago's Moody Memorial Church (Graves, 2007, para. 6). Today, Moody Radio is another large radio network of "36 radio stations, satellite, and digital broadcasting, reaching millions of people worldwide" (Banks, n.a., para 1).

For the first time in human history, "church" was now available seven days a week regardless of location—the home, work, or car (Lochte, 2005, p. 116). In fact, one no longer had to go to church in a physical sense at all; through religious broadcasting, church would come to the faithful and the faithless alike in a new form called radio evangelism (p. 64). The radio pulpit was plugged in and ready for business. Sometimes Christian broadcasts were merely whole services aired for the homebound, but many American radio evangelists played to the microphone so well they practically jumped right out of the speakers. One of those Americans was actually Canadian—Pentecostal Christian Aimee Semple McPherson.

Before radio, McPherson had been part of a tent revival circuit that she managed with her husband while living and working out of her "Gospel Car," a Packard convertible that served as both a mobile pulpit, a camper, and a billboard all in one (McPherson, 2009, p. 148):

> No member of our party takes a more active part or renders more efficient and obedient service in every branch of the service than does the Gospel Car. Are there a thousand tracts to be distributed through the byways and hedges or placed in the R.F.D. boxes? The Gospel Car is ready. Is there a street meeting to be held? There is one preacher that can always be counted upon—the Gospel Car. (McPherson, 2009, p. 128)

McPherson's mother and her children came with her, too, as she travelled coast to coast across the United States. Having isolated one of the busiest corners in a given city, the convertible top of the Gospel Car would be put down, and before McPherson preached, her singers and their musical instruments would fill the streets; "how those dear ones did sing and testify of Jesus. Illustrated charts were hung from a stand; these charts drew crowds from all about" (McPherson, 2009, p. 151).

At the end of her many cross-country car crusades, McPherson settled in Los Angeles where her ministry prospered enough to finance the building of a large, 5,000-seat landmark church, Angelus Temple, the original home of the International Church of the Foursquare Gospel, "where she incorporated theatre and patriotism into her church services and torch-lit revivals" (Moore, 2012, para. 1). Sometimes, between the crowds and cars trying to hear McPherson preach, the area around the Temple had to be shut by traffic police (McPherson, 2009, p. 521).

On a Sunday morning in April 1922, McPherson became the first woman to broadcast a sermon over "the wireless telephone," as radio was called for a while (McPherson, 2009, pp. 402–403). While not a "fire and brimstone" preacher like her radio contemporaries, McPherson's theatrical and often controversial sermons "rivaled productions in nearby Hollywood, and her use of spectacle, celebrity status, patriotism, and marketing foretold modern evangelism" (Moore, 2012, para. 2). For example, she illustrated her denunciation of the theory of evolution by performing the ritual hanging of an effigy of a biology teacher (Moore, 2012, para. 2).

When McPherson decided she needed a radio station of her own, her followers "raised $25,000 and on February 6th, 1924, KFSG—a powerful 500 Watt station broadcasting at 278 Meters—went on the air" (Rudel, n.a, para. 4). As owner, McPherson became only the second woman to be granted a broadcast license by the Department of Commerce which helped make her a solid media celebrity in her own right by the mid–1920s. In 1925, KFSG's license to broadcast was revoked for deviating from its transmitter power restrictions. As the story goes, McPherson herself sent then-Secretary of Commerce Herbert Hoover a telegram (Moore, 2012, para. 5):

> PLEASE ORDER YOUR MINIONS OF SATAN TO LEAVE MY STATION ALONE. YOU CANNOT EXPECT THE ALMIGHTY TO ABIDE YOUR WAVE-LENGTH NONSENSE. WHEN I OFFER MY PRAYERS TO HIM I MUST FIT INTO HIS WAVELENGTH RECEPTION. OPEN THIS STATION AT ONCE.
> (Rudel, n.a., para. 6)

The decision was reversed, and McPherson would later support Hoover for president. After first becoming famous for preaching from her car, McPherson was even more famous for preaching through radios in cars: "But think of it, seated in a radio studio, or standing in the pulpit of Angelus Temple, we will now be heard for thousands of miles without lifting the voice above an ordinary conversation" (McPherson, 2009, p. 568).

Shake, Rattle, and Roll: The Jesus Revolution on Wheels

Aimee Semple McPherson's blend of automobility, bombast, and radio savvy formed a model for broadcast evangelism that others have mimicked in various forms ever since. Charles Fuller, another dominant voice in early radio evangelism, also built a broadcasting empire based in Los Angeles. On the air,

Fuller would regularly quote letters received from "black and white … from sick beds in hospitals, asylums … from the Bible Institute boys who pick up our program while bumping along in their car on the Florida highways" (Hangen, 2002, p. 174). Robert Schuller founded the Garden Grove Community Church, in Orange County, California—the first-ever "drive-in church" that accommodated up to 1,000 cars at a service—before building his permanent Crystal Cathedral (Bockelman, 1975, para. 6). Schuller's ministry later went bankrupt, but at the Daytona Beach Drive-In Christian Church in Daytona Beach, Florida, "people park(ed) in rows on the grass facing an altar on the balcony of an old drive-in theater. To hear the service, they switch(ed) on their radios" (NPR, 2014, para. 2).

In-car radio listening remained a major part of Moody Bible Institute's media plans, and it remained vigilant to invest in any new broadcasting technology. Lochte (2005) relates the vision of Dr. Joseph Stowell, past president of MBI, when he marveled:

> One of the new frontiers that technology is opening up to Christian broadcasters is that listening to the radio in your car will not only be done through local radio stations, but there will be a little satellite dish on your back windshield that will pull down hundreds of streams. (p. 77)

The extent that satellite radio has impacted in-car listening of terrestrial stations is debatable, but there is little doubt that successive technological improvements to personal listening devices such as MP3 players, smartphones, and Internet radios has limited the growth of broadcast stations with younger demos (Albarran et al., 2007, p. 9). In terms of expanding the reach and popularity of any one format, CCM has not fared any better than any other format on the satellite platform, which as an industry has been traditionally hampered by low adoption rates (Lin, 2006, p. 140).

That said, CCM stations have not been considered a "niche" radio format for years. WLUP-FM in Chicago, "The Loop," a rock/personality station that led Chicago radio in the 1970s, 1980s, and 1990s, a "part of the culture in a city where young listeners in black Loop T-shirts became an army of rockers," was sold in early 2018 to Educational Media Foundation, syndicators of the CCM K-Love format (Chicago Tribune, 2018, paras. 1–10). Arbitron research concluded over a decade ago that CCM stations perform so well in the key 25–54 sales demographic that they are generally "richer" in this lucrative audience base than secular Adult Contemporary, Current Hit Radio, Country, News/Talk, and Oldies stations (Kelly, 2003, p. 1).

Similarly, Christian conservative talk radio, a sub-genre of secular conservative talk radio, continues to flourish. Salem Communications Corporation is the "undisputed" leader of talk programming focused on religious and family themes and one of the leading media groups in terms of audience reach of kind in America (Lochte, 2005, pp. 96–97). According to the last national, comprehensive survey, "98 percent of U.S. residents aged 18 or older have either driven or ridden in a vehicle in the past month and 93% of Americans have listened to AM/FM radio during the past week" (Arbitron Car Study, 2009, p. 2). To the extent that Shattuck (2017) is correct in asserting that weekly attendance at mainline American Christian churches in the digital age may be as low as 17% (Shattuck, 2017, para. 3), Salem, Moody, and other Christian broadcasters have been wise to adapt to media platforms that connect to where the potential worshippers are going—and how they are getting there—instead of where they used to be.

On The Road ... to Damascus

In previous chapters, authors have called attention to the impact that road poets such as Jack Kerouac have had on the expanding U.S. highway system and the culture that was built on its vagabond-like exploration. His real-life characters represented the ultimate in antiestablishment, antiheroes of that time. As an informative aside to a discussion of Christian radio, Mark Sayers (2012) provides an unexpected spiritual bookend to Kerouac's On the Road, one that offers a different interpretation to Kerouac's seminal works that helped to form and inspire the Beat generation. Toward the end of his life, Kerouac found himself on a road that took him back to a place of faith, of rediscovering his Christianity.

In popular culture, Kerouac, as an iconoclastic literary figure, never seems to age. Readers think fondly of how "Kerouac and the beat writers wanted to use their literary creations to rebel against the religious stigmas" (Tabassum, 2015, p. 11). In pursuit of wild parties, sex, drugs, and existentialistic discussions about life, formal religion is eschewed while spirituality "is present in poetry, music, nature, fraternity, innocence. God is a minor character in the book, forming a kind of subplot to the main action, in the background and yet somehow always present" (Maher, 2000, p. 147).

But the truth of Kerouac's real journey may be a very different thing. Per Sayers (2012), while popular culture "may choose to ignore the middle-aged, worn-out Kerouac, hip to the futility of the American dream and the reality

of sin," Kerouac shamelessly spent "his last days meditating on the Cross" (p. 13). Sayers helps the reader understand the road to Christianity came through the frailties of the characters. Kerouac's *Road Novel 1957–1960* (2007) is a collection of his works, including *The Dharma Bums*, that provides a larger context for his most famous novel, *On the Road*. As Sayers (2012) asserts, Kerouac's *On the Road* actually represents a contradiction inherent in the pivotal 1950s era in which Kerouac came of age: "Born in 1922, [Jack] Kerouac was part of Brokaw's greatest generation, but his influence would shape the generation following his own" (p. 15).

As he set off to find himself, Kerouac's spiritual quest had little to do with the regular disciplines of religion, but was an unconventional mix of Christianity, Buddhism, and lessons from the road. Sayers (2012) calls attention to the spirituality that emerged from Kerouac's work, even if America "prefers the romantic vision of the handsome, twentysomething seminal hipster of *On the Road*. Speeding across America in a beat-up car that flew like a rocket, high as a kite, pretty girls in the back, jazz pouring out of the radio" (p. 13).

In *The Dharma Bums* (1971), Kerouac made reference to a "rucksack revolution," one in which upward to millions of young Americans would turn from the imprisonment of consumerism (p. 78). Sayers (2012) noted, this pivot was "a generational move away from home on to the road, a new kind of lifestyle for young people that would be built upon experience, pleasure, mobility, and self-discovery" (p. 23). Might "the rucksacks" be those also seeking God on the road and through music, responding to his or her spiritual call in the 1960s and 1970s and then emerging once again in the 1990s? It may be a stretch, but perhaps a stretch worth speculating, at least to partially explain why—just like Jack Kerouac chose Neal Cassady—U.S. in-car listeners increasingly choose Christian radio on their life journeys as "a trusted friend."

References

Albarran, A., Anderson, T., Bejar, L. G., Bussart, A. L., Daggett, E., Gibson, S., ... Way, H. (2007). "What happened to our audience?" Radio and new technology Uses and gratifications among young adult users. *Journal of Radio Studies, 14*(2), 92–101. Retrieved from https://www.researchgate.net/profile/Alan_Albarran/publication/249052010_What_Happened_to_our_Audience_Radio_and_New_Technology_Uses_and_Gratifications_Among_Young_Adult_Users/links/56a8d84d08ae40c538a8e9e7.pdf.

Arbitron national in-car study. (2009). Retrieved from http://www.arbitron.com/downloads/InCarStudy2009.pdf.

Banks, M. (n.a.). The story of how moody radio began is fascinating. *UrbanFaith.com*. Retrieved from https://urbanfaith.com/2014/09/the-story-of-how-moody-radio-began-is-fascinating. html/.

Barrington, L. (2011, October 16). 3 steps to bonding with audience—Step 1-Connection! *LynnBarrington.com*. Retrieved from http://www.lynnbarrington.com/2011/10/16/3-steps-to-bonding-with-your-audience-step-1connection/

Bockelman, W. (1975). The pros and cons of Robert Schuller. *Religion-online.org*. Retrieved from https://www.religion-online.org/article/the-pros-and-cons-of-robert-schuller/.

Chicago Tribune. (2018, March 6). Chicago rock station WLUP to switch formats to Christian music Saturday under new owners. *ChicagoTribune.com*. Retrieved from http://www.chicagotribune.com/business/ct-biz-wlup-sold-emf-christian-20180306-story.html.

Gaille, B. (2017, May 25). 13 Christian music industry statistics and trends. *BrandonGaille.com*. Retrieved from https://brandongaille.com/11-christian-music-industry-statistics-and-trends/.

Graves, D. (2007). KDKA made religious waves. *ChristianityToday.com*. Retrieved from: https://www.christianity.com/church/church-history/timeline/1901-2000/kdka-made-religious-waves-11630722.html.

Hangen, T. J. (2002). *Redeeming the dial: Radio, religion, & popular culture in America*. Chapel Hill, NC: University of North Carolina Press.

Hangen, T. J. (2008). *Speaking of God, Listening for grace, in radio cultures: The sound medium in American life*, (Ed. Michael Keith). New York, NY: Peter Lang Publishing.

Howard, J. R., Streck, J. M. (1999). *Apostles of rock: The splintered world of contemporary christian music*. Lexington, KY: University Press of Kentucky.

Kelly, B. (2003). Christian radio: Not just a "niche format" anymore. *NRB Magazine*. Retrieved from http://www.arbitron.com/downloads/christianradio.pdf.

Kerouac, J., & Brinkley, D. (2007). *Road novels 1957–1960: On the road/ The Dharma Bums/The subterraneans/tristessa/lonesome traveler/journal selections*. New York, NY: Library of America.

Kerouac, J. (1957). *On the road*. New York, NY: Penguin Books.

Kerouac, J. (1971). *The Dharma Bums*. New York, NY: Penguin Books.

Lin, C. A. (2006). Predicting satellite radio adoption via listening motives, activity, and format preference. Journal of Broadcasting & Electronic Media, 50(1), 140–159. Retrieved from https://www.researchgate.net/profile/Carolyn_Lin/publication/249024277_Predicting_Satellite_Radio_Adoption_via_Listening_Motives_Activity_and_Format_Preference/links/56b2970b08ae795dd5c7d2b5/Predicting-Satellite-Radio-Adoption-via-Listening-Motives-Activity-and-Format-Preference.pdf.

Lochte, B. (2005). Christian radio: The growth of a mainstream broadcasting force. Jefferson, NC: McFarland.

Maher, E. (2000) On the road to somewhere with Jack Kerouac. *Doctrine and Life, 50*(3), 144–149. Retrieved from https://arrow.dit.ie/cgi/viewcontent.cgi? article=1029&=&context=ittbus&=&sei-redir=1&referer=https%253A%252F%252Fscholar.google.com%252Fscholar%253Fhl%253Den%2526as_sdt%253D0%25252C3%2526q%253D-beat%252Bkerouac%252BMaher%252Bgod%2526btnG%253D#search=%22beat%20kerouac%20Maher%20god%22.

McPherson, A. S. (2009) *This is that: Personal experiences, sermons and writings of Aimee Semple McPherson*. Eugene, OR: Wipf & Stock.

Moore, R. (2012). Aimee Semple McPherson. Reports of the National Center for Science Education.com. Retrieved from http://reports.ncse.com/index.php/rncse/article/view/73.

Rudel, A. (n.a.). Aimee Semple McPherson: Radio religion and reality. Old time radio catalogue (OTRCAT.com). Retrieved from https://www.otrcat.com/aimee-semple-mcpherson-radio-religion-and-reality.

Sayers, M. (2012). *The Road trip that changed the world: The unlikely theory that will change how you view culture, the church, and, most importantly, yourself*. Chicago, IL: Moody.

Shattuck, K. (2017, December 14). 7 startling facts: An up close look at church attendance in America. *Churchleaders.com*. Retrieved from https://churchleaders.com/pastors/pastor-articles/139575-7-startling-facts-an-up-close-look-at-church-attendance-in-america.html.

Tabassum, A. (2015). *Rise and decline of beat literature*. (Unpublished thesis). BRAC University, Dhaka, Bangladesh. Retrieved from http://dspace.bracu.ac.bd:8080/xmlui/bitstream/handle/10361/4987/Thesis%20Afsana.pdf?sequence=1.

· 5 ·

FROM AIRPLANE TO "ZEPPELIN"

A Quick Primer on Radio Traffic Reporting

Wafa Unus

Radio traffic reporters are a dying breed. The once prominent part of every morning and afternoon drive radio show is fighting to keep its place at the media watering hole. "Traffic news," as some radio industry executives call it, is still an essential tool in the trillions of miles that American, radio-listening commuters drive every year, but the source of that information soon may no longer even be human. The friendly, ubiquitous eye-in-the-sky traffic reporter who used to be employed by the radio station itself, and later became part of a "radio service," is slowly being replaced by a smartphone app.

Since the early 1930s, traffic news has been evolving. What started as short, irregular pronouncements by the New York Port Authority that were read by radio news announcers became so popular that some stations recognized its potential early on. WINS in New York City—a station that to this day gives traffic reports every ten minutes—is credited with introducing the archetype of the traffic news reporter when, on August 10, 1935, Police Deputy Commander Harold Fowler dictated the least congested routes to in-car radio listeners—from the Goodyear blimp ("Blimp and Radio," 1935, para. 1).

Within two years, KNX in Los Angeles began its regular traffic reports, this time from a United Airlines airplane, as CBS radio reporter Tom Hanlon helped California motorists navigate the busy streets below ("Air Survey," 1937, para. 1). The survey of the highway conditions in Southern California

lasted an hour. The United Airlines flight was co-operated under the supervision of an official known as "the district inspector." The event was a "unique broadcast from the air, giving listeners, in many cases motorists seen from the observation plane, a word picture of traffic conditions on roads ... [the conditions] were 'pointed out' for motorists below" ("Air Survey," 1937, para. 1).

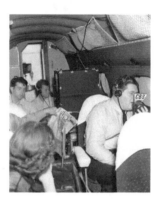

Figure 5.1. KNX/CBS radio reporter Tom Hanlon reports on Los Angeles–area traffic from a United Airlines airplane in an undated photograph. Courtesy of John Schneider.

After these ventures by blimp and fixed-wing aircraft, traffic reporting slowly took flight in other major cities, this time hovering overhead in helicopters. In an effort to combat congested holiday traffic in the Chicago metro area, the Cook County Sheriff's Department provided "Birds Eye" reports to WMAQ radio over Memorial Day weekend in 1948. A sheriff's deputy went up in a helicopter with a pilot and monitored the city routes from mid-afternoon to evening. These reports were not broadcast live, however. Instead, the deputy waited until landing to phone in reports to the station. They repeated the special traffic broadcasts during the 1948 Independence Day weekend and Labor Day weekend (Conway, 1948, para. 10), but it was not until the mid-1950s that traffic reporting on a daily basis began to emerge around the country, in various forms.

For example, the first radio station to broadcast live, hourly traffic reports from its own craft was likely KLIF in Dallas, Texas, in 1956 ("News: The Ace Up Radio's Sleeve", 1956). Soon after, in March 1957, WOR radio in New York introduced the "Flying Studio" (Siller, 1960, pp. 86–89). WOR opted for a small airplane rather than a helicopter—despite a fixed-wing craft's lack of maneuverability and inability to hover over a congested area—because planes were far less expensive to purchase and operate. Aerial data collection by radio stations was an attractive and revolutionary advancement; to be cost effective, planes reported on breaking news events as well (Siller, 1960, pp. 86–89).

As other pioneers began to take flight, many stations were still finding their footing on the ground as reporters began trolling for traffic problems in cars. This innovation did not come without its own challenges, however. Regardless of the increasing number of reporters running around the streets and the rare big-dollar investment in coverage from the sky, traffic reporting on the main was mostly dependent on local government authorities providing information free of charge or reporters working directly from radio-friendly precincts.

For example, in the winter of 1957, Detroit's WWJ began broadcasting "Expressway Reports" by a Detroit Police Department officer who would call in every 10 minutes from a WWJ news desk at headquarters ("WJJ, The Detroit News," 1957, para. 1). Meanwhile, Louisville, Kentucky, station, WAVE, began morning and afternoon reports from a newsperson in residence at that city's main police station ("Simulation Simulates," 1957, p. 122). Law enforcement authorities were not always so accommodating to the media. While radio saw traffic reporting as a public service, some local police jurisdictions viewed the extra attention to road mishaps as a nuisance which only contributed to the chaos of traffic accidents and congestion ("Police Claim," 1951, p. 16).

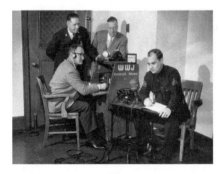

Figure 5.2. WWJ-Detroit's "Expressway Reports" were called in every 10 minutes from a WWJ news desk at headquarters at a Detroit police department. Courtesy of John Schneider.

Either way, drive time radio listeners seemed to want more. When John Pace became general manager of KABC radio in Los Angeles, the market-leading station had an established fleet of traffic reporters that were doing an effective job at story gathering, but Pace thought commuters needed to get the info faster. Because mobile units could sometimes become entangled in the very traffic jams on which they were reporting, Pace pushed for helicopter-based traffic reporting at regular intervals the listeners could expect ("KABC 'Copter,'" 1958, p. 87).

So, on December 30, 1957, at a cost of about $500 a day, KABC introduced "Operation Airwatch," reports of L. A. highway conditions given in 15-minute intervals weekday mornings from 7 a.m. to 9 a.m. and 3:30 p.m. and 5:45 p.m. every afternoon by newsman Donn Reed in a KABC-leased helicopter piloted by Captain Max Schumacher ("KABC 'Copter,'" 1958, p. 87). Due to the popularity of Southern California's coast, Operation Airwatch soon added weekend highway conditions focused on the major beach routes. Radio commercials during traffic reports targeting commuters—largely coming from automobile manufacturers such as Volvo, Dodge, Ford, and Renault—brought in significant revenue for the station ("KABC 'Copter,'" 1958, p. 87).

Operation Airwatch also brought in significant publicity. On March 31, 1958, a local paper wrote about KABC's new "rush hour traffic data" in its Programs and Promotions section. After lauding KABC's traffic copter for being able to report on traffic problems in real time unlike any other media, the reporter noted that "traffic reporting is an important part of the rush hour service of Los Angeles radio stations" ("KABC 'Copter,'" 1958, p. 90).

Fewer than four months after introducing the broadcast, however, Operation Airwatch halted for a week after Schumacher wrecked the helicopter. Shortly after takeoff for the afternoon traffic report, the helicopter experienced engine failure ("Mishap Delays," 1958, para. 1–2). As Schumacher attempted to make an emergency landing on a vacant playground, children began running toward the helicopter, causing the pilot to steer away and hit a tree. Schumacher broke two vertebrae in the accident. Reporter Donn Reed walked away with only minor injuries. After a lengthy hospital stay, Schumacher returned to the air. The wreck cost the station an estimated $50,000 Despite the setback, KABC was back in—and on—the air soon after ("Mishap Delays," 1958, para. 1–2).

After KABC's success, ABC Radio's owned-and-operated San Francisco powerhouse, KGO, who already had four mobile ground units covering traffic, took off in its own helicopter on May 12, 1958 ("KGO Covers," 1958, p. 100). On month later, KXYZ in Houston followed with "Operation Skycast" broadcast each weekday from 7:15 to 8:15 a.m. as Bob Smith joined Police Captain Tom Sawyer for traffic reports six times every hour ("KXYZ Reports," 1958, p. 87).

As the next decade approached, helicopter-based traffic reporting was becoming the norm. In late 1958, Chicago's WGN radio scored an immediate hit with Chicago police officer Leonard Baldy broadcasting traffic safety programs along with traffic news in his "Trafficopter." Baldy quickly became a

much-loved radio personality, but in 1960, he was killed when a rotor blade broke during a traffic flight (Siller, 1960, pp. 86–89).

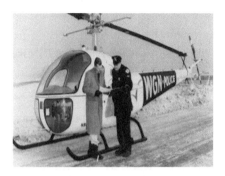

Figure 5.3. WGN Radio's "Flying Officer" Leonard Baldy, Chicago's first traffic news celebrity, was killed in his "Trafficopter" in 1960. Courtesy of John Schneider.

In the 1960s, traffic reporting was no longer a novelty, it was seen as an essential expectation of big city radio programming; helicopters were everywhere. Unfortunately, the increased helicopter traffic needed to cover the increase in accidents on the ground meant a greater chance for accidents in the air as well. In 1966, Operation Airwatch's Captain Max Schumacher, who had already survived one helicopter crash, was killed in a midair collision. Frank McDermott of WOR radio died in 1969 after his helicopter crashed into a Queens apartment building in the middle of a traffic report (Siller, 1960, pp. 86–89). Yet another WGN reporter died in 1971 when the helicopter he was in hit a utility pole.

With suburban sprawl increasing in the 1970s, more road congestion and a quickly expanding highway infrastructure decreased the efficiency of mobile units on the ground which were largely abandoned. Despite safety concerns, air traffic reports still provided more robust information faster to the in-car radio listener. As proof of that, Dann Shively joined the Sacramento NBC-affiliate KCRA in 1972, first as a producer and after getting his helicopter pilot license seven years later, he began flying for the station (Gauthier, 2011, para. 2–4). KCRA was the first station in northern California to own a chopper of its own and Shively was one of the first pilot-reporter hybrids.

As a pilot-reporter, Shively distinguished himself by covering the 6.9 magnitude, Loma Prieta earthquake of 1989 and the arson fire at the Roseville Galleria in 2010 that caused more than $55 million in damage (Gauthier, 2011, para. 2–4). Shively considered helicopter traffic reports to be a "first

strike tool" providing an analysis of unparalleled perspective and speed (Gauthier, 2011, para. 2–4). By the end of the 1980s, technology would provide alternatives to the risks.

While at one time reporting from the air had added a new dynamic to the function of radio broadcasts, the form of the reports largely stayed the same. Shifts in financial resources, and the high cost of owning and operating a traffic chopper, eventually drove stations to emerging broadcast companies that sold traffic news services (Ward, personal communication, 2018). Shadow Traffic used commuter traffic flow reports as well as police and civilian sources to create comprehensive traffic reports. Shadow Traffic hired its own staff of reporters who would often be assigned to multiple radio stations, and in some cases, reporters would provide traffic reports for five or six different stations during a single-shift either under their own name or a series of aliases catered to each radio station (Ward, personal communication, 2018).

Shadow Traffic was formed by Michael Lenet in 1975 in Philadelphia. In 1979, the company opened an office in New York City which led to two other major cities in the 80s. In NYC, Shadow Traffic started out with a fleet of ground SUV units and a single helicopter that collected data and reported conditions via two-way radio and "bag phones" (Salvas, n.d, para. 58). The company would sign traffic reporting contracts, notably with WCBS radio and later a number of other stations. At the time of its sale in 1998 to Westwood One, and combined with Metro Traffic, Shadow Traffic was providing service to 350 stations in 15 markets. In 2008 its 60 offices were reduced to 13 regional hubs and many of their best known traffic personalities were let go ("Traffic, news reports," 2008, para. 1). In 2011, the company was sold to Clear Channel Communications for 119.2 million dollars and was combined with Clear Channel's Total Traffic Networks.

Matt Ward, a traffic reporter for nearly three decades and long-time employee with Shadow Traffic, suggests that aside from the introduction of conglomerate traffic news companies, the advent of traffic cameras ("jam cams" as they were called at Shadow Traffic) in the early 90s had perhaps the most significant impact on radio traffic reporting. The company would rent out space on buildings in key locations, and places that afforded excellent views of high traffic areas. The first iterations of the cameras captured still pictures that would update slowly but consistently (Ward, personal communication, 2018). Ward and his colleagues affectionately referred to them as "Picasso Paintings." Soon after, live video was introduced and the proliferation of more advanced cellphone technology eventually would revolutionize traffic reporting. Even

before smartphone technology, cellphones themselves allowed for drivers to become significant sources of traffic data. In essence, reporters on the ground and in the air had a new, robust and enormous fleet of citizen mobile units who would call in tip lines. This influx of data, along with emerging mapping and data analysis software resulted in a new zenith of traffic reporting (Ward, personal communication, 2018).

Today, advancements in mapping technology, along with advancements in camera and drone technology, have now allowed traffic reporters like Ward to report more easily from the ground, and from a significant distance. According to Ward, an entire traffic report can be effectively pieced together by collecting and analyzing data from these sources (Ward, personal communication, 2018). The ability to calculate travel times has added a new element to the reports as well, transforming the basic traffic updates from decades ago into minute-by-minute guidance for motorists (Ward, personal communication, 2018). The implementation of radar has allowed contemporary traffic reporters the opportunity to inform motorists of storm conditions in the direction of their travel, and advise safety measures if necessary, acting not only as informers of current conditions but as a preventers of potential roadway accidents (Ward, personal communication, 2018).

As traffic reporting technology has changed the way traffic news is reported, the dramatic increase in activity on the roads has increased its importance in radio broadcasts as well. In 2016, Americans drove a record 3.22 trillion miles, an increase of 2.8 percent over the previous year (Schaper, 2017). According to Ward, traffic reporting in major cities is the reason listeners tune in, and motorists now expect regular traffic updates regardless of time of day (Ward, personal communication, 2018). Traffic has become a major factor in the calculation of a city's livability. Where individuals choose to live is often dictated by the amount of time they would have to spend in traffic to get to and from work, or how far they may have to drive to reach frequented destinations. In more recent years, the increase in airfare expenses and the decrease in gas prices have reinvigorated the great American road trip, increasing the number of motorists during holiday travel times (Mac, 2017, para. 1).

In many cases, traffic news permeates other news events. In the event of inclement weather, road conditions are a significant element of the news report. Major events, concerts, sporting events, and police activity often warrant changes in routes or blocked off roads. In his decades of reporting traffic news over the airwaves, Ward recalls those unique moments when his resources allowed him to break into other major news stories. He recalls,

somewhat fondly, a cold day in January in 2009 when he looked over at his traffic camera and saw US Airways flight 1549 floating on the Hudson River. The commercial airline, piloted by Chesely Sullenberger and Jeffrey Skills struck a flock of Canadian geese after take off from LaGuardia Airport. After losing all engine power, the pilots were able to safely land the airplane on the Hudson River. All 155 people onboard were rescued. Ward was the first reporter on air to identify the airline (Ward, personal communication, 2018).

Despite the changes in traffic news reporting, Ward contends that traffic reporting in form, has stayed fundamentally the same. Traffic reporters, like general reporters, report the top stories first and follow a logical progression of data in terms of geographic proximity (Ward, personal communication, 2018). Likewise, data is fused into a narrative that allows listeners to easily visualize traffic conditions without the aid of a screen or graphic. Unlike television reports, radio traffic reporting requires a level of descriptive skill that is both detailed and engaging without being overly complicated or distracting to a driver. Traffic reporters are specifically trained and uniquely equipped to help motorists navigate roadways at all hours, day and night (Ward, personal communication, 2018).

As technology advances and motorists have easier access to traffic maps, motorist interaction with traffic reporting has undoubtedly changed. Smartphone maps applications allow motorists to easily access real-time traffic reports and, in some cases, automatically provide detours or faster routes for the driver. Applications like Waze allow users to share data with other motorists, including traffic jams, accidents and even the location of police vehicles. While these applications, along with GPS technology and internet access on smartphones arguably challenge the need for radio traffic news reports, the industry seems to maintain a significant degree of relevance in radio news broadcasts, particularly in large metropolitan areas. In the case of traffic news, technological advancements and ease of information gathering by individuals on roadways seemingly adds to the richness of the reporting, not the degradation of it. However, the on-air personalities that once punctuated drive-time radio have taken a backseat to new mobile technology.

Much like other traditional news formats, traffic news reports have taken a hit in recent years. In 2015, WAMU in the Nation's Capitol ended its morning traffic reports (Aratani, 2015, para. 1). At the time, reporter Jerry Evans was reporting not from D.C., but from his home in Florida. Of the ending of its reports, "In a world now filled with smart phone map services, GPS devices in cars, and traffic apps, there is better, more up to date information available

to our listeners than we could provide" (Aratani, 2015, para. 4). That same year, long-time traffic radio reporter and sidekick personality Leslie Keiling was released when WGN Radio informed the service for which she worked that they no longer wanted to pay her salary ("WGN Drops," 2015, para. 2). Keiling, affectionately remembered by her tongue-in-cheek radio handle, "Lane Closure," had been a fixture in Chicago for nearly 30 years, reporting on traffic for her entire career.

However, longtime traffic reporters such as Ward see this shift as a natural evolution of the craft. Much like the early and mid-1900s which saw dramatic changes in the way traffic data was collected and reported, from the first Port Authority reports to blimps, to planes, to hovering helicopters, and later to the integration of satellite mapping and grounded cameras, a new era of traffic reporting has emerged (Ward, personal communication, 2018). The advancement of mobile technology, the proliferation of cameras monitoring countless intersections and highways, and powerful satellite imaging seems poised to contribute to the dwindling need for traffic reporters to mediate the information on the ground and in the sky to drivers.

As it is, commuters already can ask for assistance from digital concierges such as Siri or Alexa to calculate the most pain-free route to work and back. The computerized voice response, though, while more concise and perhaps even more accurate, is only a cyber-echo of those pioneering radio traffic reporters who, in some cases, quite literally

References

Air Survey Aids Southern California Traffic Control. (1937, August 23). ACME.

Aratani, L. (2015, November 13). WAMU drops longtime traffic reporter Jerry Edwards, announces end to morning rush hour reports. *The Washington Post*. Retrieved April 1, 2018, from https://www.washingtonpost.com/news/dr-gridlock/wp/2015/11/13/wamu-drops-longtime-traffic-reporter-jerry-edwards-announces-end-to-morning-rush-hour-reports/?utm_term=.c334f634b701.

Blimp and Radio Combine to Aid Week-End Motorist. (1935, August 10). ACME.

Conway, W. J. (1948, July 1). Helicopter crew directs holiday traffic in Chicago. *The Portsmouth Times*.

Gauthier, A. (2011, July 05). 'The last of a dying breed,' KCRA chopper pilot Dann Shively retires. Retrieved March 31, 2018, from http://www.adweek.com/tvspy/the-last-of-a-dying-breed-kcra-chopper-pilot-retires/14957.

KABC 'Copter Relays Rush Hour Traffic Data. (1958, March 31). *Broadcasting*, 90.

KGO Covers Commuters in Copter. (1958, May 12). *Broadcasting*, 100.

KXYZ Reports Traffic From Air. (1958, July 21). *Broadcasting*, 87.

Mac, A. (2017, May 23). Persistently low gas prices prompt more summer road trips, GasBuddy Study finds. Retrieved from https://business.gasbuddy.com/persistently-low-gas-prices-prompt-more-summer-road-trips-gasbuddy-study-finds/.

Mishap Delays 'Copter Report. (1958, July 21). *Broadcasting*, 87.

News: The Ace Up Radio's Sleeve. (1956, March 19). *Broadcasting*, 80–81.

Police Claim Hit WSAZ Defends News Report. (1951, September 10). *Broadcasting*, 16.

Salvas, E. (n.d.). *Shadow traffic on newsradio 88*. Retrieved from: http://donswaim.com/wcbsmem.sands-choppers.html.

Schaper, D. (2017, February 21). *Record number of miles driven in U.S. last year*. Retrieved from https://www.npr.org/sections/thetwo-way/2017/02/21/516512439/record-number-of-miles-driven-in-u-s-last-year.

Simulation Simulates a Pulse: Wave successfully introduces a day-long, localized 'Monitor' format. (1957, April 22). *Broadcasting*, 122.

Siller, B. (1960). *Television and radio news*. New York, NY: Macmillan.

Traffic, news reports supplier, Metro Networks, making cutbacks. (2008, September 17). *Journal Sentinel*. Retrieved from http://archive.jsonline.com/news/32518814.html/.

WGN Drops Traffic Reporter Leslie Keiling. (2015, January 26). Retrieved from https://www.allaccess.com/net-news/archive/story/137638/wgn-drops-traffic-reporter-leslie-keiling.

WWJ AM FM News. (1957). *WJJ, The Detroit News, Broadcasts Expressway Reports* [Press release]. Detroit, MI: WWJ.

· 6 ·

ENTER THE FORTIES

Riding on Fumes, and Traveling with Talk and Tunes

Philip Jeter

Figure 6.1. Smithsonian photo of an African-American family traveling during the Jim Crow Era.

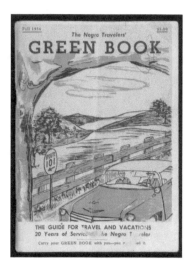

Figure 6.2. *The Negro Motorist's Green Book* (1937–1964).

On some nights I still believe that a car with the gas needle on empty can run about fifty more miles if you have the right music very loud on the radio.

—Hunter S. Thompson

I threw my bag in the truck, turned the key in the ignition, and by habit rifled over radio stations as I started to drive, all those voices suddenly speaking to me. I don't know why, but hearing them just made me feel good.

—Michael Paterniti

With the radio on to a mystery program, and as I looked out the window and saw a sign that said USE COOPER'S PAINT and I said, 'Okay, I will,' we rolled across the hoodwink night of the Louisiana plains—Lawtell, Eunice, Kinder, and De Quincy, western rickety towns becoming more bayou-like as we reached the Sabine.

—Sal Paradise in *On the Road*

In the 1940s, many media industries came to the forefront. Five motion picture studios dominated the movie industry (Gabler, 1988). Several major labels controlled recorded music between 1940 and 1960 (Chapple & Garofalo, 1977). Although the Communications Act of 1934 had set into motion a means to control the broadcast industry, the immediate problem was that more radio stations created increased need for programming, so the NBC spin-off network—ABC—and the Mutual Broadcasting System joined CBS and NBC in providing network content to radio stations large and small across the country.

According to Fowler and Crawford (2002), "It is difficult for our video-glutted generation to imagine what radio meant to Americans in the twenties, thirties, and forties" (p. 3). Nachman (1998), who grew up in northern California in the 1940s, recalled that radio helped mold the aesthetics, ideas, and values of his generation:

> There was ... a mystique to radio unlike that of any other entertainment medium ... Radio was America, presented in tones of pure red-blooded wartime patriotism. Radio instilled in me an unabashed love for the idea of America, for its lore, lingo, and popular music.... (pp. 5–6)

By 1940, network radio programming—some of it creative and unique, much of it derivative—was defining the popular culture of America. Chicago, Los Angeles, Detroit, and New York were the major program production centers. In cooperation with the major radio networks, advertiser interests were paramount.

As Barnouw (1979) wrote in *The Sponsor*, advertising agencies and their clients leveraged ad sales to become *de facto* program directors:

> In the sponsor-controlled [and most lucrative] hours (of radio), the sponsor was king. He decided on programming. If he decided to change programs, network assent was *pro forma*. The sponsor was assumed to hold a "franchise" on his time period or periods. Many programs were advertising creations, designed to fulfill specific sponsor objectives. (p. 33)

These arbiters of pop culture and taste solidified radio as the number one live entertainment and breaking news mass medium in America—and the 1940s would be radio's last undisputed decade in that top spot.

The idea was to reach the largest possible audience so that meant programming had to have mass appeal. Most of this programming was escapist entertainment, but radio news matured during the build up to, and its coverage of, World War II (Beheim, 2018, p. 1).

For example, it was on radio on March 13, 1938, at 8 p.m., when CBS made broadcasting history as Edward R. Murrow in Vienna, William L. Shirer in London, and a team of reporters in Paris, Rome, and Berlin went on the air with the first-ever multi-location live news broadcast (Bernstein, 2005. para. 8). No matter where they were on December 7, 1941, it was radio that told America first that the Japanese had bombed Pearl Harbor. The next day, it was on radio first that President Franklin D. Roosevelt told the country that a "day of infamy" meant America was going to war.

1941–1942

Households with a single radio receiver were consistent through the 1920s and 1930s, but by the 1940s, automobile and battery-powered radios were becoming more affordable and commonplace. Although cars were not as widely owned during the Depression, approximately 1.2 million of them had radios by 1940 (Sterling & Haight, 1978). The number of car radios was stagnant for the first half of the 1940s because America's carmakers switched to producing fewer cars to make military vehicles from 1942–1946. Shortages of gasoline and rubber for tires meant that many people walked more and drove less, but that didn't stop some enterprising listeners from keeping up with their favorite programs in a car. Barfield (1996) recounts this testimony:

> We would go out to the garage—winter or summer, it didn't matter—open up the garage doors and turn on the car radio … We listened to the "travelin' songs" … We 'rode' in the car … We still got home after dark, but we'd never been anywhere but out to the garage. (p. 34)

Author Brenda Seabrook had fond memories of actual regular Sunday night drives with her parents from her grandmother's home in Georgia that were filled with the antics of Jack Benny, Edgar Bergen and Charlie McCarthy, and Corliss Archer. She recalled to Barfield (1996):

> The trip took that long (three programs' worth) because of the roads … My father … would go out of the way to drive on stretches of paved road where there was less danger of picking up a nail dropped from a wagon and having to deal with the resulting flat tire in those inner tube days … The three of us all sat in the front seat, lit by the tiny radio bulb … Leaving grandparents, uncles and aunts and cousins was easier with these characters to light the way home with laughter. (p. 35)

By 1940, radio's programming was derived from vaudeville, minstrel, movie, and live theater traditions, but there was some innovation. By codifying the national radio networks schedules for 1941–1942, Summers (1971, pp. 92–106) categorized the programs thusly:

- amateur/talent contests
- hillbilly and minstrel shows
- music concerts
- musical variety
- light music

- quiz shows
- human interest
- audience participation
- panel quiz shows
- prestige dramas
- informative dramas
- light/homey "love interest" dramas
- thrillers
- women's serial dramas
- soap operas
- children's programs
- news
- public affairs
- homemaker
- miscellaneous talk programs

During non-network times, affiliated local stations offered farm reports, news and commentary, panel discussions, "man in the street" interviews, sports broadcasts, and the opportunity for local performers to break into show business. Radio programming innovations during the war years were minimal enough that according to "Radio Reruns," (2014), para. 4) military personnel leaving for service at the start of WWII found most of their favorite radio shows waiting for them when they returned.

1942–1945

After the U.S. Congress declared war on Japan, Germany, and Italy in December of 1941, America turned to radio to hear about the successes—and the setbacks—of WWII. Not surprisingly, entertainment programming, such as radio orchestras and bands playing popular tunes, was augmented by an increased number of news reports and bulletins. According to Ed Bliss, legendary CBS broadcast news writer, editor and producer (1991):

> With the outbreak of hostilities, Americans, including millions descended from immigrants of the warring nations, listened to the news as never before… . For six years, from the German invasion of Poland to the final Japanese surrender on the battleship *Missouri*, air raid sirens, gunfire, and correspondents' voices were heard in the intimacy of American homes [and cars and trucks]. Here the cliché bout being "glued to the radio" was born. (p. 106)

Another factor in radio's cultural impact during WWII was the FCC's decision to designate certain frequencies as "clear channels," meaning that radio licensees on those chosen AM frequencies could broadcast 50,000-watts not just in the day, but at night also when other radio stations had to "power down" to reduce their coverage area (Mishkind, 2010). Due to nightly atmospheric conditions that cause an AM radio signal to "skip" over long distances, this select group of clear channel radio stations—more-or-less scattered strategically around America to ensure that even the most rural parts of the country would get some radio service—could be heard from Canada to the Caribbean (Mishkind, 2010).

Also during this period, advances in industrial manufacturing and battery design improved the quality and longevity of portable radios. WWII-era teenager Roger Rollin cites his relationship with his battery-powered portable, a "pink and grey leatherette" model (Barfield, 1996):

> What was most important about that radio was that it was my own. I could listen to the program I wanted to hear without interfering with my parents' use of the radio—and without interference from them. It was liberation—even though I still usually listened to the same shows they did anyway. (p. 37)

Military officer appointments for William S. Paley and David Sarnoff, the CEOs of radio CBS and NBC respectively, meant the most powerful radio interests were on board for the implementation of the war effort. According to Barlow (1993), "Network radio was viewed by government leaders and broadcast industry executives as a ready-made conduit for propaganda to encourage the mobilization" (p. 203). Through the news, live broadcasts of war bond rallies, messages to conserve and recycle, and pleas to plant so-called "victory" gardens, radio proved to be a good and patriotic citizen. As Bliss further observed (1991):

> A burst of morale-lifting programs of the magazine type came with America's entry in World War II. Outstanding [for example] was "The Army Hour" produced by the Army and NBC. In 1943 alone, the program carried [remote] pickups from 102 Army posts, 10 war plants, and 21 military hospitals, plus scores of reports from bases overseas. (p. 280)

But once WWII was over, network radio corporate interests—most notably RCA and CBS—began putting their money into television programming and started to scale back their commitment to radio (Bliss, 1991). The radio industry's resiliency and its ability to adapt to changing market forces would be tested. The introduction of television to the mass consumer was impactful,

but radios in cars were also becoming standard, and nobody was driving into work watching a TV—yet.

1946–1949

World War II had solidified radio's importance to society but nobody was certain of radio's future role. According to Keith (2001), many media critics forecast grim prospects for the audio-only medium such as that radio would be relegated to nothing more than that of a service for farmers (p. 75). In *The Rise of Radio*, however, Balk (2006) asserts that at the end of WWII, radio appeared ready to continue its dominance in mass media because in 1946, "nearly 90 percent of urban homes and six million cars had radio. Top programs remained morning-after conversation pieces. Polls affirmed radio as the majority's source for news and entertainment" (p. 266).

And it was not just day-to-day listening habits, either. Radio remained at the center of American culture during major broadcast events such as the World Series, the Kentucky Derby, the Rose Bowl, and title bouts in boxing. In 1946, almost "1,000 AM stations were licensed. Time sales exceeded $331 million (Balk, 2006, p. 266). … In the next year local radio time sales exceeded the networks' total" (p. 268). Either way, dire prophesies about the demise of radio were "off the mark" (Keith, 2001, p. 75).

America's post-World War II economic boom meant massive U.S. government spending on national infrastructure, the military, and education that only added to a robust manufacturing sector which boosted the nation's gross domestic product (Rugh, 2008, pp. 16–17). As the middle class expanded, higher pay and benefits like paid vacations meant more cars sold and more time to drive in them. Freed from the demands of producing war-related items, U.S. automakers gave Americans what they wanted and now could more easily afford (Rugh, 2008, p. 16). After the war, however, Americans were enjoying their leisure to a slightly different beat.

Swing music played by big bands such as Benny Goodman and His Orchestra, the Count Basie Orchestra, and Glenn Miller and the Army Air Force Band was wildly popular from the mid-1930s to the mid-1940s, but the high cost of maintaining a big band and the development of bebop, a kind of avant-garde movement in jazz that was small group-focused, hastened the end of the big/swing band era (Balk, 2006, p. 272). In another indication of the shift of radio's economics, in 1946, 95 percent of all radio stations were affiliated with one or more of the four largest national networks (CBS, NBC,

ABC, and Mutual). By 1952, however, network affiliation had dropped to just over half of all stations on the air during radio's greatest listenership period in its history (1945–1948) This decline was significant because the drop in networking programming was filled with more radio stations becoming sponsored jukeboxes with "formats oriented toward the new subculture that dominated record-buying fad-conscious, free-spending youth" (Balk, 2006, p. 282).

Whether it was because of the increase in local sales dollars or the decision to forgo any network affiliations, after the war, radio station owners began to experiment with a variety of programming approaches, one of which was to fill more time slots with disc jockey programming that had become popular in the 1930s (Maltin, 1997, p. 259). Since Reginald Fessenden's first broadcast of the human voice in 1906, radio had used recorded music as an easy, inexpensive way to fill time (Maltin, p. 260). In the 1930s, Al Jarvis and later Martin Block with his "Make Believe Ballroom" used records to create the illusion the audience was part of a crowd where the music artists of the day were appearing and performing (Fong-Torres, 1998, p. 19). Local news on radio had peaked in 1946 (Bliss, 1991, p. 179). High-budget, highly produced radio newscasts were replaced with less expensive options like announcers reading summaries from newspapers, particularly on music stations.

WLAC, a 50,000-watt clear channel AM radio station in Nashville, provides an interesting example of the post-war shift in programming. While rival AM radio giant WSM, the home of the Grand Ole Opry since 1927, was an NBC affiliate, CBS programs in Nashville were carried by WLAC. With CBS network radio programming waning, WLAC turned to the nation's growing black consumer market for an audience. From 1946 on, white announcers Bill "Hoss" Allen, Gene Nobles, and John "John R" Richbourg introduced millions of listeners to blues, jazz and so-called "race music" of the era (Williams, 1998, p. 30).

A similar phenomenon was transpiring about the same time in Memphis, Tennessee, but this time with African American announcers. On Oct. 25, 1948, white-owned WDIA-AM became the first entirely black-oriented commercial radio station when Nat D. Williams, an African-American schoolteacher in the segregated Memphis public system, went on the air. His first show generated over 5,000 letters and cards. As Cantor (1992) confirms the experiment provided a series of broadcast milestones:

> Claiming to reach an incredible 10 percent of the total black population of the United States, WDIA was a celebration of firsts: the first radio station in the country with a format designed exclusively for a black audience; the first station south of the

Mason-Dixon line to air a publicly recognized black disc jockey; the first all-black station in the nation to go 50,000 watts; the first Memphis station to gross a million dollars a year; the first in the country to present an open forum to discuss black problems; and most important, the first to win the hearts and minds of the black community in Memphis and the Mid-South with its extraordinary public service. For most blacks living within broadcasting range, WDIA was "their" station." (p. 1)

The economic power of the black audience should not have surprised anyone. Although America's black population increased only slightly between 1940 and 1950, their aggregate income quadrupled during the same period (Gibson, 1978; "The $30 billion Negro," 1969); Kahlenberg, 1969). Demand for labor during World War II allowed many African Americans to move from low-paying farm jobs in the country to higher paying manufacturing jobs in urban areas (Ferrie, 2006). Per Chapple and Garofalo (1977), the economic opportunities of urban manufacturing centers also attracted poorer whites from the South, a migration that also impacted radio station formats:

Large numbers of blacks and poor whites moved North and West to work in defense plants and brought their music with them. At the same time many Midwesterners and Easterners were stationed in the South where they were bombarded with some 600 hillbilly stations. The new audiences liked what they heard. Detroit jukebox operators reported in 1943 that hillbilly records were the most popular." (p. 8)

Genres that were once known as "hillbilly music" and "race music" became "country music" and "rhythm and blues," respectively, to a wider audience (Williams, 1998, p. 9). As a result, some radio stations added "A Country Music Hour" or a "Negro Hour" while still maintaining a general audience approach to programming during other times (Fong-Torres, 1998). Also see Barlow (1993), Ramsey (2004), Smith (1989) and Mrvidz (2011) for additional resources.

In October 1949, a year after WDIA started to court a black audience, WERD in Atlanta became the first black-owned, black-oriented radio station (Williams, 1998, p. 32). Being at the center of the community, radio helped African Americans who migrated to urban areas assimilate. According to Gilbert Williams (1998), disc jockeys on urban black-oriented radio stations reassured residents new to the city by playing "music 'with a little chitlin' juice on it,'" while at the same time giving advice on services that were available to everybody and taking the time to help listeners better "understand the concrete jungle they had moved into" (p. 8).

The post-war economy also created more in-car radio listeners. Rugh (2008) notes that the "car ownership by families rose from 54 percent in 1948 to 77 percent in 1960 and 82 percent by 1970 (pp. 18–19). New and old businesses began to provide Americans with drive-in movies, drive-in restaurants, and drive-through banks so they did not have to get out of their cars (or turn off their radios) (Heimann, 1996). Just as the growth in the automobile industry had been delayed by World War II, the rollout of television had been delayed because national security interests diverted industrial resources for this new form of electronics to the war effort. This reprieve extended radio's reign as king of the electromagnetic spectrum until the end of the 1940s, but the advent of television and several geographic and economic factors were about to overhaul radio for everybody.

1950 and Beyond

Radio's "Golden Age"—the period when radio was America's primary entertainment—lasted for only about a quarter century, roughly the period between the passage of the Radio Act of 1927 and the lifting of the freeze on television at the start of the 1950s. By the time the FCC's Sixth Report and Order established a license and regulatory framework for television in 1952, radio had spent the early post war years looking over its shoulder. In five years, radio set usage had fallen to less than two hours per day (Balk, 2006, p. 279–280). Increased competition among recorded music formats triggered an "audio arms race" of attention-getting behavior that would be defined by gimmicky sound effects, screaming disc jockeys, news in snippets, and lots of commercials (Balk, 2006, pp. 282–283).

Meanwhile, television was coming into its own and changing radio listening patterns in the process. In the early days of television programming, the product was described as "radio with pictures" or "radio movies," and many of the earliest popular television shows were just carry-overs from radio (Pendleton, 2001, para. 1). Eventually however, just as it had been with radio, television made its own stars. Increasingly, families were turning off the radios at night and gathering around the television (Fong-Torres, 1998, p. 17). Families also were taking advantage of the new highways and moving further away from the city into the suburbs. Because of the popularity of nighttime television and the increase in the ownership of automobiles, morning and afternoon commuting times were becoming radio's most lucrative listening periods (Fong-Torres, 1998, p. 17).

Radio was a medium that was refusing to go quietly; millions more listened. Mobile enough for an economy on the move, radio remained an essential component of American life thanks in part to the invention of the transistor, a small solid-state semiconductor that eliminated the need for radio vacuum tubes (Brinkman, Haggan, & Troutman, 1997, p. 1858). Portable and in-dash radios improved almost immediately. Because the technology had been developed in cooperation with the government and was under a "consent decree," Bell Laboratories was legally compelled to license this new technology to all responsible parties for a one-time fee of $25,000 (Brinkman et al., 1997, pp. 1861–1862). This was a global game-changer. Sterling and Keith (2008) maintain "the tiny transistor-receiver sets allowed young listeners to more easily combine rock music with their increasingly mobile lives. ... Now radio could accompany teens to school, the beach, and anywhere else in addition to home and car" (p. 71).

When a Japanese electronics company that had just changed its name to "Sony" began marketing inexpensive transistor radios to the American market, their advertising made clear that now "everyone in your family can have a radio. You do not have to just have this big mahogany box in the living room anymore. You could all have a radio of your own" (Brinkman et al, 1997, p. 1862). As NBC radio executive Matthew Culligan put it in a speech in the late 1950s, the masses did not stop loving radio because of television, the public just started "liking it in a different way" (MacDonald, 1979, p. 88).

At the start of the 1950s, radio was barely hanging on to its status as the focal point of the family gathered in the living room. By the end of the decade, radio had become a companion to every family member no matter where they went. Rock and roll radio stations that appealed to a baby-boom of post-war children who cruised in the dark listening to the car radios in their hot rods or tuned into their small transistors under the covers led the ratings surveys in most markets (Keith, 2001, p. 79). When the smoke cleared on the decade, radio proved it could adapt, change with the times and find new audiences, particularly at the local level (Fong-Torres, 1997, p. 17). By 1953, nearly 27 million automobiles had radios (p. 17).

AM radio reigned into the sixties, but its dynasty was about to be challenged. When the Federal Communications Commission approved the new standards for FM radio, which allowed for a stereophonic, high fidelity sound, ideal for the expanded music interests of the baby boomers, that was the beginning of a new era for radio, one which would transform it from Top 40 to niche formats, i.e., classical music, progressive rock, country, easy listening,

and so forth. Most AM and FM sister stations owned by the same company had simply simulcast programming, until in 1964 when the FCC limited that practice.

Radio companies had to respond to the mandate with separate, and that meant additional, programming. FM would usher in a signature sound for music and even deejays, who would become the "priests, rabbis, and gurus" for a new generation (Neer & Van Zandt, 2001, p. ix). As FM expanded listeners' options, new stations competed for audiences, and there seemed to be a demographic for every advertiser (2001). Changes to in-car listening didn't happen overnight for not everyone had a FM tuner in their automobile (2001, p. 119), so AM radio commanded the airwaves through the decade and much of the seventies. AM radio owned morning radio, and that was a time slot FM radio was not ready to challenge out of the box.

The 1960s would see seismic shifts in social orders, sexual mores, racial/gender inequities, the Cold War with the Soviets, armed conflicts in Southeast Asia, and political assassinations that transformed America and the world. But one thing was not changing. Wherever people were, they were still likely hearing it all happen on the radio, and likely still the AM radio when on the way to and from work, or running errands.

References

Balk, A. (2006). *The rise of radio, from Marconi through the golden age.* Jefferson, NC: McFarland.

Barfield, R. (1996). *Listening to Radio, 1920–1950.* Westport, CT: Praeger.

Barlow, W. (1993). Commercial and noncommercial radio. In J. L. Dates, & W. Barlow (Eds.), *Split image: African Americans in the mass media.* Washington, D.C.: Howard University Press.

Barnouw, E. (1979). *The sponsor: Notes on a modern potentate.* New York, NY: Oxford University Press.

Beheim, E., (2018). *CBS world news today: World War II Broadcasts 1942–1945.* San Diego, CA: OTR INC. Retrieved from https://www.otrcat.com/cbs-world-news-today-world-war-ii-broadcasts-1942-1945

Bernstein, M. (2005, June). Edward R. Murrow: Inventing broadcast journalism. *American History Magazine.* Retrieved from http://www.historynet.com/edward-r-murrow-inventing-broadcast-journalism.htm

Bliss, E., Jr. (1991). *Now the news: The story of broadcast journalism.* New York, NY: Columbia University Press.

Brinkman, W. F., Haggan, D. E., & Troutman, W. W. (1997, December). A history of the invention of the transistor and where it will lead us. *IEEE Journal of Solid-State Circuits, 32*(12),

1858–1865. Retrieved from https://classes.soe.ucsc.edu/ee171/Winter06/notes/transistor. pdf.

Cantor, L. (1992). *Wheelin' on Beale: How Wdia-Memphis became the nation's first all-black radio station and created the sound that changed America.* New York, NY: Pharos Book.

Chapple, S., & Garofalo, R. (1977). *Rock 'n' Roll is here to pay: The history and politics of the music industry.* Chicago, IL: Nelson-Hall.

Fatherley, R. W., & MacFarland, D. T. (2014). *The birth of top 40 radio: The Storz stations' revolution of the 1950s and 1960s.* Jefferson, NC: McFarland.

Ferrie, J. P. (2006) Internal migration. In S. B. Carter, S. S. Gartner, M. R. Haines, A. L. Olmstead, R. Sutch, & G. Wright (eds.), *Historical statistics of the United States: Earliest times to the present* (Millennial edition, 5 vols). New York: NY: Cambridge University Press. Retrieved from http://faculty.wcas.northwestern.edu/~fe2r/papers/essay.pdf

Fong-Torres, B. (1998). *The hits just keep on coming: The history of Top 40 radio.* San Francisco, CA: Miller Freeman Books.

Fowler, G., & Crawford, B. (2002). *Border Radio: Quacks, yodelers, pitchmen, psychics, and other amazing broadcasters of the American Airwaves, Revised Edition.* Austin, TX: University of Texas Press.

Gabler, N. (1988). *An empire of their own: How the Jews invented Hollywood.* New York, NY: Crown Publishers.

Garay, R. (1992). *Gordon McLendon: The Maverick of radio.* Westport, CT: Greenwood Press.

Gibson, D. P. (1969). *The $30 billion Negro.* New York, NY: Macmillan.

Gibson, D. P. (1978). *$70 billion in the black: America's black consumers.* New York, NY: Macmillan.

Havighurst, C. (2007). *Air castle of the South: WSM and the making of Music City.* Urbana, IL: University of Illinois Press.

Heimann, J. (1996). *Car hops and curb service: A history of American drive-in restaurants 1920–1960.* San Francisco, CA: Chronicle Books.

Hilliard, R. L., & Keith, M. C. (2001). *The broadcast century and beyond: A biography of American broadcasting.* Burlington, MA: Focal Press.

Kahlenberg, R. (1969). Negro radio. *The Negro History Bulletin*, 29(6), 125–128.

Kallen, S. A. (2012). *The history of country music.* Detroit, MI: Gale, Cengage Learning.

Keith, M. C. (2001). *Sounds in the dark: All-night radio in American life.* Ames, IA: Iowa State University Press.

Kerouac, J. (1959). *On the road.* New York, NY: Penguin.

MacDonald, J. F. (1979). *Don't touch that dial! Radio programming in American life, 1920–1960.* Chicago, IL: Nelson Hall.

Maltin, L. (1997). *The great American broadcast: A celebration of radio's golden Age.* New York, NY: New American Library.

Mishkind, B. (2010, June 6). Clear-Channel Stations. *The Broadcast Archive.* Retrieved from https://www.oldradio.com/archives/stations/ccs.htm.

Nachman, G. (1998). *Raised on radio: In quest of the Lone Ranger, Jack Benny …* New York, NY: Pantheon Books.

Neer, R., & Van Zandt, S. (2001). *FM: The rise and fall of rock radio*. New York, NY: Random House.

Oermann, R. K. (1999). *America's music: The roots of country*. New York, NY: TV Books.

Pendleton, N. (2001, March). Early electronic television: The dawn of modern, electronic television. *Early television museum.org*. Presented at the March 2001 meeting of the South Carolina Historical Association. Retrieved from http://www.earlytelevision.org/pendleton_paper.html

Radio Reruns. (2014). *1945–1952*. Retrieved from http://www.radioreruns.com/1945_1952.html.

Ramsey, G. P. (2004). *Race music: Black cultures from Bebop to Hip-Hop*. Berkeley, CA: University of California Press.

Ripani, R. J.(2006). *The new blue music: Changes in rhythm & blues, 1950–1999*. Jackson, MS: University Press of Mississippi.

Rugh, S. S. (2008). *Are we there yet? The golden age of American family vacations*. Lawrence, KS: University Press of Kansas.

Smith, W. (1989). *The pied pipers of rock 'n' roll: Radio deejays of the 50s and 60s*. Marietta, GA: Longstreet Press.

Sterling, C. H., & Haight, T. R. (1978). *The mass media: Aspen Institute Guide to communication industry trends*. New York, NY: Praeger.

Sterling, C. H., & Keith, M. C. (2008). *Sounds of change: A history of FM broadcasting in America*. Chapel Hill, NC: The University of North Carolina Press.

Summers, H. B. (Ed.). (1971). *A Thirty-year history of programs carried on national radio networks in the United States, 1926–1956*. New York, NY: Arno Press and The New York Times. Retrieved from http://www.americanradiohistory.com/Archive-Bookshelf/History-of-Broadcasting/A-Thirty-Year-History-of-Programs-Summers-1958-HOB.pdf

Williams, G. A. (1998). *Legendary pioneers of Black radio*. Westport, CT: Praeger.

· 7 ·

CADILLAC RADIO

Lady Dhyana Ziegler

In the winter of 1959, Berry Gordy, the founder of Motown Records, and Smokey Robinson, one of Motown's most famous singers, songwriters, and producers, were driving Gordy's Cadillac from Detroit to a Flint, Michigan, record-pressing plant to pick up advanced copies of a new single. Detroit radio was blasting as they drove; the two legends took turns commenting on the songs from the Cadillac's radio just "like two professionals talking shop" (George, 2007, p. 27). At first glance, this joyful image of the soon-to-be famous, successful artists riding in a Cadillac, listening to R&B music on the car radio, might seem as non-eventful as two up-and-coming white record executives doing the same. But that is not the case. The casualness of that Cadillac conversation between Gordy and Smokey belies a darker history—one with a hidden anomaly—an agenda that actively had worked against African-American ownership of the very car the two men at the heart of Motown were riding in on this trip (Myers & Dean, 2007, p. 157).

This chapter focuses on the sometimes tortured relationships between the Cadillac, radio, African-American car buyers/listeners, and the cultural history that bonded Motown automotive manufacturing methods with Motown assembly-line recording standards in "Hitsville, USA." "Cadillac Radio" blares loudly through the paradox of human impulse to desire most that which

we are most denied. Although the Cadillac brand was as synonymous with U.S. automotive status as the Jaguar was for the British, or Alfa Romeo was for Italians (Bluntzer, Ostrosi & Sagot, 2014, p. 258), Cadillac maintained a perception of prestige by actively reinforcing a classist, racist artifice of exclusivity at great cost; Cadillac was on the verge of closing because "part of its strategy to capture that market was its refusal to sell to African-Americans" (Gordon, 2009, para. 16).

As the story goes, the Depression had hit the Cadillac division of General Motors hard. In 1933, four years after the Stock Market Crash, GM only sold 6,736 Cadillacs, a decline of 84% since 1928 (Gordon, 2009, para. 11). General Motors was about to drop the Cadillac brand completely when Nicholas Dreystadt, a German immigrant in charge of the Cadillac service division nationwide, convinced GM executives that the car was "very popular with the small black bourgeoisie of successful entertainers, doctors and ghetto businessmen" who flourished despite the thumb on the scale against them from Jim Crow-era regulations (Cray, 1980, p. 279). As part of its company policy, in order to buy a new Cadillac, most black consumers needed a paid, white proxy to arrange the purchase from a GM-authorized dealer. Dreystadt's question was an audacious, if not a self-interested one: "Why should a bunch of white front men get several hundred dollars each when that profit could flow to General Motors?" (Gordon, 2009, para. 16).

Given 18 months to develop a new strategy, Dreystadt's diversity plan was so successful that by the 1940s, new African-American Cadillac ownership had put the luxury brand back "in the black," so to speak (Cray, 1980, p. 279). Unable to purchase homes in whites-only neighborhoods or join established country clubs, the "African-American elite: the boxers, singers, doctors, and lawyers who earned large incomes despite the flourishing Jim Crow atmosphere of the 1930s," drove Cadillacs as a statement of arrival (Gordon, 2009, para. 16). To the extent that Majors and Billson (1993) are correct, Cadillacs were the car of choice in the black community: "Cadillac-type cars epitomize class because of their reputation, and because they take up a great deal of physical space"—perhaps a natural reaction to black consumers having been penned in and invisible in America for so long (p. 62).

Myers and Dean (2007) question the claim that the Cadillac was saved from extinction by African-Americans, but concede that the narrative "has metaphoric appeal to it. Certainly, if nothing else, it foreshadows the success of the brand in the 21st century when Cadillac embraced 'bling' as a major selling proposition" (p. 160). If black conspicuous consumption did not keep

Cadillac afloat, it was not for a lack of well-publicized efforts. In post-WWII America, for example, world-champion boxer "Sugar Ray" Robinson defied majoritarian demands that African Americans "be humble, docile, and grateful for favors received" when he accentuated his independence and social mobility through the order of a custom-made, fuchsia-pink, drop-top Cadillac, a car so photographed and followed around New York City that it became known as "the Hope Diamond of Harlem" (Nathan, 1999, p. 166).

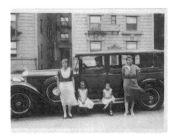

Figure 7.1. Unnamed African-American women on a windy day in 1930s Harlem posing in front of their Cadillac.

To be sure, racial discrimination was/is not limited to only one region or one era in American history. As recently as 2017, homeowners in Minneapolis, Minnesota, still were uncovering "racial covenants" in home deeds that stipulated older houses could not be "transferred or leased to a colored person" (Furst, 2017, para. 1). During the 1950s, however, and particularly in the South, prejudice ran so high that even white entertainers that copied black artists faced discrimination. In September, 1954, fearful of the corruption of "white southern youth," one music promoter advised Elvis Presley, "We don't do that nigger music around here. If I were you, I'd go back to driving a truck" (Kloosterman & Quispel, 1990, p. 151). Of course, unlike African Americans, even if he did "sound black," Elvis Presley could drive his pink Cadillacs without restriction in any neighborhood of his choosing.

Historically, white R & B performers did expand the popularity of black culture in America, but advancements in a fair representation of African Americans in U.S. media were only sporadic. A survey taken by *Ebony Magazine* in 1947 found that of the 3,000 deejays in the U.S. at that time, only 16 of them were black (Walsh, 1997, p. 50). Jack L. Cooper's "The All-Negro Hour" had aired on WSBC in Chicago since the station went on the air in 1920s, "Sonny Boy" on KFFA, in Helena, Arkansas, was nationally famous,

and African-American Detroit dentist Haley Bell had become the first black businessman to build a radio station entirely from the ground up in 1956 (Patterson, n.d., paras. 6–10). Every weekday afternoon at 4 p.m. in 1950s Chicago, "most radios in the black community are tuned to radio station WGES, where the top radio personality of the time came into the homes and cars of black Chicago": Al Benson, the Godfather of Chicago black radio ("Al Benson, the Godfather of Chicago black radio," 2010, 00:50). But Benson was a rarity. More times than not, black radio personalities were a minority within a minority.

> In the early '50s, it became commonplace for stations to hire white men, who sounded or appealed to blacks, to do a black music show. One example of this was Dewey Phillips at WHBQ (Memphis). Phillips was launched at WHBQ in October 1949 with a nighttime show called "Red, Hot and Blue." Even though he was white and made no concerted attempt to sound black, listeners thought he was. (Patterson, n.d., para. 12)

As mentioned in chapter four, at the beginning of the 1950s, "race music" was considered a separate sales category and mostly sold in record shops in black neighborhoods (Kloosterman & Quispel, 1990, p. 158). In evidence of Cadillac's vaunted status in the black community, various models of Cadillac were prominently mentioned in either the title of vocal groups, the title of the songs they sang, or in the lyrics, such as in Chuck Berry's "Maybellene," a 1955 hit about a girl in the center of a car race between a Cadillac and a Ford, credited as one of the first formal rock and roll records (Myers & Dean, 2007, p. 157):

It was about this time that lifelong Detroit resident, Berry Gordy, landed a job with Ford Motor Company earning $86.50 a week by "fastening on chrome strips and nailing upholstery to Lincoln-Mercurys as they rolled by" (George, 2007, p. 17). But Gordy, a habitual gambler, carouser, and late night club patron, saw himself as a songwriter and record producer—not a factory man with a family—so in 1957 he left his wife and children to pursue his fortune in a recording industry that was still "racially segregated and dominated by a few large recording labels" (Posner, 2009, p. 21).

After a some success as a songwriter and a minor league record producer, Gordy built his Detroit music empire on the same assembly-line model that Detroit car factories used—complete with a Quality Control department that all recordings had to pass through to ensure the songs were the right length (short), catchy, and tuneful because "the Motown sound had an identifiable

beat and the right tone" (Posner, 2009, p. 83). Before Quality Control gave its approval, however, all artists and their songs moved along a series of departments in order to be sung right, dressed right, choreographed right, coiffed right, and marketed right before they were introduced to the consumer (Latimer, 2016, paras. 16–19). "I got the idea to do my music business and have it like an assembly line, where artists would come in one door an unknown kid off the street and go out another door a big star" (Gordy, 2014, para. 3).

But Gordy had also gleaned something else from that brief period when he worked for Ford. Gordy was fascinated by the increase in car radio listening and knew that kids would be blasting Motown records through little tinny dashboard speakers, so "Mike McClain, Motown's chief engineer, built a small radio that approximated the sound of those in cars. Everyone listened to early mixes on that radio" (Posner, 2009, p. 52). If the bass was too high, or if a part of the song sounded muddy, Gordy would quickly fix the mix until he satisfied his primary concern: "Was it a song that teenagers cruising in their new Cadillac or Ford could sing along to and groove to in a car?" (Boyce, 2008, p. 38).

Cadillac played yet another important role in the history of Motown's dominance on the radio: Motivation. Norman Whitfield became one of Motown's most successful writer/producers for hits such as "I Heard It Though the Grapevine," "Just My Imagination (Running Away with Me)," and "Papa Was A Rollin' Stone," but before he started out, Whitfield had no musical training. "When I saw Smokey Robinson driving in a Cadillac, to be absolutely point-blank, that's what inspired me," Whitfield recounted before his death, "I actually ran up behind him and asked him: 'How do you get started?'" (Perrone, 2008, para. 8).

Gordy was so convinced of this connection between "cool" music and "cool" cars that he "made many of the Motown artists take photographs next to cars, usually Cadillacs" (Boyce, 2008, p. 39). One of The Supremes, Mary Wilson, asserts that Cadillac owed just as much to Motown as Motown owed to Cadillac: "A writer, producer, or performer got his first check, it was as good as endorsed over to the local Cadillac dealership" (Sugrue, 2005, para. 14). But this celebratory relationship between pop star and star car had a darker side too. Some unsophisticated performers were known to be bought off with a brand new Cadillac that was worth only a fraction of what they were owed by promoters or record labels (Greene, 2008, p. 1198).

This financial dipsy-do concurs with scholars who maintain that Cadillac ownership should not be viewed as an act of achievement or liberation

by a black consumer, rather, as self-enslavement, because "autos associated with the subculture of American blacks do not serve to break racial stereotypes but merely to maintain and bind them to mainstream consumer culture" (Gartman, 2004, p. 190). A signifier of success such as a Cadillac becomes a substantial cultural buy-in, but it is ultimately the culture that comes out ahead in the exchange by those who see "the African-American auto subculture of expensive cars, chrome rims, and elaborate car stereos as corporate race-branding that maintains stereotypes while simultaneously salving African-Americans' chronic injuries" (Gartman, 2004, p. 191).

The perception in the black community that Cadillac ownership was a marker of personal achievement suffered when the "pimpmobile" image of the 1970s "blaxploitation" movies and stories of so-called "Cadillac-driving welfare queens" collided in the early 1980s (Myers & Dean, 2007, p. 158). Although he did not create the myth, President Ronald Reagan popularized the story of "the 'Chicago welfare queen' who had 80 names, 30 addresses, 12 Social Security cards, and collected benefits for 'four non-existing deceased husbands,' bilking the government out of 'over $150,000'" (Myers & Dean, 2007, p. 158). The race-baiting runaway rumor was based on the court conviction of a woman who *had* defrauded the welfare system, but of only $8,000 by using only two different aliases. Still, Reagan continued to tell his inflammatory exaggeration long after it had been debunked (https://washingtonmonthly.com/2003/09/01/the-mendacity-index-4/). The impact was that the image of both welfare recipients and Cadillacs had been degraded. "The Cadillac, historic symbol of big money among African Americans, slowly gave way to less ostentatious European luxury cars" (George, 1998, p. 2).

Meanwhile, the popularity of Motown fell parallel to Cadillac's misfortunes; in 1984, Motown Industries, the parent company to Motown Records, lost its ranking as the largest black-owned U.S. corporation to Johnson Publishing (Bates, 1988, para. 7). Just four years later, Motown Records, which had long since left Detroit, was sold to publicly held, media conglomerate MCA Inc. for $61 million (Bates, 1988, para. 2). The attenuation of the Motown brand, however, never weakened mainstream America's interest in "the black sound." By the mid-1980s, "urban contemporary radio" formats, as they were then called, were in every major U.S. market (Neal, 2004, p. 365). Also, *The Tom Joyner Morning Show*—considered an activist outlet for African-American culture (Means Coleman, 2006, p. 92)—has dominated certain syndicated morning drive demographics with more than a million daily listeners on more than 100 radio stations since the 1990s (Barlow, 1999,

p. 259). Howard Stern's African-American sidekick for 30 years, Robin Quivers, and former New York deejay-turned-television star, Wendy Williams, are two more black radio personalities who became national household names.

The demographic trend in the popularity of music derived from the American black experience remains positive. Urban contemporary radio stations—now called "hip-hop"—have moved from being the seventh to the fifth-most popular format among Millennials according Nielsen, the radio ratings service—and that's just among broadcast radio stations (http://www.nielsen.com/us/en/insights/news/2017/taking-stock-of-sports-radio-listening-millennial-music-tastes-and-more.html). Digital music channels, net-native stations, and satellite radio options comprise an even larger delivery system for rap, soul, blues, jazz, and R & B oldies fans.

It's been quite a ride. Sixty years after Berry Gordy and Smokey Robinson first took that wintry drive to Flint in 1959, Cadillacs, black-oriented radio stations, and Motown artists all remain part of the same constellation, with some noticeable changes. Of the three entities, black-oriented radio is now the biggest star, Cadillac is no longer an aspirational luxury brand for young African Americans, and—for better or for worse—Motown Records is now so mainstream-American that it is just another corporate-owned legacy consumer brand like Corn Flakes and Kleenex.

References

Al Benson: The Godfather of Chicago black radio. (1995). Independent video archive. Retrieved from http://mediaburn.org/video/al-benson-the-godfather-of-chicago-black-radio/.

Barlow, W. (1999). *Voice over: The Making of black radio.* Philadelphia, PA: Temple University Press.

Bates, J. (1988, June 29). Berry Gordy sells Motown records for $61 million. *Los Angeles Times.* Retrieved from http://articles.latimes.com/1988-06-29/business/fi-4916_1_motown-records

Bluntzer, J., Ostrosi, E., & Sagot, J. (2014). Car styling: A CAD approach to identify, extract and interpret characteristic lines. *ScienceDirect.* Retrieved from https://www.sciencedirect.com/science/article/pii/S2212827114007409?via%3Dihub

Boyce, A. K. (2008). *'What's going on': Motown and the Civil Rights Movement.* (Unpublished thesis). Boston, MA: Boston College. Retrieved from http://hdl.handle.net/2345/590.

Cray, E. (1980). *Chrome colossus: General Motors and its times.* New York, NY: McGraw-Hill.

Furst, R. (2017, August 26). Massive project works to uncover racist restrictions in Minneapolis housing deeds. *Star Tribune.* Retrieved from http://www.startribune.com/massive-project-underway-to-uncover-racist-restrictions-in-minneapolis-housing-deeds/441821703/.

Gartman, D. (2004). Three ages of the automobile: The cultural logics of the car. *Theory, Culture & Society, 21*(4/5), 169–195.

George, N. (2007). *Where did our love go*. Champaign, IL: University of Illinois Press.

Gordon, J. S. (2009, May 1). The Man who saved the Cadillac. *Forbes*. Retrieved from https://www.forbes.com/2009/04/30/1930s-auto-industry-business-cadillac.html#65d81db219d2.

Gordy, B. (2014, December 4). Motown: Berry Gordy's 'assembly line' made songs for everybody. *Bloomberg News*. Retrieved from https://www.bloomberg.com/news/articles/2014-12-04/motown-berry-gordys-assembly-line-made-songs-for-everybody.

Greene, K. J. (2008). 'Copynorms,' Black cultural production, and the debate over African-American reparations. *Cardozo Arts & Entertainment Law Journal, 25*(3), 1179–1229. Retrieved from https://papers.ssrn.com/sol3/papers.cfm?abstract_id=1478119

Kloosterman, R. C., & Quispel, C. (1990). Not just the same old show on my radio: An analysis of the role of radio in the diffusion of black music among whites in the south of the United States of America, 1920 to 1960. *Popular Music, 9*(2), 151–164. Retrieved from http://www.jstor.org/stable/853498.

Latimer, C. (2016, July 11). At Motown, Berry Gordy's assembly line of talent remade pop music. *Investors Business Daily*. Retrieved from https://www.investors.com/news/management/leaders-and-success/at-motown-berry-gordys-assembly-line-of-talent-remade-pop-music/

Majors, R., & Billson, J. M. (1993). *Cool pose: The dilemmas of black manhood in America*. New York, NY: Simon & Schuster.

Means Coleman, R. (2006). The Gentrification of "Black" in Black Popular Communication in the New Millennium. *Popular Communication, 4*(2), 79–94. Retrieved from http://dx.doi.org/10.1207/s15405710pc0402_2

Myers, M., & Dean, S. G. (2007). "Cadillac Flambé": Race and Brand Identity. *Charm*, 157–161. Retrieved from http://citeseerx.ist.psu.edu/viewdoc/download?doi=10.1.1.630.8342&rep=rep1&type=pdf

Nathan, D. A. (1999). Sugar Ray Robinson, the sweet science, and the politics of meaning. *Journal of Sport History, 26*(1), 163–174. Retrieved from http://library.la84.org/SportsLibrary/JSH/JSH1999/JSH2601/jsh2601h.pdf

Patterson, D. R. (n.d). Black radio pioneers. RockRadioScrapbook.com. Retrieved from http://rockradioscrapbook.ca/black.html.

Perrone, P. (2008, September 18). Norman Whitfield: Songwriter and producer who added a political edge to Motown. *Independent.co.uk*. Retrieved from http://www.independent.co.uk/news/obituaries/norman-whitfield-songwriter-and-producer-who-added-a-political-edge-to-motown-934145.html.

Posner, G. (2009). Motown: Music, money, sex, and power. New York, NY: Random House.

Sugrue, T. J. (2005). Driving while Black: The car and race relations in modern America. Automobile in American life and society. Retrieved from http://www.autolife.umd.umich.edu/Race/R_Casestudy/R_Casestudy.htm

Walsh, S. R. J. (1997). Black-oriented radio and the campaign for civil rights in the United States 1945–1975. (Unpublished dissertation). New Castle, UK: New Castle University. Retrieved from https://theses.ncl.ac.uk/dspace/bitstream/10443/376/1/walsh97.pdf.

· 8 ·

A TIDAL WAVE OF CHANGE

Surfin' the Sixties on the Dashboard

Jenny Johnson and Phylis Johnson

With regard to the *roman a clef* characters in Jack Kerouac's *On the Road* (1957), Mark Bliesener (2018, p. 183) asks "what music motivated" Neal Cassady? He explains that "Neal was the driver" (p. 183). He was the in-car philosopher and deejay, spinning rhythm and lyrics, an eclectic mix of pop, big band, swing, jazz and classics. He would introduce a beat that motivated generations of youth. "He got you from here to there" (p. 183). The highway helped connect the dots across America; Kerouac (as Sal Paradise, the narrator) introduced the world to the new freedom emerging during his era. As the federal road system expanded across the nation, the legacy of Neal grew as quickly through character Dean Moriaty). Neal's son, John Allen, recalls (p. 189) one trip, when Chuck Berry was on the car radio as they "cruised Highway 17 on the way to watch the car races at the Speedway in San Jose ... driving a '49 Pontiac:

> "Maybelline" came on the radio and he cranked it up loud, swinging the steering wheel from side to side to the beat and banging on the dashboard, all the while driving with his knees. "Maybelline" was kind of the story of his life.

From the 1940s to the 1960s, the number of installed car radios had more than tripled to approximately 50 million (Biagi, 2015, p. 117). It wasn't so surprising then how it became part of folk lore and literature. Sharing the

dashboard with AM, were turntables in 1955, but that was a short–lived experiment for obvious reasons (Berkowitz, 2010, para. 5). In the early 1950s, the first FM car radio made its debut in select luxury cars, although AM Radio was still King of the road (Berkowitz, 2010, para. 3).

AM Radio mainly relied on a cost effective strategy of repetition, an idea that began with music and later was adapted for news and sports; basically the concept was to repeat the major hits and headlines of content in 20 minutes cycles (Chapple & Garofalo, 1977, p. 59). The *Hit Parade* weekly music countdown first aired on radio in 1939 (television debut in 1935), and it was the predecessor to the Top 40 format created by Todd Storz in the fifties, refined by Gordon McLendon through the sixties (Chapple & Garofalo, 1977, pp. 58–59), and then transformed and eventually nationally syndicated by Los Angeles' disc jockey Casey Kasem as *American Top 40* (Battistini, 2004, p. 6). By the time Kasem came on the scene, Top 40 music was losing its edge and influence over the American youth, for it had become highly commercialized, and jam-packed with programming elements such as jingles, sweepers, and lots of dj chatter (Chapple & Garofalo, 1977, p. 59). Fortunately for radio, there was no competition inside the automobile like today. Listeners had little recourse except to change to another station, which often followed the same popular programming model (until FM arrived en masse).

As already established in Chapter 3, as women increasingly went to work and during their errands, they would tune to the car radio. Most women stayed at home, and television programming grew through the 1950s, displacing radio's dramas and variety shows. Teens would borrow the family car on weekends, with the car radio providing the soundtrack to their good times. By the early 1960's, 60% of the cars had radios (DeMain, 2012, para. 4). At this time, an-in car listener likely heard a repetitive mix of programming during drive times, news updates at least every half hour, and lots of commercials in between elements and deejay chatter over songs (Chapple & Garofalo, 1977, p. 60). By the early 1960s, all-news radio stations began to operate across the U.S. (Schneider, 2013, para. 26–28). Car radio was mostly defined by popular music and headline news that spun around the clock.

Kerouac and Radio-Road Culture

American beat author Jack Kerouac was a different kind of protagonist for the younger generations, entering the literary scene in the early 1950s, and by 1960 he was legendary. An increasing number of youth were in search of

new ways of thinking, and formed a close-knit counter-culture group, meeting at each other's homes to simply engage in discussions about Kerouac. *On the Road* (1957) intertwined music and word into a self-fulfilling prophetic narrative. Kerouac wrote his novel *On The Road* in "marathon typing sessions in the first few weeks of April of 1951," resulting in "a 120-foot long scroll consisting of a series of single-spaced typed twelve-foot long rolls of paper … scotched taped together" (Eimont, 2002, para. 10). It had the pacing of a mix tape produced for a literary rave. His novel inspired individualist and experimental pursuits, pushing away from the social norms of his era. Kerouac established friendships with authors Allen Ginsburg and William Burroughs, and their conversations impacted each other's writings. Kerouac may not have intended it as such, but his words and actions were idolized, influencing pop culture and counter culture simultaneously from coast to coast. Building upon last chapter's discussion, the TV show *Route 66* was speculated to be a sanitized adaptation of Kerouac's first novel.

It is written as an autobiographical account of his road trips across the U.S. and Mexico, with his companion Neal Cassidy. Kerouac lived in Manhattan during his first draft, but it would be several years later before its publication, with the setting of the book ultimately changing from New York City to San Francisco. Kerouac's original scroll was released as a book in 2007, and its editor Jack Kerouac and Howard Cunnell (2007) notes in the preface, "It's the first book that I've heard or read with a built-in soundtrack" (p. 1). Kerouac (2007) writes about blasting the car radio to the point that the car "shudders" during a trip down to New Orleans (p. 286). *On the Road* blurs the line between reality and fiction; Kerouac wrote the book "with bop on the radio" (p. 1) while high on Benzedrine (Rasmussen, 2011, para. 3). Kerouac's book was influential for bringing the beatnik counterculture to North Beach, San Francisco, approximately 300 miles north of Santa Monica, where Route 66 ended outside Los Angeles. "Beatnik" (Ybarra, 1997, para. 14) was a West Coast phrase credited to *The San Francisco Examiner's* infamous gossip columnist Herb Caen, who began his career on radio in the late 1930s, and switched to newspaper, writing first for *San Francisco Chronicle* (Ybarra, 1997, para. 7). The Beach Boys and Jan and Dean epitomized the California youth culture that would quickly emerge on the West Coast. Kerouac avoided the public spotlight. Music themes in the sixties portrayed a conflicted decade of ups and downs across the social Richter scale. In the early years, lyrics boasted of hot rods, teen crushes and cruising to the radio. Towards the end of the decade, the music echoed the tumultuous events of the times, providing commentary

on serious social and political issues. It became a phenomenal springboard for many musicians to lyrically address these concerns, arousing public dialogue over the airwaves and sometimes protests. In the book *Kerouac On Record: A Literary Soundtrack*, Simon Warner and Jim Sampas (2018) edited a collection of essays on how Kerouac's writings have profoundly impacted musicians, particularly their lyrics since publication of *On the Road*. The Velvet Underground's Willie "Loco" Alexander, one of the Boston's original punk rockers, was strikingly impacted by reading it when it was published in 1957.

Quoted in James Sullivan's (2018) chapter "Punk and New Wave," Alexander states that Kerouac words "just hit him, and explained how the book "coincided with what I was getting out of the radio at the time, jazz and rock'n'roll. I was totally into the music, and Kerouac was writing very excitingly about the music that was exciting me. I went through phases, Dixieland to swing to bebop. I could dig it" (p. 356). It was an era of improvisations, and Kerouac's approach was to create a metaphor of "being like a horn, improvising, blowing" (Sullivan, 2018, p. 356). Kerouac would soon do for writing what Thelonious Monk on piano was doing for jazz. The car radio transported the beat across the nation. By the mid sixties, preferences for music like many of Alexander's generation gravitated to the "pounding rock'n'roll of Little Richard, Jerry Lee Lewis and Fats Domino" (Sullivan, 2018, p. 356). He appreciated the bohemian lifestyle, but explained it wasn't so much about being beatnik or a hippy, really it was about Kerouac. All these forces simmered until a confluence of synergies came together, reshaping the cultural soundscape within the automobile. In the final chapter of his novel, looks upon the landscape that unfolds beyond his reach, we hear him, reading aloud his words within one extended breath:

> So in America, when the sun goes down, and I sit on the old broken down pier, watching the long, long skies over New Jersey and sense all that raw land that rolls into one unbelievable huge bulge over to the West Coast. ...
> It is then, he attempts to find himself within ... all that road going, and all the people dreaming and the immensity of it. ... (Kerouac, 2007, p. 408)

Like a Bruce Springsteen song (Morrison, 2018, p. 321), Kerouac was in search for those larger than life characters, and he found them on the road. Words blended into a soundtrack. Imagination fueled the trip. It is the contemplation of self and possibility. The radio embedded within the dashboard is both companion and instigator, urging the listener to crank up the volume and imagine what's ahead.

The Merry Pranksters Go Furthur

The 1960s is best remembered as a "collection of trends and fads from hip-pie fashion to British rock … but nothing defined youth culture more than the '60s car," according to historian Matt Anderson (Inman, 2014, para. 5), curator for The Henry Ford Museum in Dearborn, Michigan. It was in this decade that the car would become extremely important to American youth as a means to establish their freedom and social circle: "It was a big deal for a teenager to actually own one. In the 1960s, nearly 79% of American households owned fewer than two vehicles, and more than one-out-of-five households didn't own a vehicle at all" (Anderson cited in Inman, 2014 para. 6, 7).

Owning a car also meant that you had to work to maintain it. It was difficult to just pick up and head for the highway. Life was fairly predictable for most young adults, with work and school filling their days. For those seeking adventure, another trip would soon make headlines in the sixties, as the Merry Pranksters took to the road in a bus across the U.S. In 1964, Ken Kesey, author of *One Flew Over the Cuckoo's Nest* and *Sometimes a Great Notion* set to road in a psychedelic bus, transporting 13 passengers, collectively referred to as The Merry Pranksters, from California to the New York World's Fair (Brown, 2016, para. 1). The driver was Neal Cassady (a.k.a. Dean Moriarty from *On the Road*), and along the way they met Timothy Leary and Jack Kerouac. In the destination window, it stated "Furthur." To archive the trip and produce a documentary about the event, the bus was equipped with a huge sound system. More than 150 hours of audio and 50 hours of film were recorded. But they never synched the two together. The co-director of the documentary, *Magic Trip*, co-director Alison Ellwood explained:

> They found some synch points, including a wild sequence where Cassady drove the bus while high on speed. Listening to music on huge headphones Cassady raps into the on-board public address system, waving his arms and howling into the microphone, only occasionally looking at the road. (cited in Kerr, 2011, para. 21)

As war loomed over the latter half of the decade, lyrics darkened. Edwin Starr's "War" (1970) introduced the seventies with his anti-Vietnam protest message written by Norman Whitfield and Barrett Strong. In a matter of a decade, everything changed. Initially U.S. involvement with Vietnam had personally touched very few U.S. families, but troops would be deployed under Lyndon B. Johnson's presidency beginning in 1965.

American youth grew weary of conservative politics, and this was reflected in the music and road culture. Artists like The Byrds, Bob Dylan, Peter, Paul and Mary, The Yardbirds, The Rolling Stones, War, The Animals, The Mamas and the Papas, Cream, Spencer Davis Group, The Rascals, and Jefferson Airplane, among others, began to set the stage for messages of peace and love. People were hungry for the next prophet, be it Bob Dylan or John Lennon.

The airwaves were also filled with car jingles and commercials sung by pop musicians of the moment (e.g., Paul Revere & The Raiders' 1969 song about the Pontiac GTO). Automobile culture grew exponentially stronger with more choices for styles and in-car options, depending on your budget. George Harrison's car was equipped with an in-car vinyl record player (Spice, 2013). In the case of John Lennon's psychedelic Rolls Royce, his car was fully loaded acoustically:

> On-demand music was available from a state of the art Philips Auto-Mignon AG2101 "floating" record player, boasting an ingenious suspension system that prevented the needle from jumping when the car was in use. A Philips tape player was also added in a specially built cabinet. (Runtagh, 2017, para. 11)

For a peek at his car's dashboard accessories, you can take a video tour (British Pathé, 1967). Lennon also changed the horn to play "Lilli Marlene." (para. 11)

All in all, the automobile was becoming culturally omnipresent, and its connection to the outside world was the in-car radio. The music of a new generation was heard emerging from its dashboard radio - perhaps except in the case of when John Lennon used his microphone to bypass the radio and broadcast live from his car's public address system, John Lennon literally spoke to his fans (and critics) through his car stereo system:

> … Lennon derived much of his entertainment from the "loud hailer" public address system. Speakers mounted in the front wheel wells allowed occupants to communicate with the world outside via microphone. "You could ask people to cross the road a bit faster which scared the daylights out of them …" The car's stereo could also be switched to these outdoor speakers, and Lennon enjoyed blasting sound-effect recordings of trains and jet engines to confuse bystanders. (Runtagh, 2017, para. 12)

Lennon at 24 was the last member of The Beatles to get his license (Runtagh, 2017, para. 7). When he did start driving, he was so bad that he hired a chauffeur (para. 8). "Drive My Car" (1965) from the Beatles the *Rubber Soul* album served as an anthem for car culture, although the song had little do with it. His friends joked "Ticket to Ride," really was really about all the tickets that he received for his horrible driving and speeding (para. 7)

As car radio matured in the next decade, so did the music that broadcast across the dial. Marvin Gaye's LP "What's Going On" (1971) ignited dialogue on what it means to be an African-American veteran; it was a protest album about social inequalities from the perspective of a returning soldier. The vibrations that emanated from the radio were far greater than even Gaye would have imagined. The 1970s brought further changes and challenges, it became legal for 18-year-olds to vote, student protests at Kent State and Jackson State turn violent, Jimi Hendrix, Jim Morrison and Janis Joplin all overdosed, all at the age of 27. Cigarette commercials are banned from the airwaves, abortion becomes legal, "Watergate" becomes a household word, and Los Angeles native Casey Kasem was at the helm to launch *American Top 40* as the seventies started. Through the turbulence of the years ahead, with outcries for revolution and societal change, Kasem kept his show inspirational to his audience and "wholesome" because a big chunk of his listeners tuned in Sundays mornings on the way to church (Meisler, 1999, para. 12).

References

The Beatles Bible. (1965, December 3). Drive my car. *Rubber Soul*. George Martin (Producer). Liverpool, England: Northern Songs.

Battistini, P. (2004). *American top 40 with Casey Kasem (The 1970's)*. Bloomington, IN: Author House.

Biagi, S. (2015). *Media/impact: An introduction to mass media*. Stamford, CT: Cengage Learning.

Berkowitz, J. (2010, October). The history of car radios; 1955: First "music on demand." *Car and Driver*. Retrieved from https://www.caranddriver.com/features/the-history-of-car-radios

Berkowitz, J. (2010, October). The history of car radios; 1952: First radio with FM. *Car and Driver*. Retrieved from https://www.caranddriver.com/features/the-history-of-car-radios

Bliesener, M. (2018), Driver: Neal Cassady's musical trip. In S. Warner, & J. Sampas (Eds.), *Kerouac on record: A literary soundtrack* (pp. 183–190). New York, NY: Bloomsbury Academic.

British Pathé. (1967). John Lennon's Rolls Royce. [Video]. Retrieved from https://www.youtube.com/watch?time_continue=18&v=lmBg4yQzdyA

Brown, M. (2016, November 2). Trip of a lifetime: Ken Kesey, LSD, the Merry pranksters and the birth of psychedelia. [Culture Section: Books]. *The Telegraph*. Retrieved from http://www.telegraph.co.uk/books/what-to-read/trip-of-a-lifetime-ken-kesey-lsd-the-merry-pranksters-and-the-bi/

Burroughs, W. S. (1959). *Naked lunch*. New York, NY: Grove Press.

Chapple, S., & Garofalo, R. (1977). *Rock 'n' roll is here to pay: The history and politics of the music industry*. Chicago, IL: Nelson-Hall.

DeMain, B. (2012, January 3). When the car radio was introduced, people freaked out. *Mental Floss*. Retrieved from http://mentalfloss.com/article/29631/when-car-radio-was-introduced-people-freaked-out

Eimont, J. (2002, September 1). The scroll of Jack Kerouac. *Literary traveler*. Retrieved from http://www.literarytraveler.com/articles/the-scroll-of-jack-kerouac/

Gaye, M. (Producer). (1971, January 20). *What's going on*. Detroit, MI: Hitsville USA.

Ginsberg, A. (1956, November 1). *howl and other poems*. San Francisco, CA: City Lights.

Inman, J. (2014). When owning a car made you a god. CNN. Retrieved from:https://www.cnn.com/2014/07/15/living/teenagers-1960s-cars-irpt/index.html

Johnson, B. (2011, October 31). From 'see the USA in your chevrolet' to 'like a rock,' Chevy ads run deep. *Advertising Age*. Retrieved from http://adage.com/article/special-report-chevy-100/100-years-chevrolet-advertising-a-timeline/230636/#1930

Kerr, E. (2011, September 2). The harsh reality behind the Merry pranksters 'magic trip'. Arts & Culture. *Minnesota Public Radio News*. Retrieved February 3, 2018, from https://www.mprnews.org/story/2011/09/01/magictrip#gallery

Kerouac, J., & Cunnell, H. (Eds.) (2007). *On the road: The original scroll*. New York, NY: Viking Press.

Kesey, K. (1962, February 1). *One flew over the cuckoo's nest*. New York, NY: Viking Press.

Kesey, K. (1964, July 27). *Sometimes a great notion*. New York, NY: Viking Press.

Meisler, A. (1999, May 2). Television/Radio: After 29 years, still counting down the hits. Arts/television/radio section. *New York Times*. Retrieved from http://www.nytimes.com/1999/05/02/arts/television-radio-after-29-years-still-counting-down-the-hits.html

Morrison, S. A. (2018). Tramps like them: Jack and Bruce and the myth of the American road. In S. Warner, & J. Sampas (Eds.), *Kerouac on record: A literary soundtrack* (pp. 321–338). New York, NY: Bloomsbury Academic.

Paul Revere & The Raiders. (1969). Pontiac GTO. [Video] etrieved from https://www.youtube.com/watch?v=Ea4OgV7wGHs

Rasmussen, N. (2011, September 22). How a generation of "beat" writers burnt out on speed. *The Fix*. Retrieved from https://www.thefix.com/content/beat-poets-speed5123

Runtagh, J. (2017, July 27). John Lennon's Phantom V: The story of the psychedelic beatle-mobile. *RollingStone*. Retrieved from http://paulontheruntour.blogspot.com/2017/07/john-lennons-phantom-v-story-of.html

Schneider, J. F. (2013). The history of KJBS Radio. San Francisco, CA: Bay Area Radio Museum. Retrieved from http://bayarearadio.org/schneider/kjbs.shtml

Schneider, J. F. (2018, January 2). Remember the radio traffic cowboys of the skies: Chronicling the rise and fall of the on-air traffic report (para. 2, photo caption, August 1937). *Radio World*. Retrieved from https://www.radioworld.com/columns-and-views/remember-the-radio-traffic-cowboys-of-the-skies

Spice, A. (2013, October 22). Amazing photos of a time when cars had vinyl record players. *The Vinyl Factory*. Retrieved from https://thevinylfactory.com/news/amazing-photos-of-a-time-when-cars-had-record-players/

Starr, E. (1970, January 1). War & peace. (Norman Whitfield, Producer). Detroit, MI: Hitsville USA.

Sullivan, J. (2018). Punk and new wave. In S. Warner & J. Sampas (Eds.), *Kerouac on record: A literary soundtrack* (pp. 349–358). New York, NY: Bloomsbury Academic.

Warner, S., & Sampas, J. (2018). *Kerouac on record: A literary soundtrack*. New York, NY: Bloomsbury Academic.

Ybarra, M. J. (1997, February 2). Herb Caen, 80, San Francisco Voice, Dies. *New York Times*. Retrieved from *http://www.pulitzer.org/winners/herb-caen*

· 9 ·

LOS ANGELES, POPULAR MUSIC, AND THE AUTOMOBILE

Justin A. Williams

"If you ever plan to motor west ..."

Since the English Puritans first landed on Plymouth Rock, America has been expanding westward. Debate exists concerning whether famed *New York Tribune* founder-editor Horace Greeley ever really advised a 19th century coming-of-age reader, "Go West, young man, and grow up with the country," but nobody doubts how perfectly the aphorism encapsulates the American philosophy of Manifest Destiny (Lightfoot, 2006, p. 275). The concept of "Going West," in fact, has been so seminal in shaping the identity of the United States, that it may be one reason why California has always enjoyed an elevated position in the American mythos.

In some ways, major coastal cities such as San Francisco and Los Angeles were what the nation had been building up to be from the beginning—the apogee of the "Go West" movement. First for settlers by horse/mule/ox cart, then for the Southern Pacific Railroad, Los Angeles was both the "end of the line" and a new beginning in the popular American imagination. After Route 66 connected L. A. more easily to the rest of the country by car and bus, the city became the victor-victim of modern highways and regrettable sprawl. L.A's notoriously poor public transportation system concretized its car

dependence that literally paved the way for post-WWII suburban development. Paul Grushkin (2006) asserts that no major American city is as strongly identified with the automobile as Los Angeles: "Yes, there's the New York City taxicab. There are the Detroit factories and design studios. Indianapolis has the Brickyard. But in L.A., without a car, you wouldn't survive" (p. 73). The city has witnessed tremendous surges in population and growth since the 1880s, including variable influxes of ethnically and racially diverse peoples seeking its favorable climate, but full citizenship in the Land of Dreams is only achieved with a car.

Los Angeles was the only metropolis in America whose major development occurred entirely within the automobile era (Brilliant, 1989, pp. 121–122). It was, therefore, more adaptable to the incorporation of the automobile into its physical and cultural landscape than other previously developed cities such as Chicago, Boston, Philadelphia, and New York. Los Angeles was coming into its own in the 20th century, while older American cities that been firmly established earlier were already more dense and with compact business districts (Bottles, 1987, p. 5). L. A. business, in fact, is not just spread out geographically, it spreads across many sectors. Los Angeles, it is said, has "assembled more cars than any city other than Detroit, made more tires than any city but Akron, made more furniture than Grand Rapids, and stitched more clothes than any city except New York" (Weiser-Alexander & Alexander, 2013).

L.A.'s business reputation, however, is overshadowed by the motion picture, television, and music industries. Good or bad, whatever is culturally happening in L. A. can be easily exported globally via popular movies, hit television shows, radio, and songs. For example, because Los Angeles leads the nation in this cultural production, whenever car enthusiasts—especially California teenagers—create a new car trend, it is not long before the country is aware of it—or copying it.

Starting with hot rods, drag racers, so-called surf cars that could accommodate long boards, and later phenomena such as lowriders and, regrettably, drive-by shootings, every L. A. car culture seemed to require its own dashboard soundtrack. This chapter outlines the importance of L. A. as the seismic epicenter of car-centric popular culture shifts that shook up American automobility in the 1960s and beyond, with special attention paid to how it impacted and is still impacting the relationship that teenagers have with their cars, their coming of age, and their vehicular autonomy.

"Round, round, get around, I get around ..."

To some, the American car was viewed as a solution to the expensive inefficiencies of public transportation, a panacea that could change the spatial organization of the modern city for the better (Bottles, 1987, p. 211). As early the 1920s, one commentator wrote that "If California ever adopts a new State flower, the motor car is the logical blossom for the honor" (Brilliant, 1989, p. 5). In the 1930s, a California city planner joked that Southern Californians might evolve in such a way as to add wheels to their anatomy (Urry, 2005, p. 31). This love of the automobile then spread to other cities, partially from observing Los Angeles, a city described by Brilliant (1989) as "pathologically bent upon advertising itself" (p. 18).

Waksman (2004) notes that Southern California also was the incubator of early electric guitar innovation—such as the legendary improvements by Leo Fender and Les Paul—and suggests the most automobile-oriented region of the country had extra garage space for tinkering on things like musical instruments (pp. 680–681). Either way, both cars and guitars were being pushed to go faster. Grushkin (2006) identifies that similarity between hot rods and rock and roll by citing an interview with proto-garage band guitarist Link Wray:

> "I'd been playing it real loud through these small 6-watt Sears and Roebuck amplifiers, and the kids were hollering and screaming for it. But, in the studio, the sound was too clean, too country. So I started experimenting, and I punched holes in the speakers with a pencil, trying to re-create that dirty, fuzzy sound I was getting onstage. And, on the third take, there is was, just like *magic*." Wray had just hot-rodded his equipment. (p. 9)

Hot rods—loud, but street legal cars with modified engines for increased speed—became a craze starting in the 1930s, thanks in part to the broad streets and seemingly endless boulevards of Southern California's flat terrain. Per Grushkin (2006), the "first-era highways leading out of Burbank and central L. A. to dry lakes like Muroc and El Mirage" were perfect "for people to open up the throttle, drag with other cars, and establish performance standards" (Grushkin, 2006, p. 8). By 1957, there were 130 drag strips in 40 US states, with 100,000 rot rods and 2,500,000 spectators (Wollen, & Kerr, 2002, p. 19). Hit songs about hot rods developed concurrently such as the rockabilly tune, "Hot Rod Race" by Arkie Shibley and his Mountain Dew

Boys (1950), that, not surprisingly, started in the San Pedro neighborhood of Los Angeles:

> Now me, and my wife, and brother Joe
> Took off in my Ford from San Pedro
> We hadn't much gas and the tires were low
> But the doggone Ford could really go

An "answer song" to "Hot Rod Race" that told the same story from another perspective, "Hot Rod Lincoln" (1955) by Charlie Ryan, has enjoyed enduring popularity over the years, including a 1971 Top Ten version by Commander Cody and His Lost Planet Airman. "Hot Rod Lincoln" also specifies San Pedro, California, and nearby "Grapevine Hill" as the location for the action.

Songs about racing around Southern California were moneymakers. One of first releases by the Beach Boys after they were signed to Capitol Records was "409" (1962), a tribute to the powerful, cast-iron 409 cubic inch Chevrolet V-8 engine. As David Howard (2004) tells the story:

> Like any good Southern California boys, [Gary] Usher and [Brian] Wilson loved cars, especially hot rods. Usher drove a 348 Chevy but dreamed of a hot rod 409. That inspired the two to write "409," which became the first in a long line of hit car songs for the Beach Boys and in turn kickstarted the hot rod music craze. After Wilson decided he wanted the sound of a real car for the demo of "409," the two got an idea around 2 a.m. that night to record Usher's 348 in the middle of Wilson's slumbering Hawthorne street. Stringing together a line of extension cords, they placed the tape recorder beside the car's hood and repeatedly gunned the engine, rumbling the entire block awake. (2004, p. 53)

In addition to "409" (1962) and "Little Deuce Coupe" (1963), the Beach Boys had other early car-based hits such as their first number one record, "I Get Around" (1964).

Along with Wilson and Usher, Terry Melcher, son of actress Doris Day, worked with Bruce Johnston in the early 1960s under the name "Bruce and Terry," and performed California car songs like "Custom Machine" (1964) written by Brian Wilson. Melcher also produced a group called The Rip Chords' who sang a number of hot rod-related tunes, including "Hey Little Cobra" (1964). Johnston would later join the Beach Boys as a permanent member.

The California duo "Jan and Dean" were other leaders in the surf rock sub-genre. Jan Berry and Dean Torrence were high school friends from West

Los Angeles, and buddies with Brian Wilson who gave them "Surf City" to record. What this means is that groups like The Rip Chords, Jan and Dean, and The Beach Boys—a small set of still-teenage, white, upper-middle class suburban music makers—were not just projecting one faddish aspect of the Southern California lifestyle to the American culture at large, the popularity of these songs was then re-fed to Southern Californians recursively through the media. These same images "(real or imagined) of Los Angeles/Hollywood … then are assimilated back into the city's fund of cultural assets where they become available as inputs to new rounds of production" (Scott, 1997, p. 325).

A self-affirming, highly fantasized simulacra of the Southern California lifestyle was not just on the radio. In 1964, at the same time that surf rock was number one on the record charts, on the big screen, Annette Funicello and Frankie Avalon were starring in so-called "beach movies" such as *Muscle Beach Party* (1964) (with music by Link Wray and the debut of Motown's Little Stevie Wonder). To complete the onslaught, network television was replete with Hollywood-produced, Southern California-based features such as *77 Sunset Strip* (1958–1964 on ABC) and *Route 66* (1960–1964 on CBS) further solidifying the mythologies between West Coast cool, cars, and the open road. Grushkin (2006) explains:

> *Route 66* was filmed on location all over the United States, along the course of the famous (pre-Interstate) Highway 66, 'America's Main street' (and author John Steinbeck's 'Mother Road'), stretching from Chicago westward to Southern California. The premise was simple but highly ambitious then and even now. Actors Martin Milner and George Maharis took off in their Corvette to discover America, in search of adventure and enlightenment. There were no other co-stars, just the changing locales and the exotic, conflicted personalities they encountered. (p. 74)

If *Route 66* played off Kerouac's *On the Road* beat generation mystique as it told "traveling angel" stories on its way to California, *77 Sunset Strip* re-created its own. By the late 1950s, that once-glamorous, celebrity-filled portion of West Hollywood's Sunset Boulevard known as "the Strip" had fallen to the rise of Las Vegas. As a result, it had to be reimagined for the hit television show starring Edd 'Cookie' Byrnes, "an Elvis-like co-star who played a parking-lot jockey who was also a part-time sleuth" (Davis, 2007, p. 203). Despite the obvious truth to the L. A. locals, on television, "the Strip was portrayed as a dazzling nocturnal crossroads for a handsome Corvette-and-surfboard set" (Davis, 2007, p. 203). As a result of the show, the Sunset Strip experienced a rebound. Once more, a fiction that played up the region's myths, California-styled convertible luxury cars and aspirational characters triggered actual, real-world capital

investment, proving again that "place, culture, and economy are highly symbi-otic with one another" (Scott, 1997, p. 325).

It is seemingly impossible to separate car culture from commerce because with every new innovation in car culture came profitable commercial devel-opments such as race tracks, drive-ins, and fast food. The repetition of this symbiosis over the years has given Southern California music/car nostalgia production an audio/visual image that is as distinct, identifiable—and often as romanticized—as Motown. Shumway (1999) posits that *American Graffiti* (1973), produced by Francis Ford Coppola but written and directed by George Lucas, was Lucas's cinematic depiction of radio-listening teenagers cruising around Modesto, California, in a classic case of classic cars, radio, and music combined to evoke false memories of an idealized past that never was (Lucas et al., 1973, p. 39).

Furthermore, Shumway (1999) describes the commodification of nostal-gia that also has manufactured rejiggered memories of the Middle Ages or the Renaissance to the masses as a profit-driven effort that "involves the revival by the culture industry of certain fashions and styles of a particular past" (p. 39). For Shumway (1999), *American Graffiti* was so effective because "music is the most important ingredient in the production of the affect of nostalgia or the recollection of such affective experience in the viewer" (p. 40). Per Rickels (2001) *American Graffiti*, projected a deep concern (even obsession) with the body, adolescence, and excess (pp. 3–6), but at the sacrifice of real "memory, history, and time" (Grainge, 2000, p. 29). This is achieving by "seeing" the music in a movie in the same way that "hearing an old song on the radio invites us to remember our own past, movies use the same technique to evoke the fiction of a common past" (Shumway, 1999, p. 40). Not surprisingly, then, the first page of the shooting script for *American Graffiti* begins with "Rock Around the Clock" by Bill Haley and His Comets coming on the car radio:

RADIO

On a dark screen an immense amber light appears and an electric humming begins. The eerie light glows brighter and illuminates a single huge number—11. We hear static and a large vertical band of red floats mysteriously across the screen. Pulling back slowly, we watch the glowing band traverse back and forth over the amber light and past more numbers appearing—70 … 90 … 110 … 130. And we begin to hear voices—strange songs, fading conversations and snatches of music drifting with static.

Pulling back further, we realize it is a car radio filling the screen and radio stations we're hearing, until the indicator stops. There's a pause … and suddenly we are hit by

a blasting-out-of-the-past, Rocking and Rolling, turn-up-the-volume, pounding intro
to a Vintage 1962 Golden Weekend Radio Show—back when things were simpler
and the music was better.

And now a wolf howl shatters through time as the Wolfman Jack hits the airwaves,
his gravel voice and growling while the music pumps and grinds ...

WOLFMAN

"Awwrigght, baay-haay-baay! I got a oldie for ya—gonna knock ya right on de
flowa—baay-haay-hee-baay!"

The Wolfman howls like a soulful banshee as "Rock Around the Clock" blasts forth.
(Lucas and Huyck, 1973, p. 1)

And so begins the movie viewer/listener's hot-rod ride through a South-
ern California past they never experienced, a warm night of drag racing, pop-
ular music on the car radio, and teenagers facing their adulthood. The car
is central because "the automobile satisfies not our practical needs but the
need to declare ourselves socially and individually" (Marsh & Collett, 1986,
p. 5), but the entire movie is framed around car radio because the music of
the era "was and is widely shared, but not necessarily because the audience
literally remembers the songs" (Shumway, 1999, p. 40). The climactic drag
race in *American Graffiti* is a defining moment because the hot rod "became a
metaphor for the sexual prowess of the American male and the race a means
to prove it" (Witzel & Bash, 1997, p. 72). Later inheritors of the "playlist"
soundtrack, films such as the more recent *Baby Driver* (2017), use a simi-
lar logic of the car radio while updating the playback technology (iPod) to
allow the driver a greater level of autonomy and control over her/his musical
choices. Regarding the iPod-listening young and talented getaway driver (in
Atlanta rather than L.A.), the film's 70s soundtrack may invoke nostalgia
in some viewers, but largely serves as vehicle to accompany the car-centric
action scenes and supplement the narrative development.

American Graffiti impacted the 1970s by reconstituting pre-Beatles nos-
talgia and depicting the simple boredom/joys of "cruising" for another gen-
eration of American teenagers. In the process, the movie visually updated
the mythologies and iconographies surrounding coming of age on the fron-
tier, young guns itching for action, and the midnight riders in steel horses of
the automotive era. Most of those images were ethnocentric to the music,
industry, and art of white Southern Californians, but by the 1970s, there

was also a strong appetite for the re-imagining of Hispanic myths of the Old West as well.

"All my friends know the Low Rider ..."

To the extent that Viesca (2004) is correct in claiming more than 70 percent of the sizable Latino population of Los Angeles is of Mexican origin, one might have expected a more positive image for Mexican-Americans would have seeped into the culture industry (p. 720). Instead, most Hollywood-produced depictions of Mexican-Americans in the first half of the 20th century were negative if not outright racist. In early movie cereals, radio, and later on television, however, there was the relatively positive and later completely heroic "Cisco Kid," an evolving creation of short story writer O. Henry that was "a more refined *Californio*, dashing, a kind of Robin Hood type" (Treviño, 2005, para. 5). The Cisco Kid was one of the few exceptions to the "greasy, violent, drunken bandito" Mexican trope, but his sidekick, "'Gordito,' or 'Pancho' in some films, was a weak, bumbling fool" (para. 5). In its musical tribute to "The Cisco Kid" (1972), the Los Angeles funk-fusion band War went to number two on the Billboard Top 40 chart with a song that celebrated Cisco's legend from a proud Southern California Chicano perspective.

In their song "Low Rider" (1975), the band War was also responsible for the national popularization of the L.A.-based Hispanic "lowrider" car culture. Speaking in generalities, as the hot rod was to white Angelinos, the lowrider was to Hispanic kids. Lowrider refers to both the style of car and the person who drives it, but the usage is split between being denoted as single word and a two word phrase. For the sake of clarity, this chapter will use the single word form, lowrider, for both car and driver even though War's Top Ten hit, "Low Rider" used two.

For the uninitiated, a lowrider is a car with a suspension modified such that the chassis is so close to the street that it barely clears the car's wheels (Jackson, n.d., para. 1). Researchers agree that the lowrider had its origins in the late 1930s with the so-called "Pachucos," second- and third-generation Mexican-Americans in Los Angeles who would wear zoot suits and flashy accessories (Lipsitz, 1987, p. 172). In this way, rooted in a desire to stand out against the white hegemonic culture of Los Angeles, the lowrider car can be viewed as the vehicular extension of an outrageous Pachuco outfit (Orona-Cordova, 1983, p. 104).

If hot rods were used cars jacked upward by white teens to go faster as a way to get noticed, it would seem, Chicano teens dropped used cars downward and went slower. After California outlawed this car design in 1957 for safety reasons, enterprising fans of the lowrider circumvented the ordinance by using hydraulic pumps to raise and lower the car as needed to pass state inspection and/or avoid getting a ticket (Jackson, n.d., para. 1). In early cases, the hydraulic systems came from decommissioned B-52 bombers from WWII. (Bell, 2001, p. 15). Along with the car's ability to "hop up and down" to get noticed, lowriders traditionally feature a barrio art aesthetic inside and out (Calvo, 2011, p. 145).

Thusly, lowrider cars were dominantly, "though not exclusively, built and driven by Mexican Americans in the southwest U.S" (Chappell, 2010, p. 27). The lowrider slow cruising style may derive from a separate strain of Mexican culture, the *paseo*, the tradition of young men and women walking slowly around the village square to make sure that they were noticed (Marsh & Collett, 1986, pp. 107–108). A reference to lowriders cruising Sunset Boulevard may be the subtext of a line in War's "The Cisco Kid": "They rode the Sunset, horse was made of steel."

If a custom paint job on a car that can bounce down the street fails to get attention, however, a typical lowrider car will have an elaborate stereo system with speakers in the front doors and in back, even more if it is a lowrider "boom" car (Morris, 2014, p. 336). Somewhere along the way, lowrider car culture became associated with drug dealing, but War's drummer, Harold Ray Brown, an African American who grew up in a lowrider L. A. neighborhood, demurs: "As a rule, most lowriders are not big druggies because we all had regular jobs as machinists, body and fender, and mechanics. We didn't have any extra money for drugs. We put the money into our cars" (Brown, 2007, para. 6).

Brown is not the only current or former lowrider to challenge the cliché association with gangs, drugs, and criminality, some have even gone so far as to form "self-described 'positive clubs' with strict membership requirements and disciplinary structures, or taking on various charity projects" (Chappell, 2010, p. 33). In a tribute to the more positive aspects of lowrider culture, Parra, Malgesini, & Ballesteros (2014), relate the story of a recent intergenerational "barrio party" in the old, densely Hispanic Lincoln Heights neighborhood of Los Angeles that was to feature hit music of the *American Graffiti* era, by description almost an old-fashioned "sock hop" (p. 276). While younger people lined up to enter the oldies show with their parents, a line of vintage

lowrider cars made their way up the street toward the packed venue with their radios all tuned to a local oldies radio station. After the dancing, the lowriders once more paraded away, but for those two hours of the concert, "these youth were off the street, which in Lincoln Heights, is two hours away from the danger of being a victim in a drive-by shooting" (Parra et al., 2014, p. 276).

"Throw my Westside, ain't no thang. We was raised off drive-bys, brought up to bang …"

Adrienne Brown (2012) in her provocative essay on hip hop automobility reminds us:

> … [T]he hip hop car often remains rooted in the social, deriving its value from its proximity to the commons of creativity and performance. One could trace these dynamics from Fresh Prince's "Summertime," through the hydraulics of 90s West Coast rap, the communal car of Outkast's Elevators,' up to Kanye West's own incitement to "Drive Slow," and Drake's recent eulogy for his "Acura days." (Brown, p. 272)

Moreover, Brown (2012) insists that the car was a factor in the development of rap, going so far to say cars were a force that "has been slighted as a critical midwife" in rap's birth, but Brown posits that rap's arrival in the South Bronx was due partly because of 1960s "white flight" to the suburbs in Post-WWII urbanity:

> If hip hop's rise is concomitant with the black post-industrial city, this history is deeply interwoven with cross-currents involving highway policies such as the Cross Bronx Expressway, automobile technologies, and the layout of the street itself … hip hop's origins depend as much on the postwar spatial stories of cars and highways as they do on sound technologies. (p. 265)

Brown is suggesting that after the highways went up to allow for suburban commuters to drive in and out of the city, rap grew in the vacuum of the economic struggle that was left behind starting in the mid-1970s. This is one reason why the deejays who invented rap were *not* the kind that were on the radio, they were the ones jocking jams in the parks, in local clubs, and house parties in the South Bronx. As Brown posits (2012. p. 265), the automobile was central to the birth of hip-hop music and culture, but it had a different role than as vehicle for audio playback or as an object centrally associated with the subculture. DJ Hollywood, considered the first rapper, is

so crucial that copies of his raps—preferably original cassettes—are treated like first edition books by famous authors (Ford, 2004, p. 43). Not until "Rapper's Delight" (1979) by The Sugarhill Gang become a smash hit did hip-hop even have any real presence on the radio. There were no rap record labels or vinyl albums to speak of so. The O.G.'s of hip-hop made some money selling tapes of their mixes (George, 2004, p. 51), music often first heard on bootleg cassettes played in New York City taxis. If young people were driving around listening to rap in a car, it was most likely on a cassette; that is, if they had access to a car at all.

Because African American households in urban communities are roughly five times more likely to be carless than white households (Raphael & Stoll, 2001, p. 192), nice cars were more of a symbol of success, freedom, and power than a daily reality. Still, having a car would be one thing, however, having an in-car radio would be another. As Rivkin & Ryan (2004) joke, in New York, it was not uncommon to see a large sign that said "No Radio" in the windshield of a parked car to designate "don't bother breaking into the body of this car; the radio has already been either stolen or else removed by the owner" (p. x). Another extreme that urban car owners used to go to was the installation "fake stereo boxes full of wires that looked like the stereo had already been stolen" (Sullivan, 2009, para. 14).

After hip-hop sought its fortunes by going west along with the rest of American history, hip-hop culture was forever changed when it intersected with routine California car culture. Owning a car was no longer an urban New York aspiration, it was an L. A. necessity—along with the rest of the Hollywood bling. As Kubrin (2005) says, West Coast hip-hop's focus on conspicuous consumption as a means to establish a successful self-image and gain respect required "nice cars, expensive jewelry, and the latest clothing fashions that not only reflect one's style, but also demonstrate a willingness to possess things that may require defending" (p. 364). Indeed, to many L. A. youths, guns were the way to both get and keep the signs of respect that one wants, and at least one study found that guns were a "central part of status and identity formation within the 'street-oriented' world of the inner-city" (Wilkinson & Fagan, 1996, p. 78). To hear rappers talk about it, packing a gun was as common as carrying a wallet or keys. When asked, "Whatcha gonna do when you get outta jail?" in the song "High Speed" (1999), California-raised 2Pac Shakur answers matter-of-factly: "I'm gonna buy me a gun" (Kubrin, 2005, p. 372).

After L. A. hip-hop performers started regaling their listeners with stories about taking and/or keeping the spoils of the street wars, "gangsta rap" became

the term of art for songs about gang life, guns, anti-authoritarianism, drugs, and pimping, a unique West Coast sub-genre of hip-hop popularized in 1987–88 by Niggaz With Attitude (N.W.A.), Ice Cube, Lil' Kim, and others (Baldwin, 2004, p. 160; Forman, 2004, p. 204; also see, Lusane, 2004, p. 410). In this way, gangsta rap was similar in form and function to the battle epopees of the ancient Greeks, and the result was "a deluge of recordings that celebrated and glorified the street warrior scenarios of the California cities of South Central Los Angeles" (Forman, 2004, p. 214). Although primarily endemic to L.A., gangsta rap soon resonated in other major American cities due to the consistent themes of "alienation, unemployment, police harassment, social, and economic isolation" (Kubrin, 2005, p. 366). The whole "East Coast vs. West Coast" thing was real because "the rise of the L. A. rap sound and the massive impact of the gangster themes after 1987 resulted in the first real incursion on New York's dominance" (Forman, 2004, p. 213).

But if the bi-coastal rap rivalries were real, so was the L. A. gang violence—and the line between "gangsta rapper" and actual gangster could be pretty thin. For instance, gangsta rapper Snoop Dogg, featured performer on Dr. Dre's milestone album *The Chronic* (1992), was tried but acquitted of first- and second-degree murder charges in the shooting death of a rival gang member (Daunt, 1996, para. 1). However, many other well-known rappers of the same era who found themselves in street fights are still serving life sentences for murder (Giacomazzo, 2015, para. 3).

In L.A., the drive-by shooting was the guerrilla tactic of choice by turf terrorists in the ongoing, inter-gang, internecine street battles that arose simultaneously with the popularity of gangsta rap. Ice T's galvanizing title song for the movie *Colors* (1988), for example, was the centerpiece of the Dennis Hopper-directed gang war movie that was playing inside theaters (Forman, 2004, p. 214) while the actual gang wars were being fought outside from moving cars in South Central Los Angeles, Compton, and Long Beach (Perkins, 1996, p. 18). The bloodshed that was taking place in L. A. took such a toll that the New England Journal of Medicine did a study of all the drive-by shootings of 1991 and found:

> A total of 677 adolescents and children were shot at, among whom 429 (63 percent) had gunshot wounds and 36 (5.3 percent) died from their injuries. Three hundred three of those with gunshot wounds (71 percent) were gang members. Arms and legs were the areas of the body most commonly injured. Handguns were the most frequently used type of firearm. All the homicide victims were African American or Hispanic, and 97 percent were boys. (Hutson, Anglin & Pratts, 1994, para. 3)

Just as hit tunes about hot rods both warned of the dangers of drag rac-
ing and inspired young people to risk it at the same time, gangsta rap seem-
ingly had weaponized slow moving cars and turned the guns back on itself. If
gangsta rap was originally hip-hop keeping it real about L. A. "ghetto life" by
relating "incidents and experiences with a more specific sense of place and,
subsequently, greater significance to local youths" (Forman 2004, p. 213), lyr-
ics such as "Exist to put the jack down, ready and willin', One more Compton
drive-by killin'" by MC Eiht either seemed to be inspiring more drive-bys or
least playing down the tragedy of the murders.

The national popularity of surf rock radio by the Beach Boys was fed back
to Southern Californians making beach life more "beachy," but the cultural
feedback loop of gangsta rap was making L. A. more "gangsta," which only
encouraged dangerous new rounds of production (Scott, 1997, p. 325). As
popular as the music was, prominent African-American celebrities and artists
began to speak out against gangsta rap for celebrating thugs, guns, and the
demeaning of women (Fuetsch and Puig, 1993, para. 5). Suddenly, gangsta rap
was caught in a crossfire of its own creation.

By 1993, outrage was building on every block. The perceived connection
between gangsta rappers and drive-by killings—even when it was tenuous or
circumstantial—prompted angry condemnation from politicians, black com-
munity leaders, and parents, and compelled black-owned or programmed media
to allocate "much less airplay and print coverage to rap than is warranted by
its impressive record sales" (Dyson, 2004, p. 63). In response to continued
killings, just before Halloween in 1993, L. A. R & B/hip-hop station V-103.9
(KACE-FM) publicly pulled the plug "on music that glorifies drugs and vio-
lence, denigrates women or is sexually explicit" (Fuetsch & Puig, 1993, para. 4).

It may be difficult for the contemporary reader to imagine it, but this period
of drive-by shootings in Los Angeles was so terrifying that civic leaders advo-
cated gangsta rap's suffocation by banning it from the radio. V-103.9's ironically
named program director, Mark Gunn, recognized his station's part in the cul-
tural feedback loop: "It's been shown that if you feed somebody enough nega-
tivity, that's what they're going to buy into" (Fuetsch and Puig, 1993, para. 6).
Whether it is heavy metal, songs with suggestive lyrics, or anti-religious themes,
however, as a long-term strategy, audio asphyxiation of music rarely works.

While one may argue that the in-car radio was less important to gangsta
rap subcultures than cassette decks, radio play increased as artists like Dr. Dre
had gone mainstream with major labels now purchasing the independent rap
record labels.[1] Music videos of "Nuthin but a 'G' Thang," and "Let me Ride"

from Dre's The Chronic (1992) depicted the everyday lifestyle of Compton's black youth, complete with modified classic cars such as Dre's 1964 Chevy Impala. The same type of critics who echoed previous cries that the Sunset Strip looked a lot better on television, or that lowriders were a lot less menacing in person than in the media, were now saying that hip-hop was giving South Central a bad rap, that L. A. was not nearly as dangerous or bleak as it sounded in gangsta rap (Forman, 2004, p. 217).

They were probably right technically, but gangsta rap's "narrative depictions of spaces and places" was completely consistent with how young people of color *felt* about their lives, their futures, and their neighborhoods (Forman, 2004, p. 217). Once more, just like small town cruising was never really as sweet as the way it was romanticized in *American Graffiti*, or how the Beach Boys were never actually surfers, we always picture our world differently when we see with our ears (Shumway, 1999, p. 40).

Note

1. Editors' Note: For an interesting read on Los Angeles; KDAY radio's direct role in the promotion of hip hop and rap, and as one of the few stations, if only West Coast station, to thoroughly cater to young Latino and African-American youth on the radio in the eighties, by reaching out to them on the street, recruiting local party djs to become radio deejays, read *The Big Paycheck: The History of Business of Hip Hop* (2010, New American Library, New York) by Dan Charnas. In 1983, the station hired Program Director Greg Mack from KJMQ in Houston, Texas to run KDAY, and the station soon made history with his insight on what needed to happen in the market. He moved into his mother's house in South Central, and began to realize the station wasn't playing anything popular to the younger demographics (p. 216): "The sounds coming from car stereos and boom boxes in his neighborhood, the records selling in shops and swap meets, were the sounds of rap which Mack began adding to the station's playlist." Moreover, he "discovered the epicenter of the rap scene wasn't a place, but a moving target, the roving series of parties ..." From 1983 to 1986, Mack flipped the station from a weathered R&B format to a youth charged playlist in which rap records consisted of 60% of its rotation, and that also increasingly included homegrown artists from So. Cal. and East L. A. (Charnas, 2010, p. 217). For more on KDAY's influence, see *The LA Weekly*'s "KDAY, the Gangsta Rap Oldies Station, Breaks New Ground by Playing Music From The Bad Old Days," by Ben Westoff, (August 2, 2012),(http://www.laweekly.com/music/kday-the-gangsta-rap-oldies-station-breaks-new-ground-by-playing-music-from-the-bad-old-days-2175862). And, KDAY is Closing: A Eulogy to Best Station in L. A, *L.A.Weekly*, by Jeff Weiss (April 11, 2013), http://www.laweekly.com/music/kday-is-closing-a-eulogy-to-the-best-station-in-la-4168841.

 From its earliest forms, gangsta rap was not an essential part of an in-car radio culture, it was centered in a handmade-mixtape-in-the-car-cassette-deck culture. It was bigger than radio, although some stations KDAY stand out as West Coast forerunners for airplay.

References

Baldwin, D. (2004). Black empires, white desires: The spatial politics of identity in the age of hip-hop. In M. Forman & M. A. Neal (Eds.), *That's the joint! The hip-hop studies reader* (pp. 358–369). New York, NY: Routledge.

Bell, J. (2001). *Carchitecture: When the car and the city collide*. London, UK: Birkhäuser.

Bottles, S. L. (1987). *Los Angeles and the automobile: The making of the modern city*. Los Angeles, CA: University of California Press.

Brilliant, A. (1989). *The great car craze: How southern california collided with the automobile in the 1920s*. Santa Barbara, CA: Woodbridge Press.

Brown, A. (2012). Drive slow: Rehearing hip hop automotivity. *Journal of Popular Music Studies, 24*(3), 265–275.

Brown, H. (2007). *Songfacts*. Low Rider by War. [Album: Why can't we be friends?]. Retrieved from http://www.songfacts.com/detail.php?id=2694

Calvo, W. (2011). *Lowriders: Cruising the color line* (Unpublished dissertation) Tempe, AZ: Arizona State University. Retrieved from https://repository.asu.edu/attachments/56913/content/CalvoQuiros_asu_0010E_10900.pdf

Chappell, B. (2010). Custom contestations: Lowriders and urban space. *City and Society, 22*(1), 22–47.

Daunt, T. (1996, February 21). Rapper Snoop Doggy Dogg is acquitted of murder. *Los Angeles Times*. Retrieved from http://articles.latimes.com/1996-02-21/news/mn-38322_1_rapper-snoop-doggy-dogg

Davis, M. (2007). Riot nights on sunset strip. *Labour/Le Travail, 59*, 199–213. Retrieved from http://www.lltjournal.ca/index.php/llt/article/viewFile/5499/6363

Dyson, M. E., & Hurt, B. (2004). "Cover your eyes as I describe a scene so violent": Violence, machismo, sexism, and homophobia. In M. Forman & M. A. Neal (Eds.), *That's the joint! The hip-hop studies reader* (pp. 358–369). New York, NY: Routledge.

Forman, M. (2004) "Represent": Race, space, and place in rap music. In M. Forman, & M. A. Neal (Eds.), *That's the joint! The hip-hop studies reader* (pp. 201–222). New York, NY: Routledge.

Ford, R. (2004). B-beats bombarding Bronx: Mobile DJ starts something with oldie R&B disks and Jive talking N. Y. DJs rapping away in black discos. In M. Forman, & M. A. Neal (Eds.), *That's the joint! The hip-hop studies reader* (pp. 41–44). New York, NY: Routledge.

Fuetsch, M., & Puig, C. (1993, October 30). KACE-FM bars songs it says are violent. *Los Angeles Times*. Retrieved from http://articles.latimes.com/1993-10-30/entertainment/ca-51225_1_radio-station

George, N. (2004). Hip-Hop's founding fathers speak the truth. In M. Forman, & M. A. Neal (Eds.), *That's the joint! The hip-hop studies reader* (pp. 45–56). New York, NY: Routledge.

Giacomazzo, B. (2015, February 4). Murder was the case: 10 rappers charged with murder. *HipHopWired*. Retrieved from http://hiphopwired.com/442985/murder-case-10-rappers-charged-murder/

Grainge, P. (2000). Nostalgia and style in retro America: Moods, modes, and media recycling. *Journal of American Culture, 23*(1), 27–34. ISSN 1542–734X

Grushkin, P. (2006). *Rockin' down the highway: The cars and people that made rock roll*. St. Paul, MN: Voyageur Press.

Howard, D. N. (2004). *Sonic alchemy: Visionary music producers and their maverick recordings*. Milwaukee, WI: Hal Leonard.

Hutson, H. R., Anglin, D., & Pratts, M. J. (1994, February 3). Adolescents and children injured or killed in drive-by shootings in Los Angeles. *The New England Journal of Medicine, 330*, 324–327. Retrieved from http://www.nejm.org/doi/full/10.1056/NEJM199402033300506

Jackson, A. (n.d.). Hydraulic laws for a lowrider vehicle. *Legal Beagle*. Retrieved from http://legalbeagle.com/7268051-hydraulic-laws-lowrider-vehicle.html

Kubrin, C. E. (2005). Gangstas, thugs, and hustlas: Identity and the code of the street in rap music. *Social Problems, 52*(3), 360–378. Retrieved from https://www.researchgate.net/profile/Charis_Kubrin/publication 251418343_Gangstas_Thugs_and_Hustlas_Identity_and_the_Code_of_the_Street_in_Rap_Music/links/00b4952bd08ccd3349000000/Gangstas-Thugs-and-Hustlas-Identity-and-the-Code-of-the-Street-in-Rap-Music.pdf

Lightfoot, K. G. (2006). Mission, gold, furs, and manifest destiny. In M. Hall, & S. W. Silliman (Eds.), *Historical archeology* (pp. 272–292). Malden, MA: Blackwell Publishing.

Lipsitz, G. (1987). Cruising around the historical bloc: Postmodernism and popular music in East Los Angeles. *Cultural Critique, 5*, 157–177.

Lucas, G., Katz, G., & Huyck, W. (1973). *American Graffiti*. [Screenplay]. Retrieved from http://www.lc.ncu.edu.tw/learneng/script/AmericanGraffiti.pdf

Lusane, C. (2004). Rap, race and politics. In M. Forman, & M. A. Neal (Eds.), *That's the joint! The hip-hop studies reader* (pp. 351–362). New York, NY: Routledge. Retrieved from http://www.iupui.edu/~womrel/Rel%20101_Religion&Culture/Lusane_RapRacePolitics.pdf

Marsh, P. E., & Collett, P. (1986). *Driving Passion: The Psychology of the Car*. London: Jonathan Cape.

Morris, D. Z. (2014). Cars with the boom: Identity and territory in American postwar automobile sound. *Technology and Culture, 55*(2), 326–353. Retrieved from http://historyandsound.org/wp-content/uploads/2018/01/david-z-morris-cars-with-the-boom.pdf

Orona-Cordova, R. (1983). Zoot suit and the Pachuco phenomenon: An interview with Luis Valdez, Revista Chicano-Riquena. Retrieved from https://mseffie.com/assignments/zoot_suit/Valdez%20Interview.pdf

Parra, F., Malgesini, F., & Ballesteros, A. C. V. (2014). Lowrider music: Those oldies but goodies and their transformative communicative power. *La Palabra: Lenguaje, medios y sociedades digitales*. Retrieved from https://www.researchgate.net/profile/Horacio_Almanza_Alcalde/publication/274700529_Organizaciones_de_desarrollo_y_maiz_nativo_La_vulnerabilidad_de_un_patrimonio_cultural_y_natural_de_la_Sierra_Tarahumara/links/5525ca1b0cf295bf160eb24a.pdf#page=274

Perkins, W. E. (1996). *Droppin' science: Critical essays on rap music and hip hop culture*. Philadelphia, PA: Temple University Press.

Raphael, S., & Stoll, M. (2001). Can boosting minority car-ownership rates narrow interracial employment gaps? *UC Berkeley Working Papers* (online). Retrieved from https://cloudfront.escholarship.org/dist/prd/content/qt4k4519pw/qt4k4519pw.pdf

Rickels, L. A. (2001). *The case of California*. Minneapolis, MN: University of Minnesota Press.

Rivkin, J., & Ryan, M. (2004). *Literary theory: An anthology*. Maiden, MA: Blackwell Publishing.

Scott, A. J. (1997). The cultural economy of cities. *International Journal of Urban and Regional Research*, 21(2), 323–339. Retrieved from https://s3.amazonaws.com/academia.edu. documents/35479527/Scott.pdf?AWSAccessKeyId=AKIAIWOWYYGZ2Y53UL3A&Expires=1520064347&Signature=0PfqcVdIiXTZISP%2Fxl7KJkt9tLk%3D&response-content-disposition=inline%3B%20filename%3DThe_Cultural_Economy_of_Cities.pdf

Shumway, D. R. (1999). Rock 'n' roll sound tracks and the production of nostalgia. *Cinema Journal*, 38(2), 36–51. Retrieved from https://pdfs.semanticscholar.org10a6/2a75e6a6898e6d4f90713f36f1e4e440ee7a.pdf

Sullivan, L. (2009, March 24). Car stereo theft: A dying crime. NPR.org. Retrieved from https://www.npr.org/templates/story/story.php?storyId=101998015

Treviño, J. S. (2005). Latino portrayals in film and television. *Jump Cut*, 30, 14–16. Retrieved from https://www.ejumpcut.org/archive/onlinessays/JC30folder/LatinosFilmTvTrevino.html

Urry, J. (2005). The 'system'of automobility. In M. Featherstone, N. Thrift, & J. Urry (Eds.), *Automobilities* (pp. 25–40). London: Sage Publications.

Viesca, V. H. (2004). The battle of Los Angeles: The cultural politics of Chicana/o music in the greater Eastside. *American Quarterly*. Retrieved from https://learcenter.org/pdf/ViescaAQ.pdf

Waksman, S. (2004). California noise: Tinkering with hardcore and heavy metal in Southern California. *Social Studies of Science*, 34(5), 675–702.

Weiser-Alexander, K., & Alexander, D. (2013, March 14). Los Angeles history. *Legends of America*. Retrieved from http://www.legendsofamerica.com/ca-losangeles.html

Wilkinson, D. L., & Fagan, J. (1996). The role of firearms in violence "Scripts": The dynamics of gun events among adolescent males. *Law and Contemporary Problems*, 59(1), 55–89.

Witzel, M. K., & Bash, K. (1997). *Cruisin': Car culture in America*. Osceola, WI: Motorbooks International.

Wollen, P., & Kerr, J. (Eds.). (2002). *Autopia: Cars and culture*. London, UK: Reaktion Books.

· X ·

CAR TREK

Morning Drive Radio … in Space!

Ian Punnett

Figure X.1. Starman, an Elon Musk interplanetary thought-piece, drifting toward Mars in a cherry red Tesla Roadster with "Don't Panic!" on his dashboard. (Courtesy of SpaceX)

When Elon Musk launched a cherry red Tesla Roadster in the direction of Mars during the shakedown cruise of the SpaceX Falcon Heavy rocket on February 6, 2018, the real payload was interplanetary pop culture. Firstly, the image of the convertible Tesla sports car being driven by a spacesuit-wearing mannequin dubbed "Starman"—a reference to a David Bowie character/song

on the *Ziggy Stardust and the Spiders from Mars* (1972) album—appears almost rotoscoped from the opening title sequence of the classic adolescent-oriented animated film, *Heavy Metal* (1980). Secondly, the visible reminder on the Tesla's dashboard—"Don't Panic!"—nodded to Douglas Adams' *A Hitchhiker's Guide to the Galaxy*. Thirdly, the Roadster's car radio was programmed to play only one song. Bowie's "Space Oddity" (1972) is on a continuous loop as Starman navigates his infinite commute around the galaxy (Loria, 2018, para. 4).

According to Musk, the floating thought piece was designed to inspire creative thinking, but some scientists found the prospect of a dummy-driven Tesla Roadster trapped in an elliptical Mars orbit for millions of years to be "horrifying" (Mosher, 2018, para. 3–4). Bowie predicted unsettled reactions to Starman in the eponymous track: "There's a Starman waiting in the sky/He'd like to come and meet us/But he thinks he'd blow our minds" (https://www. youtube.com/watch?v=sI66hcu9fIs). Interpreted loosely, the songs of *Ziggy Stardust* constitute "something of a modern-day secular morality play, the rise of a media-age Christ figure and his destruction by his acolytes" (Buckley, 2012, p. 129). In the *Ziggy* story arc, Starman is an encouraging God-like figure who has been "keeping tabs on just how human life has been progressing" (Perone, 2007 p. 29). In effect, then, Musk is closing the inspirational loop on the *Ziggy Stardust* narrative: as a Bowie fan, Musk was inspired by the song "Starman" about a benevolent space presence sending inspiring messages to Earth teenagers through their radios, so Musk jettisoned his own Bowie-listening Starman into space from a Falcon Heavy to inspire future generations to think creatively as well.

But as novel as Musk's efforts might be, it is not the first time that Bowie's "Space Oddity" had rattled the windows of a real-life space vehicle on the way to work. On June 26, 1996, Mission Control's Capsule Communicator (CAPCOM) Kay Hire woke up the crew of NASA's Space Shuttle Columbia mission with Bowie playing through the tiny capsule sound system (Fries, 2015, p. 31). On October 10, 2002, "Space Oddity" was heard again, this time for the Space Shuttle Atlantis crew as part of a medley of music that included the "(Theme from) *The Monkees*," Elton John's "Rocket Man," and "I Am Woman" by Helen Reddy with a special dedication to Mission Specialist Sandra Magnus "from her family" (Fries, 2015, p. 51).

Mission Control letting its crew-cut hair hang down a little by horsing around as morning drive deejays for an orbiting carpool of astronauts is a practice that started on December 15, 1965, for the Gemini 6 mission of

Command Pilot Wally Schirra and Pilot Thomas Stafford (Cellania, 2017, para. 1). Like typical morning radio pranksters, the first musical wakeup call was a song parody, in this case a comedy rewrite of "Hello Dolly" performed by Jack Jones (Cellania, 2017, para. 1). Jones, a two-time Grammy Award-winner probably best known for his title theme to *The Love Boat*, surprised the crew with a bespoke serenade that began: "Hello, Wally/This is Jack Jones, Wally/It's so nice to know you're up where you belong" (Blitz, 2017, para. 1).

At first glance, CAPCOM might seem an unlikely source of morning drive radio but that assertion rests not in Mission Control's form, but in its function (Hamer, 2017, para. 3). Per Geller (2012), the primary role of all morning drive radio programming is to provide reassuring communications: "When people wake up to face the day, they need to know basic information: What happened while I was asleep? Did anything explode?" (p. 16). The secondary function of morning radio—one might even claim its central function—it to entertain listeners while it is informing (Geller, 2012, p. 325; Libben, 2006, p. 7). For many music stations, "morning drive is the last bastion of personality" (Geller, 2012, p. 13).

In the context of Mission Control, as "deejay gigs go, this is a short one, but the audience is captive and the venue is very exclusive" (Matson, 2010, para. 1). Perhaps the best way to picture the space capsule's exotic work/ live environment is to imagine a Winnebago full of business colleagues on a cross-country sales mission in a camper that serves as both office and sleeping quarters except, "You can't get out until the trip is over, pot and beer are forbidden, and [...] somebody who isn't even traveling with you gets to pick what's on the tape deck" (Knopper. 2000, para. 3). Condensed living spaces are always problematic, but living in a weightless space environment for any length of time presents some unique human stressors that include "danger, confinement, periods of extreme activity alternating with monotony, separation from family and friends, and interpersonal tensions between crew members" (Kanas, 1987, p. 703). Astronauts are like any car-pooling commuters, and all people transitioning from sleep to work in a short period of time and space require the right attitude adjustment coming out of the speakers to promote congeniality (Geller, 2012, p. 14).

To be clear, the original *scientific* purpose of the wakeup call was merely to keep the astronauts on a rigid schedule in the presence of a constant sun, yet "playing music to wake astronauts from their space slumber quickly became tradition" (Blitz, 2017, para. 2). Adding dedications to the songs was

a natural, collegial next step. Nobody knows who first suggested going for laughs with "Hello, Wally," but NASA Chief Historian Bill Barry suggests "it may have simply been an inside joke" (Cellania, 2017, para. 2). Thus, almost from the beginning, CAPCOM's radio schtick was viewed as a necessary stress reliever—one part "reveille" to maintain a disciplined crew, one part runaway gag to uphold morale.

That may account for why—judging by the Gemini Program log—Jack Jones reprised his wakeup bit for Gemini 7 a few days later (Fries, 2015, p. 4). The parody song this time was the mega-hit "Wives and Lovers" (1963). There is no known record of why NASA asked Jones to record an altered version of this intimate mid-tempo ballad for the Gemini 7 crew, and even less is known about the lyrical content of the parody. It should be noted, however, that the chorus of "Wives and Lovers"—"Time to get ready for love/Yes, it's time to get ready for love"—might have been referencing Gemini 7's first attempt at a rendezvous with Gemini 6 in orbit.

But the Mission Control "morning zoo" was just getting started. Over its record-breaking 14-day mission, Gemini 7 would receive more than 20 pop tunes, symphonies, and dedications to ease what was, at that time, the farthest road trip in history. Because NASA lacked the satellite capability up to that point, when Gemini 7 was outside of Houston's signal range, CAPCOM employed other facilities in the Spacecraft Tracking and Data (Acquisition) Network to radio up the hits. For example, on December 9, 1965, "I Saw Mommy Kissing Santa Claus" had to be broadcast from NASA's Madagascar station for Jim Lovell, a special request from "his daughter, Barbara, age 12, who hopes the song will bring her daddy home for Christmas, a little early" (Fries, 2015, p. 4). Sometimes the astronauts were treated to an "afternoon drive" radio show, too. "I'll Be Home for Christmas" and "Going Back to Houston" were played for the Gemini 7 crew shortly before retrofired rockets sent the capsule earthbound on December 18, 1965.

Just as the technology of the Gemini missions had been building up for a future moon landing, the space deejays from Houston were honing their act for the Apollo Program (Fries, 2015, p. 4). From where the astronauts sit, "[The wakeup call] becomes the soundtrack of the surreality of what's going on up there" (Blitz, 2017, para. 8). By Apollo 10, the first of the Apollo missions, the rotating ersatz radio hosts of Mission Control were showing major market personality, but sadly, only middle-of-the-road musical tastes.

To that point, the unnamed CAPCOM of May 21, 1969, kicked off the first Apollo 10 workday with "On a Clear Day" by Robert Goulet, the

archetypical lounge singer known to inflame Elvis Presley to the point where the King would fire his.44 magnum at any television set that dared display him (Stromberg, 1990, p. 17). In the following days, Tony Bennett's "The Best Is Yet To Come," and "It's Nice to Go Trav'ling" by Frank Sinatra kept the Easy Listening thrills coming, but on May 25, 1969, according to the Apollo Program log, the crew itself either sang or played back to Houston, Sinatra's "Come Fly With Me" for a giggle (Fries, 2015, p. 6). Mission Control may have gotten the last laugh, however. That same morning, CAPCOM piped in Disney's "Zip-A-Dee-Doo-Dah" to the Apollo 10 capsule because there is nothing quite like an ear worm in space.

The history-making Apollo 11 crew of Commander Neil Armstrong, Commander Module Pilot Michael Collins, and Lunar Module Pilot Edwin "Buzz" Aldrin were noteworthy not just for the mission that put a man on the moon, but in their preference for news/talk radio transmissions to get them going; "wakeup calls were sent on Apollo 11, but they were not music, they consisted of news and sports" (Fries, 2015, p. 4). Despite Mission Control's best efforts to fight off the insomnia, hostility, and anxiety that can develop in cramped isolation, one of the Apollo 11 astronauts "experienced depression and marital problems after his return to Earth that necessitated psychiatric intervention" (Kanas, 1987, p. 705). In space, human bodies may be weight-less, but there is no such thing as zero-emotional gravity. This is why CAP-COM Kay Hire stressed the need for collegial levity, because humor "tends to stand out as a human element in an otherwise complex technical enterprise" (NASA, 2005, par. 5).

The song choices found on the Apollo Program log are punctuated by the occasional pop tune, but for most of the Apollo radio transmissions up to 1972, the music selections ran "the gamut of the four B's of music: Bach, Bee-thoven, Brahms, and Brass, Tijuana Brass that is" (Fries, 2015, p. 4). Indeed, Herb Albert and the Tijuana Brass has been well—if not disproportionately—represented in space by Mission Control, particularly Herb Alpert's "The Lonely Bull" which was broadcast to Gemini 9 and to the Skylab Missions on seven separate occasions.

Not every astronaut shared in NASA's apparent obsession with Herb Alpert, however. In his autobiography, Al Worden, Command Module Pilot for Apollo 15 (the mission that tooled around the moon in the Lunar Roving Vehicle), said The Tijuana Brass' vibe was all wrong for space:

> On my last morning alone around the moon, I woke to a breezy blast of mariachi
> trumpets. With the serene lunar surface gliding by below me, Herb Alpert's "Tijuana

Taxi" was about the strangest music mission control could pipe up over the radio. But still, it got me awake. (Worden & French, 2011, para. 2)

With its obnoxious, old fashioned car horn-honk beginning, its peppy marimba countermelody, and typical gimmicky Herb Albert trumpet lead, it would be hard to design a musical experience less compatible to the transcendent "sense of awe and humility at the beauty of the Earth and the vastness of the cosmos" that astronauts experience in space (Kanas, 1993, p. 705).

The need for music suitable to the mood of waking up in space may explain why Richard Strauss' "Also Sprach Zarathustra" (1896)—also known as the theme to *2001: A Space Odyssey* (1968)—has been one of the most played NASA tracks over the years. John Williams' "Theme from *Star Wars*" (1977) and "The Imperial March" (1977) also have gotten a lot of airplay (Higgins, 2012, para. 21). In light of the Beatles' enduring popularity on Earth, solar-centered tracks from the Fab Four such as "Hard Day's Night" (1964), "Good Day Sunshine" (1966), and "Here Comes the Sun" (1969) might be expected to receive multiple CAPCOM spins, while other lesser known artists such as torch singer Julie London, who charted on NASA's Top 10 frequently, might come as a surprise (Fries, 2015, pp. 8–11).

In fact, judging by the tally, it looks like some of the CAPCOM boys were crushing on London, a dirty blonde perhaps best remembered for being nurse Dixie McCall on NBC's *Emergency!* In one stretch, from August 22, 1973, to January 26, 1974, somebody at CAPCOM played "Cry Me a River" (1955), "Misty" (1960), "The Party's Over" (1960) or "In the Wee Small Hours of the Morning" (1960), all by Julie London, *seven* times. Usually, it was just London by her sultry self, but on August 25, 1973, CAPCOM's Bob Crippen played a medley of London favorites mixed with, you guessed it, Herb Alpert and the Tijuana Brass (Fries, 2015, pp. 8–11).

John Phillip Sousa may not get a lot of radio airplay on—well, anywhere—but military marches and college fight songs echo to eternity on space radio. For instance, on the first Space Shuttle mission to take off and land at night, the 1983 crew of the Challenger roused to a medley of "fight songs of Georgia Tech, Illinois, Penn State, and North Carolina, along with 'Semper Fidelis' in honor of astronaut Brian O'Connor, a Marine Corps officer" (NASA, 2005, para. 7). Sadly, a few years later, Challenger exploded shortly after lift-off killing her crew of seven. Two years would pass before NASA resumed the Space Shuttle program on Discovery. By then, the Mission Control Morning Show was a little rusty and required some professional assistance.

So, on September 30, 1988, for the first wakeup call of the first mission after the Challenger disaster, actor/comedian Robin Williams surprised the crew by announcing, "Goooooood morning, *Discovery!*" a la his morning deejay character from the 1987 hit movie Good Morning, Vietnam (1987) (Fries, 2015, p. 18). In keeping with the spirit of Jack Jones' prototypical contribution to NASA history, Mike Cahill, a popular Houston morning personality, also contributed original lyrics to a Discovery-themed parody version of the Green Acres song (https://www.youtube.com/watch?v=S7WJtQYU8i4); "It was as dopey and stupid and corny as I had hoped it would be," Cahill confessed (Fries, 2015, p. 19).

In service to their unique demographic—adult astronauts 18–49—Mission Control has continued to be the masterminds behind prerecorded skits indistinguishable from any zany terrestrial morning show. On the second day of the inaugural Space Shuttle mission, April 13, 1981, for example, Mission Commander John Young and Pilot Robert Chippen were spoofed with the help of Houston AM disc jockeys "Hudson and Harrigan" (Fries, 2015, p. 12). Later in 1981, puppeteer Jim Henson was asked by Mission Control to create a special audio series of The Muppet Show's "Pigs in Space" skit that would be customized to lampoon the second flight of the Space Shuttle Columbia—the first time a manned craft had gone back to space—in a radio bit that aired in two parts between November 13–14, 1981 (Henson, 2012, para 1).

Space Shuttle Columbia also experienced a catastrophic ending in 2003. Before it broke apart in reentry, wakeup calls had been less frequent and/or toned down because the Columbia crew had been trading off working/sleeping in alternating 12-hour shifts (Fries, 2015, p. 52). But on January 19, 2003, about midway through the mission, "Amazing Grace" by the bagpipers of the Black Watch and 51 Band of Highland Brigade had been played for "Mission Specialist Laurel Clark, who was on her first spaceflight. The same song had been played on bagpipes at her wedding, and was later played at her funeral" (Higgins, 2012, para. 20). After another two-year period of investigation and reassessment, CAPCOM's Shannon Lucid psyched up the first "return to flight" Space Shuttle Discovery astronauts with Dire Straits' "Walk of Life," "in honor of the duo's upcoming repair work on the International Space Station" (NASA, 2005, para. 1). Mission Specialist Steve Robinson, a guitarist in the all-astronaut rock band Max Q (an aerodynamics term for "maximum dynamic pressure"), said, "What a great day to go do a walk of life!" (Fries, 2015, p. 53).

This is consistent with the best practices of the CAPCOM radio service. If the men and women of Mission Control cannot be in the same physical space as the astronauts, they strive to be in the same **head space** (Knopper, 2000, para. 3). Hosting a morning show for a captive audience who can only get one radio station is all about broadcasting optimism and positivity. Dirges, or particularly noisy tracks from heavy metal or gangsta rap artists would be considered "bad form," still "the DJs at mission control have been known to exhibit a mixchievous streak" (Knopper, 2005, para. 4). For example, most of the times U2 got airplay in a Space Shuttle it was "Beautiful Day" (2000) or "City of Blinding Lights" (2005), but when Canadian astronaut Chris Hadfield had control of the CAPCOM turntable on October, 18, 2000, he could not resist jamming the loud, updated mix of "Theme to Mission: Impossible" with his colleagues 250 miles straight up (Fries, 2015, p. 45).

Of course, as almost a rite of passage, any self-respecting broadcast morning radio show that pushes the comedy envelope too far might eventually end up getting in trouble with the U.S. government (Levine, 2000, pp. 303–6). In early 1989, it was no different for the men and women of Mission Control who, along with the Discovery crew, were chided by NASA brass for being too wacky and told to "cut the comedy, at least for public viewing" (Fries, 2015, p. 19):

> Discovery's astronauts generally toed the line on a new NASA edict [...] but they showed some flashes of fun in space, mainly in the battle of wakeup songs. When Discovery made the first post-Challenger flight last September, the five astronauts awoke to Beach Boys music parodies and clowned for television cameras in bright Hawaiian shirts. And even though the December flight of Atlantis was a classified military mission, word leaked of special wakeup music not particularly flattering to the Pentagon. (Fries, 2015, p. 19)

As a direct result of NASA's "cool it when the cameras or microphones were on" edict, the CAPCOM program log for the next five Space Shuttle missions reads more like the homeroom announcements of a reform school—mostly de rigueur messages and military marches. According to Hadfield, NASA's decision to "cut the comedy" created an unnecessary risk to every space mission because laughter is vital for keeping morale up and tensions between crew members down; per stories of the first Soviet cosmonauts, there have been "fist fights on space stations and astronauts have refused to speak to one another for days on end" (Zolfagharifard & Prigg, 2014, paras. 34–35). At least NASA allowed some exceptions to the "no levity" rule, such as on

March 16, 1989, when CAPCOM David Low played recorded congratulatory comments from actor William Shatner to the Discovery crew just before another medley of college fight songs. After the Drexel University marching band concluded the musical selections, Low went off script a bit and joked to the Discovery crew, "Beam me up, Scotty!" (although he might have meant it) (Higgins, 2012, para. 12).

Not long after Discovery astronaut Bob Springer noted, "NASA has no official sense of humor anymore," NASA brass has lightened up more or less permanently and CAPCOM found its groove again by November 25, 1991, when it collaborated with actor Patrick Stewart who was right in the middle of his own successful space mission as Captain Jean-Luc Picard on Star Trek: The Next Generation (Fries, 2015, pp. 23–4). Using the television series theme as a backdrop, Stewart celebrated the return of Atlantis by performing his signature monolog with a comic twist:

> Space: the final frontier. This is the voyage of the Space Shuttle Atlantis. Its ten-day mission: To explore new methods of remote sensing and observation of the planet Earth; to seek out new data on radiation in space, and a new understanding of the effects of microgravity on the human body; to boldly go where two hundred and fifty-five men and women have gone before! (Higgins, 2012, para. 6)

Personalizing the broadcast further, Stewart added, "Hello, Fred, Tom, Story, Jim, Tom, and especially Mario. This is Patrick Stewart—choosing not to outrank you as Captain Jean-Luc Picard—saying that we are confident of a productive and successful mission. Make it so" (Fries, 2015, p. 19).

Until the Space Shuttle program ended in 2011, the space agency largely observed a new "prime directive" with regard to Mission Control by refraining from further interference on CAPCOM's morning antics (Fries, 2015, p. 20). As evidenced by the program logs, CAPCOM radio settled in to a noticeably typical morning show rotation of request tunes, song parodies, current events, skits, and even old-fashioned radio contests, such as the live wakeup performance by Big Head Todd and the Monsters on March 8, 2011, that the band won a fan-driven online poll (Hicks, 2011, para. 1).

There were two very public Earth births while the dads were orbiting the planet, one announcement coming with a dedication of the Contemporary Christian song "Butterfly Kisses" (1997) to Mission Specialist Randy Bresnik from his wife, Rebecca (Malik, 2009, para. 2). Other praise artists to make the hit parade in the heavens include "Give Me Your Eyes" (2008) by Brandon Heath, and the original version of "God of Wonders" by Mark Byrd and Steve

Hindalong (2000). Mike Good, Mission Specialist for Space Shuttle Atlantis on its final servicing of the Hubble Space Telescope in 2009, and an observant Catholic, said, "They say there's no atheists in foxholes, but there's probably no atheists in rockets" (Shellnutt, 2009, para. 1).

Soon, just as often—if not more—hard rock/heavy metal mornings also got into CAPCOM"s rotation with Metallica's "Enter Sandman" (1991) which was played in back to back shuttle missions, "Free Bird" (1973) by Lynyrd Skynyrd twice, "Home Sweet Home" (1991) by Motley Crue, and by Blue Oyster Cult's "Godzilla" (1978), which was really quite an event on March 12, 2008:

> The wakeup call for the morning was a combination of fight scene music from the Japanese movie "Godzilla Versus Space Godzilla" and the Blue Oyster Cult song "Godzilla." The songs were played for Japanese Space Agency astronaut Takao Doi. "Good morning, Endeavor. Doi san, ohayo gozaimasu," said Alvin Drew, shuttle spacecraft communicator, to Japanese astronaut Takao Doi from Mission Control here in Houston. "Take on today like a monster." "We are very happy to hear Godzilla," Doi responded. "We are ready to go and we'll have a great time today docking with the space station." (Fries, 2015, p. 61)

Getting a big name artist to bang out a couple of songs live is typical A. M. drive fare on U.S. radio stations (Stubblebine, 2017, para. 1), but on November 13, 2005, "The sounds of cheering crowds and former Beatle Sir Paul McCartney greeted the two astronauts aboard the International Space Station (ISS) early Sunday morning during a live concert broadcast to the orbital laboratory" (Malik, 2005, para. 1). McCartney was performing at Arrowhead Pond in Anaheim, California, when the hook-up went through. Before ending with "Good Day Sunshine" (1966), Sir Paul referenced a new song of his when he told ISS Expedition 12 NASA Commander Bill McArthur, "We'd like to wake you up to a little bit of 'English Tea' (2005)." Then McCartney asked Russian flight engineer Valery Tokarev, who was sipping from a breakfast drink bag during the performance, "What's that you got there in your tea, Valery, a little vodka?" (Malik, 2005, para. 6). "It's a little early today," Tokarev joked back. McCartney's mini-concert wakeup call stands as the longest CAPCOM morning drive show, clocking in at nearly 14 minutes (Fries, 2015, p. 56).

While Sir Paul performing live in space was epic, the award for "most historic pop music recording in space" might have to go to frequent space shuttle crew member, Commander Chris Hadfield of Expedition 35. During the 144 days he spent leading the 35th long-duration mission to the International

Space Station, Hadfield performed and recorded a slightly modified cover version of Bowie's Space Oddity (1969) which was then transmitted down to Canada where Bowie's former bandmate, Emm Gryner, added a piano accompaniment while others edited and produced the final product (G.F., 2013, para. 3). As of this writing, Hadfield's Space Oddity (2013) has been viewed about 40 million times on YouTube (more than double Bowie's original version), but with "the countless re-posts and rebroadcasts on television the actual number was far higher—hundreds of millions of people, from Seoul to Lahore to Lagos, watched, listened and thus took part in what has become a defining moment in my life," Hadfield said (Zolfagharifard & Prigg, 2014, paras. 8).

Because ISS is an extended, multi-national floating condo complex of demarcated jurisdictions and not a vehicle, the visiting mission crews use individual standard alarm clocks to manage sleep; Hadfield's recording has not been used as part of a CAPCOM wakeup call (yet). In 2013, the success of Hadfield's Space Oddity, however, did spark an international—and even interplanetary—debate about the protection of intellectual property away from Earth (G.F., 2013, para. 1). Concerns over song rights prompted Bowie's attorneys to force Hadfield's video of Space Oddity—also recorded in the ISS—off of YouTube for a while, but before his death, Bowie himself granted a special provision because he felt Hadfield's cover was "possibly the most poignant version of the song ever created" (Zolfagharifard & Prigg, 2014, paras. 10).

Unfortunately, like the Borg hovering silently just outside of the Earth's atmosphere, unresolved legal issues still loom. As of 2013, hive-minded lawyers appeared to have agreed that, until it is tested in court, earthly copyright laws are extended into space by virtue of the separate national space agencies that sponsored the missions, or the governmental provenance of that portion of the ISS where those astronauts work and live (G.F., 2013, para. 4). In other words, if a NASA astronaut recorded Space Oddity on "American soil" in the space station, and beamed it down to Canada, standard North American intellectual property treaties would apply.

But all that is changing like a rocket. If some whistle-happy astronaut were to perform and then broadcast copyrighted material while going to "the Moon, an asteroid, or Mars on a privately funded spacecraft, the situation would become knottier still, because the United Nations Outer Space Treaty of 1967 applies to countries, not companies or private individuals" (G.F., 2013, para. 4). The lawyers might want to work on that sooner as opposed to later, because right now, Starman has the top down on his SpaceX-delivered

cherry-red Tesla Roadster as he drifts toward Mars, and that tune playing loudly on the dashboard radio is pretty darn catchy.

References

Blitz, M. (2017, April 27). How the NASA wake-up call went from an inside joke to a beloved tradition. *Popular Mechanics*. Retrieved from https://www.popularmechanics.com/space/a26229/nasa-wake-up-call/

Buckley, D. (2012). *Strange fascination: David Bowie: The definitive story*. Virgin Books: London

Burton, J. R., & Hayes, W. E. (1966). Gemini Rendezvous. Journal *of Spacecraft and Rockets*, 3(1), 145–147.

Cellania, M. (2017, April 29). The tradition of the NASA wake-up call. Neatorama. Retrieved fromhttp://www.neatorama.com/2017/04/29/The-Tradition-of-the-NASA-Wake-Up-Call/.

Fries, C. (2015, March 13). Chronology of Wakeup Calls. NASA.gov. Retrieved from https://www.history.nasa.gov/wakeup%20calls.pdf

Geller, V. (2012). Creating powerful radio: Getting, keeping, and growing audiences. Burlington, MA: Elsevier.

G. F. (2013, May 23). How does copyright work in space? The Economist. Retrieved from https://www.economist.com/blogs/economist-explains/2013/05/economist-explains-12

Hamer, A. (2017, May 2). Rise and Shine! Astronauts Get Wake-Up Music in Space. *Curiosity. com*. Retrieved from: https://curiosity.com/topics/rise-and-shine-astronauts-get-wake-up-music-in-space-curiosity/

Henson, J. (2012, November 2). 11/2/1981 "Recording pigs in space for NASA space shuttle." *Henson*. Retrieved from https://www.henson.com/jimsredbook/2012/11/1121981/

Hicks, L. W. (2011, March 8). Big Head Todd makes history for NASA. Denver Business Journal. Retrieved from https://www.bizjournals.com/denver/blog/cultural_attache/2011/03/big-head-todd-makes-history-for-nasa.html

Higgins, C. (2012, July 11). 11 Eye-opening NASA wakeup calls. Mental Floss. Retrieved from http://mentalfloss.com/article/31156/11-eye-opening-nasa-wakeup-calls

Kanas, N. (1987). Psychological and interpersonal issues in space. *American Journal of Psychiatry*, 144(6), 703–709.

Knopper, S. (2000, January). What do astronauts listen to in outer space? Details tracks the sounds of the final frontier. Details Magazine. Retrieved from http://knopps.com/old/DetailsRockSpacemen.html.

Levine, J. (2000). A history and analysis of the Federal Communications Commission's Response to Radio Broadcast Hoaxes. *Federal Communications Law Journal, 52*(2).

Libben, A. (2006, May 11). K105—Fort wayne's leading radio Station: Analysis Paper. (Unpublished thesis). PDF: <k105 analysis paper2.pdf

Loria, K. (2018, February 5). Elon Musk plans to launch a Tesla roadster to Mars orbit this week—and a new photo shows a dummy driver called "Starman." BusinessInsider. com. Retrieved from: https://www.businessinsider.com/photo-tesla-roadster-driver-starman-spacex-launch-falcon-heavy-rocket-2018-2

Malik, T. (2005, November 13). ISS Astronauts awake to Paul McCartney soundtrack. Space. com. Retrieved from https://www.space.com/1776-iss-astronauts-awake-paul-mccartney-soundtrack.html

Malik, T. (2009, November 22). It's a girl! Astronaut's daughter born while he's in space. Space. com. Retrieved from https://www.space.com/7576-its-girl-astronauts-daughter-born-hes-space.html.

Matson, J. (2010, August 27). A little flight music: NASA contest for wake-up songs prompts astronauts to recall tuneful highlights. Scientific American. Retrieved from https://www. scientificamerican.com/article/nasa-shuttle-music/

Mosher, D. (2018, March 14). Elon Musk explains why he launched a car toward Mars—and the reasons are much bigger than his ego. Business Insider. Retrieved from http://www. businessinsider.com/why-elon-musk-launched-tesla-mars-falcon-heavy-2018-3.

NASA. (2005, August 10). Music to Wake Up By. NASA.gov. Retrieved from https://www. nasa.gov/vision/space/features/wakeup_calls.html

Perone, J. (2007). The words and music of David Bowie. Praeger: Westport, CT.

Shellnut, K. (2011, July 8). Exploring the heavens, Christian astronauts reflect on their Creator. Chron. Retrieved from https://blog.chron.com/believeitornot/2011/07/exploring-the-heavens-christian-astronauts-reflect-on-their-creator/.

Stromberg, P. (1990) Elvis alive? The ideology of American consumerism. Journal of Popular Culture, 24 (3), 11–19.

Stubblebine, A. (2017, October 16). Halsey sings sultry cover of Charlie Puth's "attention," talks safe space for fans: Watch. Billboard. Retrieved from https://www.billboard.com/articles/columns/pop/7998837/halsey-charlie-puth-cover-elvis-duran.

Worden, A., & French, F. (2011, July). Circling the moon: In a new autobiography, an Apollo 15 pilot tells what it was like to fly solo. Air & Space Smithsonian. Retrieved from https://www.airspacemag.com/space/circling-the-moon-161409706/

Zolfagharifard, E., & Prigg, M. (2014, November 4). Space Oddity is back! Hit recording from International Space Station by Chris Hadfield re-released as David Bowie gives blessing to hit song. Daily Mail. Retrieved from http://www.dailymail.co.uk/sciencetech/article-2820849/Space-Oddity-Hit-recording-International-Space-Station-Chris-Hadfield-released-David-Bowie-gives-blessing-hit-song.html.

· 1 1 ·

BLACKOUT

Testing the Airwaves and Hanging on by a Thread

Phylis Johnson and Jonathan Pluskota

If previous chapters have proven anything about radio, it has been that the medium's popularity is durable even in the face of economic downturns such as the Great Depression, cultural shifts such as war, the civil rights movement, and the empowerment of women, plus technological developments such as television, satellite, and other entertainment platforms. Radio's longevity comes from its versatility. Commercial, terrestrial radio is inexpensive to produce and cheap to consume, so it excels at being anywhere for anybody. Radio offers something that merely putting on recorded music could never provide: a live person on the other end of the microphone, sometimes when the listener needs somebody else the most.

This chapter is about radio's place when a riot, civil unrest, or a natural disaster causes a "blackout" to an entire community. Because most radio stations maintain a backup generator, transmitter, and antenna, historically radio has been there in a crisis in ways that print, television, or the Internet cannot, at a time when another human voice can be the most comforting sound in the dark. That lonely stretch of road is no longer so empty when a car radio brings aboard a companion for the ride … unless that radio is telling us to look out for an alien invasion.

The Alien Attack on Grover's Mill, New Jersey

With regard to the CBS Radio broadcast of Orson Welles' *War of the Worlds* on October 30, 1938, popular myth maintains that swarms of panicked American radio listeners jammed local police departments with terrified calls and crowded the streets to catch a glimpse of a "real space battle" (Chilton, 2016, para. 2). The next day, newspapers all cross the country printed breathless accounts that claimed "thousands of people across the country had taken the fictional news accounts to be true and fled their homes in terror—grabbing firearms, putting on gas masks, and clogging the highways in a mad rush to escape the imaginary Martians" who had invaded unincorporated Grover's Mill, New Jersey (A.B. Schwartz, 2015, p. 7).

On the contrary, objective research shows there was no mass hysteria. As proof, Chilton (2016) points out that in 1954, "Ben Gross, radio editor for the *New York Daily News*, wrote in his memoir that New York's streets were 'nearly deserted'" (para. 2).

> Whereas the news offered a different spin to the night's activities, most soon agreed that this was more a media event than a reason to run for the hills: By the next morning, the panic broadcast was front-page news from coast to coast, with reports of traffic accidents, near riots, hordes of panicked people in the streets, all because of a radio play. … (Pooley & Socolow, 2013, para. 12)

So, while there might have been a few moments of concern, the public threat of ubiquitous automotive gridlock supposedly caused by *Mercury Theatre on the Air's* production of *War of the Worlds* was, in the counter-narrative, "a phony story puffed up by newspapers eager to discredit their competitors in radio" (Schwartz, 2016, para. 9). In effect, in an attempt to make radio news appear unreliable, newspapers inadvertently made radio seem twice as impactful as it really was on "a normal fall Sunday evening throughout North America" (Pooley & Socolow, 2013, para. 12).

Using previously overlooked evidence, however, B. Schwartz (2015) challenges the contemporary scholarly view that *War of the Worlds* was a complete non-event. According to 1400 telegrams and letters recovered from that period, second-hand rumors quickly generated by the radio show about Martians invading New Jersey may have been more potent than the broadcast itself (para. 17). B. Schwartz (2015) believes that those who write-off the reaction to the broadcast as a mere urban legend are missing the point. The *real* story of the infamous radio is not about the people who were *listening* to

the show, it is about those that were only "sort of" listening, or heard about it from somebody else (para. 14).

Indeed, the announcements that the show was a production of *Mercury Theatre on the Air*, the commercial breaks, and the FCC-required station identifications were enough to position the program as a fiction in the minds of most, but less attentive listeners were responsible for a minor, but not insignificant, furor when they started to call neighbors and friends (Schwartz, 2015, para. 14). Welles' novel use of the still-new "live" reporter motif—complete with faux technical difficulties, news bulletins and actualities—had never been done before; "People took all breaking news reported by the radio as fact, and the *War of the Worlds* broadcast was no exception" (Martin, 2013, para. 7). This might have been most irresistible to people who tuned in halfway through the show because of the "echo chamber" the show was creating (B. Schwartz, 2015, para. 14).

Using an all-star cast of voice talents, *War of the Worlds* not only sounded real, but it was perfectly timed. "Poisonous black smoke pouring in from Jersey marshes. Gas masks useless. Urge population to move into open spaces. Automobiles use Routes 7, 23, 24. Avoid congested areas [...]" (Dixon, 2008, para. 63) effectively played off existing pre-Pearl Harbor attack fears that the United States was susceptible to a sneak attack and the world was on the brink of war (Heyer, 2003, para. 2). In fact, some casual listeners might have misinterpreted the "invasion" as an attack from Nazi Germany (Martin, 2013, para. 6), a legitimate and growing threat in 1938.

Like any good story of suspense, for a time in the broadcast's story arc, the window of escape was narrowing. Before the melodramatic twist, it was in this time Welles best toyed with the listeners' imaginations by rooting the fiction in established real-world anxieties such as traffic jams and clogged bridges:

> The bells you hear ringing are to warn the people to evacuate the city as the Martians approach. It is estimated that in the last two hours 3,000,000 people have moved out along the roads to the north. The Hutchinson River Parkway is still kept open for motor traffic. Avoid bridges to Long Island—hopelessly jammed. All communication with Jersey shores closed ten minutes ago. Our army wiped out. This may be the last broadcast ... we will stay here to the end. ... (para. 64–65)

But Schwartz (2015) asserts that despite the exaggerated claims on both sides of the legend, the true reaction to the *War of the Worlds* broadcast more closely parallels the viral response to an Internet or social media hoax of modern day—something most people are just talking about, as opposed to truly falling for (p. 10).

As Schwartz (2016) sums it up, "Welles's broadcast did not create a mass panic, but neither was the hysteria it caused entirely a myth. Instead, it was something decades ahead of its time: history's first viral-media phenomenon (para. 10). To the extent that in-car listening to *War of the Worlds* contributed in any measurable way to the credibility of, or reaction to, the broadcast is understudied, but taken as a whole, radio's most famous unintentional hoax does create an intriguing yardstick to measure the human response to a *bona fide* crisis when all the lights go out, and humanity truly is left powerless.

The Great Northeast Blackout of 1965

Almost 30 years after *The War of the Worlds*, another drama unfolded for those living in the Northeast. Much of the power grid of Consolidated Edison, or ConEd, the largest energy provider for that part of the United States, suffered a cascade of failure. Because the country was still in a cold war with the Soviet Union, the nuclear missile showdown known as the Cuban Missile Crisis was still fresh in the minds of many, and the nation had not fully come to terms with the assassinations of President John F. Kennedy, the Rev. Martin Luther King, and Sen. Robert Kennedy, American paranoia was at a peak (Baron, 1992, para. 4). The technical truth behind the Great Northeast Blackout of November 9, 1965, however, lacked any true intrigue.

For almost a year leading up to the blackout, Con Edison had been reckoning with ongoing power issues in a series of controlled brownouts and (mostly brief) power outages caused by a byzantine energy grid that was overly taxed during periods of high consumption. The summer before, in fact, New Yorkers had experienced power "slowdowns" during which air conditioners wheezed, subways slowed, elevators faltered, and lights flickered, and all typically on the hottest or most humid days of the year (BrownMiller, 1970, para. 4). Also see Rosenthal & Gelb (1965) for a more comprehensive look at the events of the night.

But after 5 p.m. on November 9, 1965, a cold late afternoon in New York, the power-sucking air conditioners were off and nobody was anticipating a massive power shutdown; that is, until about 15 minutes before everything went dark. WABC 77's Dan Ingram was one of the canaries in the coal mine. In the middle of his popular, afternoon drive shift, Ingram's turntable started slowing down live on the air. Fortunately for historians, Ingram's show was being recorded, so the power failure has been archived and transcribed below.

Being rush hour, and with little other recourse, Ingram attempted ad-libbed humor to try to make light of what was becoming a worrisome situation at a peak time for his audience, approximately 5:15 p.m. to 5:30 p.m (WABC Radio, 1965, 00:01:25):

Dan Ingram:	Hold it, hold it hold it, you're going too slow fella.
	(Song continues: "… Everyone's gone to the moon" [music fades])
Ingram:	Does that sound particularly slow to you? That's "Everyone's Gone to the Moon" by Jonathan King. I think in the key of "r," right there. … That's number nine this week. What can I tell you? Twenty-one minutes past 5 o'clock. The equipment here says "SignalCore nineteen-two" (chuckles).
	(Then a commercial set begins with jingles noticeably slower, and the same goes for the commercials. The voices sound slower, deeper, but still resonant enough to be clearly understood.)
Station Jingle:	77 W-A-B-C (sung slower than usual)
Ingram:	The whole thing is running slowly … I don't know what is going on. It's 46 degrees and it is clear.
	(Back to commercials)
Ingram:	(concerned now, repeating himself) Everything sounds like it is running in slow motion. I don't know what is going on.
	(Next song begins slowly, "Up the Lazy River" (1961), a big pop jazz hit by Si Zentner and his Orchestra)
Ingram:	It is too … it's "The Very Lazy River," the Si Zentner taking us up to news time. The light is dimming in the studio. You wouldn't believe what is going on in the studio. The lights are dimming down. The electricity is slowing down. I didn't know that could happen.
	("Up the Lazy River" fades out)
Ingram:	Beautiful. That's Lazy River in the key of "r." I think Con Ed is having power problems or something because everything is running at half speed including me. Hey listen, I have Action 7 News next, and right after another complete edition of Action 7 News, we shall return with a number ten goodie by Herb Alpert and the Tijuana Brass called "Taste of Honey," honey!
	(Action 7 News intro/sounder)
Bill Rice:	It's 5:25, This is Bill Rice with [the] news, 5 minutes sooner from WABC Radio …

As newsman Bill Rice continued, the quality of the signal dissipates and then completely disappeared (WABC Radio, 1965, 00:08:04). After a 15-minute wobble, by 5:30 p.m. the blackout killed the lights throughout 80,000 square miles of the northeastern United States and parts of Canada in one giant "click" (Events, 1965, para. 4). Because the blackout occurred as people

still were getting off work, men, women, and children all over New York were caught in office and residential building elevators. Traffic lights stopped. The street lights went out. Everything in New York froze—almost literally. Being autumn, the temperature soon dropped to 37 degrees (Lescaze & Egan, 1977, para. 37).

> Patients in the middle of surgery, people in subways were trapped in darkness from New York to Canada and most states in between. A plane was getting ready to land when the runway disappeared. 1700 passengers from a powerless subway train were rescued from a bridge in New York. (Baron, 1992, para. 3)

Restaurants in the downtown areas put candles on the tables and in the windows. People decided to stay in the city. The only light was from the moon and the headlights of cars (Wainright, 1965, para. 4). A review of the historical archives paints a picture of people trying to enter the city across the darkened bridges to find friends and family members by the moonlight (Events, 1965).

At that time, most television stations across seven states lost power, too. Some came back on again through their generators, but without electricity, few people in their homes could watch the programming, particularly in the city (Pressman, 2011, para. 3). Daugherty (2015) notes that radio "rose to the occasion" because battery-powered transistor radios and people in their cars could still pick up the news from radio stations that had backup generators; as a result, the Great Northeast Blackout of 1965 was nicknamed "the day of the transistor" and "radio's greatest hour since D-Day" (para. 9). But those cars without radio reception forced people to pull over in order to learn what had happened. It was the height of rush hour in New York when traffic on a good day would almost shut down the metro area for a couple hours until the commuters got home, but on this night, the shutdown was complete. Ironically, while the rest of the country was watching national news bulletins explaining that the Northeast was in a major blackout, those in the middle of the affected areas were "in the dark" as to what was going on. At least, until the radio stations came back on. New York Times Managing Editor George P. Hunt (1965) observed:

> A few minutes later the report came in by transistor radio that the blackout embraced most of the Northeast, and the implications of our predicament dawned on us. Here was an astonishing news story unfolding all around us, and here were we, the New York editorial [staff] trapped in a skyscraper with no lights, jammed phones and stalled elevators. (para. 2)

Thanks to the borrowed presses of *The Newark Evening News*, *The New York Times* was the only city newspaper to go to print the day after with a special 10-page issue about the blackout (Lescaze & Egan, 1977, para. 58 & 64; NYTC, 1965). *Times* columnist Loudon Wainwright, Jr. wrote about the newspaper's predicament in "A View from Here: Dark Night to Remember." Reflecting back on the night, Wainright (1965) noted that it became a unique moment where people came together to discuss what had happened and to help each other out (p. 35). Transistors radios were valuable commodities, especially when one picked up a signal to share news updates and music. When the commuters made it home, many stayed tuned in on car radios in their driveways or transistors listening for more updates from across the Northeast (p. 35).

Power resumed slowly over the next 12 hours. Manhattan experienced a gradual lighting from 3:17 a.m. to 4:44 a.m. (Morse, 1965), but even by the next workday, New Yorkers were still receiving most of their news about the blackout from transistor radios. For *Life* magazine, Pulitzer Prize-winning presidential historian Theodore White (1965) attempted to explain how 30 million people had lost power, but even a man so learned struggled to make clear what went wrong (pp. 46B–51). But White was able to explain what went right:

> Radio, perhaps more than any other agency, spread the spirit. Within 10 minutes, all major stations were on the air with continuous dialogue, soothing, calming, enjoining citizens to stay put and sit it out. Radio reporters interviewed civilians who had taken it upon themselves to stand in mid-Manhattan's streets and untangle traffic snarled by the blackout of traffic signals. (p. 51)

White concluded that the calm spirit of good citizenship started by disc jockeys and news reporters had radiated through the car radios and transistors and taken over the city within an hour. Soon "hundreds—young men, college boys, workingmen—were following the example. Then, again, by curious kindred response came the reports of singing in the street—on Third Avenue the sound of Christmas carols was heard" (p. 51).

In a midrashic comparison of the *War of the Worlds* (1938) radio legend and the well-documented history of the Great Northeast Blackout of 1965, humanity shines. While radio-fueled rumors of an alien invasion in the New York metro caused a flutter of phone activity and a few isolated stories of panic, there was no mass hysteria, no looting, and no physical damage to the planet from Martians or Earthlings. Later in 1965, also a tense time when national security ebbed low, the forced darkness on the East Coast was illumined by the radio-fed lightness in the soul of New York.

South Central Los Angeles, 1992

When four Los Angeles police officers were acquitted in the racially charged Rodney King trial, the "not guilty" verdicts resulted in riotous anger for many residents of the Los Angeles neighborhood known as South Central. The Korean-American and African-American communities were the most impacted. Ultimately, violence and fires led to major, localized power outages. Bill Weiss (2017) notes:

> Unless people were watching TV or listening to their car radios, most of the city was unaware of what was going on, and those driving close to Florence and Normandie had no idea of the war zone they were about to enter or they surely would not have done so. (p. 34)

For those without electricity, it was also a media blackout at a dangerous time. Similar to the Northeast in 1965, residents listened for news updates on battery powered radios or in their cars. Understanding where the danger was spreading was not just curiosity, it was survival. Per Weiss (2017), "I thought of parents picking up their kids from after school programs in the area. Some were just blocks away and most were probably oblivious to the danger they might be driving into" (p. 34).

For the next several days, as curfews kept those living in South Central from going far, radio deejays and news crews on local radio stations such as KJLH-FM, attempted to assuage unsettled listeners who were seeking help and information (Weinstein, 1993, para. 5). The radio station quickly dumped all the commercial breaks. "The phone started lighting up, and my jocks shut down the music," recalled General Manager Karen Slade, "They stayed on the mic— they took the calls. And probably for the next three days, we just became all talk" (Reiman, 2012, paras. 5–6). The news department at KJLH would later win a Peabody Award for suspending its regular program when "most chose to play music rather than to be responsible to what was going on in the community" (Weinstein, 1993, para. 2). Sometimes it was not just the big moments such as having prominent African-Americans as the Rev. Jesse Jackson, Ice-T and Barry White take calls in order "to find nonviolent solutions to the community's frustrations" (Weinstein, 1993, para. 6), often it was the small things such which stores still had batteries or which gas station was open to keep the cars running so that people keep could keep listening. A more comprehensive discussion, beyond car radio, can be found in Johnson (2009), for those wanting to know more about African-American radio's historical community role during crisis events.

Katrina and the Radio Waves

The ability of any radio station to pivot to live coverage of a news event or an important social need is never more true than in times of impending trouble. For example, the Amber Alert System that intends to notify the public of the recent abduction of a child has proven to be useful in getting radio-listening motorists to become ubiquitous lookouts for suspect vehicles (Miller, Griffin, Clinkinbeard, & Thomas, 2009, p. 115). Tyler Lee (2017) reports that alarm systems triggered from within ambulances are being tested that have the ability to interrupt a car radio, and redirect the driver out of the way of an emergency vehicle even if they were listening to loud music (para. 1). In-car radio listening also has the prophylactic function of warning people to get off the road, seek shelter, or evacuate a city if severe weather is coming. In the case of Hurricane Katrina, however, despite multiple emergency bulletins to leave New Orleans, for whatever reason, some residents ran out of time to escape the area before storm hit (Davis & French, 2008, p. 250).

A few anecdotal new reports indicate that while New Orleans's radio station WWL "switched to a rolling news format" and "despite the urgent calls to evacuate, many didn't believe Katrina had the power to destroy" (Vaidyanathan, 2005, para. 1, 5). After WWL's Garland Robinette told listeners "Time to run, gang, time to run," on the Sunday afternoon before the storm hit, many more residents tried, but it was too late. "One man named Marco phoned to say people were running out of petrol—he'd burned three-quarters of a tank by moving at two miles an hour, and had seen a woman in tears after she had been forced to abandon her car" (Vaidyanathan, August 28, 2005. para. 3).

To the extent that it is true that "how communities function during normal times tell us much about how they will function during a crisis," (Laska, 2015, p. 17), the year-round presence of radio personalities of WWL in the life of the Crescent City was a predictor of their high-level of performance in the aftermath of Katrina as well. WWL's reputation as the radio station of record when a natural disaster such as a storm—or a manmade threat such as a police strike—creates fear in the community was established after Hurricane Betsy in 1965: "Two major types of assets combine to achieve this feat: the human interpersonal communications skills of the ordinary/extraordinary talk show hosts and the station's pre-crisis plans for crisis response logistics" (Laska, 2015, p. 17).

After New Orleans was flooded by the darkness brought by Hurricane Katrina, the station earned the right to refer to itself as "the beacon" in the storm: "we are the lighthouse, stay with us" (Vaidyanathan, 2005, para. 4).

For those stranded in attics of sea-soaked houses or stuck on roofs that risked becoming rafts, WWL became one of the few ways that city officials could deliver vital information to residents. By listening to the 50,000 watt AM radio signal of WWL, New Orleans residents were able to stay in touch with those who were still in peril and those they left behind because "radio can broadcast details available to a very large listening audience concurrently" (Laska, 2015, p. 17).

Which is why the United States should be concerned that many foreign auto manufacturers are cutting AM/FM radios completely from certain car models (Symes, 2014, para. 1). In an attempt to save a few pennies and/or focus on shifting personal technologies, for example, several new BMW models will no longer offer the AM radio band at all (Symes, 2014, para. 2). One explanation for German-made cars without AM radios is that the AM band already has been completely eliminated throughout much of Europe (Voelcker, 2017, para. 6). But given that U.S. winter storms, hurricanes, and coastal flooding events appear to be developing faster, with greater intensity, and with increased frequency (Sneed, 2017, para. 6), it would be wise to be mindful that commercial, broadcast radio—particular AM stations—have kept communities calmer, better connected, and comforted by a human touch, through car radios long after the lights went out.

References

Baron, M. (1992). The great black out of 1965. *Westislandweather.com*. Retrieved from http://www.westislandweather.com/thegreatblackout1965.htm.

BrownMiller, S. (1970, April 12). Con Ed's Charles Luce. *New York Times*, Archives. Retrieved from https://www.nytimes.com/1970/04/12/archives/con-eds-charles-luce-all-power-sometimes-to-the-people-all-power.html

Chilton, M. (2016, May 6). The War of the Worlds panic was a myth. Culture, Radio. *The Telegraph*. Retrieved from https://www.telegraph.co.uk/radio/what-to-listen-to/the-war-of-the-worlds-panic-was-a-myth/.

Daugherty, G. (2015, November 9). When New York City lost power in 1965, radio saved the day. *Smithsonian.com*. Retrieved from https://www.smithsonianmag.com/history/new-york-city-lost-power-radio-saved-day-180957194/

Davis, M. J & French, T. N. (2008). Blaming victims and survivors: An analysis of Post-Katrina print news coverage. *Southern Communication Journal*, 73(3), 243–257.

Dixon, G. (2008, October 30). The Daily News' original coverage of 'War of the Worlds.': Fake 'war' stirs terror through U.S., reprint 1938. *New York Daily News*. Retrieved from http://www.nydailynews.com/entertainment/tv-movies/daily-news-original-coverage-war-worlds-article-1.305067

Events. (1965). Survivor stories. *Blackout history project*. Retrieved from http://blackout.gmu.edu/events/stories.html

Heyer, P. (2003). America under attack 1: The War of the Worlds, Orson Welles, and "media sense." *Canadian Journal of Communication, 28*(2). Retrieved from http://www.cjc-online.ca/index.php/journal/article/view/1356/1421%26gt.

Hunt, G. P. (1965). Trapped in a skyscraper. *Blackout history project, 59*(2) Retrieved from http://blackout.gmu.edu/archive/life_11_19_1965/life_11_19_65_003.html

Johnson, P. (2009). *KJLH-FM and the Los Angeles Riots of 1992: Compton's neighborhood station in the aftermath of the Rodney King verdict*. Jefferson, NC: McFarland.

Laska, S. (2015). The Absent asset of radio in disaster response "citizen" responders: Ordinary men making extraordinary moves through radio programming. *Canadian Risk & Hazards Network*. Retrieved from http://haznet.ca/wp-content/uploads/2016/03/HazNet_2014_-10_v5n2.pdf#page=16.

Lee, T. (2017, January 16). In the future, ambulances can interrupt your car radio to issue warnings. *Ubergizmo*. Retrieved from http://www.ubergizmo.com/2017/01/ambulance-interrupt-car-radio-warning/.

Lescaze, L., & Egan, J. (1977, July 15). Blackout paralyzes New York City for day. *Washington Post*. Retrieved from https://www.washingtonpost.com/archive/politics/1977/07/15/blackout-paralyzes-new-york-city-for-day/210ab366-71fb-4c66-a87f-9a15e0a6d1a8/?utm_term=.b9e68644c564.

Martin, K. (2013, October 30). The science of fear & the 1938 war of the worlds broadcast. *NPR*. Retrieved from http://wesa.fm/post/science-fear-1938-war-worlds-broadcast#stream/0.

Miller, M. K., Griffin, T., Clinkinbeard, S., & Thomas, R. M. (2009). The psychology of AMBER Alert: Unresolved issues and implications. *The Social Science Journal, 46*(1), 111–123. Retrieved from https://s3.amazonaws.com/academia.edu.documents/46636030/The_psychology_of_AMBER_Alert_Unresolved20160620-2196-16g3snf.pdf?AWSAccessKeyId=AKIAIWOWYYGZ2Y53UL3A&Expires=1522453607&Signature=FnoxSEL5CUwm3zRXtHWi8keX2%2F8%3D&response-content-disposition=inline%3B%20filename%3DThe_psychology_of_AMBER_Alert_Unresolved.pdf.

Morse, R. (1965). And then—finally—the city lights came back on. *Life, 59*(2), 44–45. Retrieved from http://blackout.gmu.edu/archive/life_11_19_1965/life_11_19_65_044045.html.

NewsdayStaff.com. (1977). The Great Northeast Blackout of Long Island. *Newsday.com*. Retrieved from https://www.newsday.com/news/new-york/nyc-blackout-of-july-13-1977-anniversary-1.12033997.

NYTC. (1965). Our history. *New York Times company*. Retrieved from https://www.nytco.com/who-we-are/culture/our-history/.

Pooley, J., & Socolow, M. J. (2013, October 28). The myth of the *war of the worlds* panic. *Slate*. Retrieved from http://www.slate.com/articles/arts/history/2013/10/orson_welles_war_of_the_worlds_panic_myth_the_infamous_radio_broadcast_did.html.

Pressman, G. (2011, November 8). Remembering when the lights went out in 1965: November 9th is the 36th anniversary of the Great Northeast Blackout. Retrieved from https://www.nbcnewyork.com/news/local/When-the-Lights-Went-Out-in-1965-133488738.html

Rosenthal, A. M., & Gelb, A. (Eds.). (1965). The night the lights went out. New York, NY: The New York Times.

Reiman, N. (2012, April, 13). Colleagues Recall L. A. riots unfolding like "a movie." *WGBHNews.com*. Retrieved from https://news.wgbh.org/post/colleagues-recall-la-riots-unfolding-movie.

Schwartz, A. B. (2015). *Broadcast hysteria: Orson Welles's War of the Worlds and the art of fake news*. New York, NY: Hill and Wang.

Schwartz, B. (2015, April 27). Orson Welles and history's first viral-media event. *Vanity Fair*. Retrieved from https://www.vanityfair.com/culture/2015/04/broadcast-hysteria-orson-welles-war-of-the-worlds.

Sneed, A. (2017, October 26). Was the extreme 2017 Hurricane season driven by climate change? *Scientific American*. Retrieved from https://www.scientificamerican.com/article/was-the-extreme-2017-hurricane-season-driven-by-climate-change/

Symes, S. (2014, June 12). More automakers are cutting radios and CD players. *InsiderCarNews*. Retrieved from http://www.insidercarnews.com/more-automakers-are-cutting-radios-and-cd-players/.

Vaidyanathan, R. (2005). The hurricane station. BBC..Retrieved from http://www.bbc.co.uk/news/resources/idt-20ed5228-1f23-4906-9057-ffdd9d5272f2.

Voelcker, J. (2017, September 29). BMW i3 electric car quirk: No AM radio offered, but why? (update). Green Car Reports.. Retrieved from https://www.greencarreports.com/news/1098893_bmw-i3-electric-car-quirk-no-am-radio--but-why.

WABC Radio. (1965, November 9). Blackout. *MusicRadio77* [Audio]. Retrieved from http://www.musicradio77.com/images/ing11-9-65blackout.mp3

Wainright, L. (1965, November 19). A dark night to remember. 1965 blackout. *Life* 59(2), 35. Retrieved fromhttp://blackout.gmu.edu/archive/life_11_19_1965/life_11_19_65_035.html

Weinstein, S. (1993, April 2). KJLH earns Peabody for riot coverage. *Los Angeles Times*. Retrieved from http://articles.latimes.com/1993-04-02/entertainment/ca-18343_1_station-kjlh-fm

Weissa, B. C. (2017). *Never again: A never before told insight into the 1992 Los Angeles riots*. New York, NY: Morgan James Publishing.

White, T. H. (1965). What went wrong? Something called 345 KV. Unreasoning computers demanded more power. 1965 blackout. *Life*, 59(2), 46B–51. Retrieved from http://blackout.gmu.edu/archive/life_11_19_1965/life_11_19_65_046B.html

· 1 2 ·

THE SILVER AGE OF AM/FM/TAPE CAR STEREOS

An Oral History

Tim Hendrick

In 1975, 36 years before I was to become a full professor at San Jose State University, I was fortunate enough to have been a part of an exciting, historical growth period in the development of advertising and promotional campaigns for car audio manufacturers. At the time, automobile companies gave the consumer only a basic radio in the car and not much more. This opened the door for a high-end after-market of expertly or DIY-installed, customized, in-dash AM/FM car stereos and speakers. Marketing these highly prized products was fun, challenging, creative, and very rewarding.

Because the economy was doing well, America was mobile, and guys believed that a great sound system equalled a better sex life, young people had the money and the incentive to own their own car and upgrade the audio experience. One of the main reasons was FM rock stations where the deejays were the main purveyors of music that could be really *heard*. Their music became your music. With a top-end AM/FM car stereo, you could cruise around listening to your favorite radio stations in crisp, clean FM stereo.

The improvement to both car stereo receivers and FM stereo broadcast signals changed everyone's listening and usage habits. Consumers wanted to hear their favorite artists and songs on the radio, day or night. Radio stations had to improve their signals and with FM sounding so much better, consumers

began wanted the best and latest technology for their own personal lives and their rides. There was no point in having a great AM/FM car stereo if the radio stations did not sound good on it, and the benefit of a music station investing in the clearest signal with the best stereo separation would be wasted if in-car listeners could not hear the difference. So, during this time, car audio manufacturers and music radio programmers were both working toward the same goal. Also, commutes to work were getting longer and consumers wanted to get traffic reports in the car while not wanting to leave their music at home.

I worked first on the client side of the advertising and promotion business when I was employed by the #1 car audio company in a division that oversaw the final products and took them to market. We had to understand who the consumer was, what was happening on the streets as well as the coming trends in radio, music, and technology. After that, I switched to the advertising agency side and worked with other car audio manufacturers to get their new brands to the consumer. One of my favorite perks was that I had some of the first roll-outs of these new units in my cars so I could show them off and get a personal experience with the products at the consumer level.

Cars had always had radios—mainly AM—but as music continued its growth on the FM band, another development was underway. Sound accessories for in-car listening really started in the 1960s with the small record player that could be mounted under the dash or in the larger glove boxes in cars of those days. They played both 45s and 33s. You could have a radio in the dash, and an additional form of custom playable music. Along with the new radio innovations came bigger, better speakers designed to go in the doors, the rear interior deck, or even replacing factory-issued speakers already in the dash. And of course, to drive all these innovations the consumer needed more power, so an added amplifier became the rage.

Later came the 4-track player, with cartridges from 6 to 10 inches in size that would separate the mono signal in two and create "semi-stereo." The plastic tapes inside were coated in iron oxide and, because they were a continuous loop, they were a new way of playing music except that you could not fast forward or rewind them. The new 4-track players hung under the dash and were so big and bulky that if you were not careful, the dash might sag a bit. Then full stereo came into play and a new, smaller format, 8-track tapes, were easier to mount on the hump underneath the dashboard radio.

The audio manufacturers of the 1970s jumped on this trend and began a series of advertising campaigns that were ear- and eye-catching—bold, really colorful—and designed to take the auto sound industry up to the next

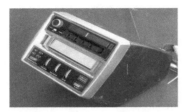

Figure 12.1. Early, bulky AM/FM stereo 8-track tape player with 5 radio presets and a few, limited controls to modify the sound.

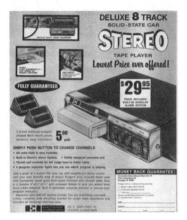

Figure 12.2. Another under-dash, after-market AM/FM stereo 8-track unit, but the built-in car alarm indicates how popular products like these were to steal from cars. One can only imagine the sound from $5 speakers.

level. First, the car audio manufacturers started by advertising on radio—what better way to reach the car stereo consumer? Then, came magazines and, finally, with the advent of MTV, television ad campaigns about AM/FM/cassette tape systems. With this new trend promoting the brands and products in newspapers and magazines came a new breed of retailers that got behind it.

Some advertising campaigns tied everything together with actual musicians like Billy Preston, known as one of the few side players ever to be given credit on a Beatles album as well as a hitmaker in own right. These print ads ran in the kinds of magazines where consumers might look to get the latest in technology and other things that would fit their lifestyle.

Later, continuing the music celebrity theme, stereos were taken out of the cars to demonstrate the power of mobile music everywhere.

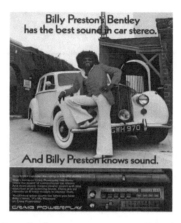

Figure 12.3. AM/FM stereo 8-track player goes uptown with higher end manufacturers delivering a better sound and image.

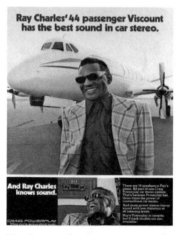

Figure 12.4. It may not seem like that much of an innovation, but at the time, people were customizing any vehicle—boats, vans, trucks, planes—with upgraded sound systems. This ad featuring Ray Charles accentuating the style of both the music lover and the music system.

As much as the technology was built around the latest studio-quality tape sound, the radio was displayed prominently in the ad. With great intention, ads for the newest car stereo systems cleverly showed radios that were tuned to popular stations in large markets.

Pop music stars usually were willing to take a pay cut to be in these national ad campaigns because their managers and record labels saw them as the perfect way to promote their upcoming new album or TV special. With millions of dollars being expended to promote these new AM/FM car stereos,

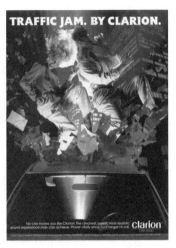

Figure 12.5. Radio station support for contests and local stereo stores was fierce in the 1970s. Sometimes the ad designers intentional chose the dial points of popular radio stations to be featured in the ads, sometimes they stayed neutral in the radio wars.

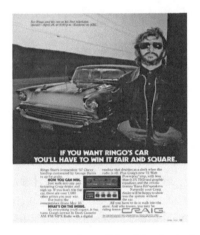

Figure 12.6. Ringo Star's car stereo was as beautiful as his wheels. In reality, Ringo "owned" this specially made car only for the period of time that he made a television special with it.

savvy artists could get nationwide awareness for both themselves and their next endeavor.

Here we added an equalizer—a special device that allowed the listener to customize the sound of the stereo system with more high end or bass—that mounted under the in-dash radio.

As sales increased profits, companies continued to thrive, many enlarged their advertising budgets and pushed for bolder, more stylish promotions

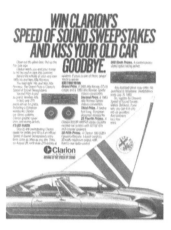

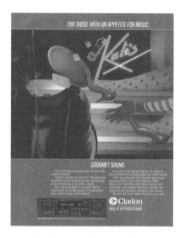

Figures 12.7 and 12.8. Next came co-promotional tie-ins with car audio retailers to bring more consumers into the stores using big prizes such as his and hers sports cars from Clarion Car Audio.

each year. Print and radio were the dominant and most cost-effective way to reach the premium car audio customer media, but some mainstream brands turned to television as the MTV cultural phenomenon took off. Either way, cars were usually involved, in some cases the more exotic the better! At one point this company actually gave away a Lamborghini in a national sweepstakes. The advertising became a form of art and sometimes posters were also given to consumers for a nominal cost or if you visited a retailer to check it all out. I know for a fact that over 5000 posters were hung in bedrooms across America.

As the premium car radio culture grew, so did other mobile dashboard entertainments such as citizen band radios (CBs) that allowed motorists to talk to each other, scanners to follow police and fire news, and finally this unique thing called a car phone that the reader may have heard of. All these products were also scaled to fit in the car along with the radio, yet in some cases, we were back to mounting them on the hump or center console of the car.

As part of my job, I was one of the first to have a mobile phone system in my car. Not only did it take up the whole center console with the necessary electronics, it also took up half my trunk. They were so new, so big, hard to hold, and rare that I really did know anybody else who had one that I could call!

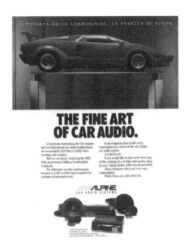

Figure 12.9. Alpine Car Audio Systems were considering top-of-the-line, but look closely in this print ad and you will see one of the first appearances of an in-dash CD player, and the chrome handle on the front of the unit that allowed the driver to take the changer out before parking and reduce auto theft temptation.

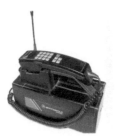

Figure 12.10. It may be hard to imagine that having cellular phone unit such as this floor-mounted between the front seats was once the yardstick of "cool."

Being a key player in car audio advertising campaigns, and marking the evolution of these in-dash technologies through these published portraits that recorded the development of all these breakthroughs, I hope the reader can see better that it was a fun time to be a "Mad Man" in America!

· 1 3 ·

ROLE-PLAYING ON VIRTUAL HIGHWAYS

Simulations and Soundscapes: What's Inside the Connected Car of Tomorrow?

Phylis Johnson

First popularized in America by the Galvin Manufacturing Corp. in 1930, the earliest [radio] road models could fit into any car. So successful was the idea that the company survives. It evolved into the Google-owned Motorola, maker of smartphones you can listen to in your car. Whatever the source, that magical convergence, music and driving, continues to define L. A.

—Roberts (2013, para. 9)

Might songs on the car radio or plugged in via the dashboard inform our impression of Route 66 or any number of road trips? The directions might take you down the same path. However, the trip is unlikely to be musically the same, when pit stops and routes are accounted for along the way. Passage of time redefines what is heard, as well as what is seen. In its early years, radio was that definitive soundscape. It is not so much the audio device that defines listening, as much as it is music and talk filling the car which creates the soundscape. But from the car radio, there is an added element of mystery: the driver is not in control of the next tune or talk bit. It is on the open road that anything can happen. The next song or voice could be anything, or perhaps it all stops—and there is nothing but dead air.

In early 2013, indie band Twenty One Pilots released the song "Car Radio" (2013) as a music video. It is a spoken word piece, serving as a metaphor for

drowning out real life thoughts: "Sometimes quiet is violent ... somebody stole my car radio." The song plays on the analogy of driving in silence; when alone on the open road, the driver is forced to confront thoughts in isolation. Broken radios or passing through dead spots such as mountainous or metropolitan areas give way to one's own thoughts or one's own personal music on iPods or other portable media. The automobile, for most, is a necessary convenience for errands, transportation to work, and socialization. Long road trips are a luxury, and some might even musically plan what music to upload for such trips. Others climb in the car, and never worry about those details, scanning the dial for whatever is readily available. Some have subscribed to satellite services to offer a plethora of choices, from audio books, sports, news/talk, radio drama, or nearly anything imaginable. Increasingly, drivers are customizing experiences with their own soundtracks, composing adventure through pre-production, creating cinematic road trips.

Occupying one's mind during a road trip goes back to the early days of radio, when travelers intuitively knew radio, especially in a portable form, would make a great road companion. In *Road Trip Radio*, Jeremy Krug and Dave Godar host travel segments focused on the highways around the nation. Krug has logged in more 300,000 miles since 2002. *Road Trip* podcasts have featured Highway 375 in Nevada ("the Extraterrestrial Highway"), Highway 100 (otherwise known as Vermont's Main Street), California's Interstate 8 (only 170 miles but filled with unusual and interesting sites along the way), Lincoln Highway (a discussion about its early days circa 1916), and then there's the duo's archive packed with classic radio commercials dating back to the 1960s—the height of Route 66 culture (Krug & Godar, 2013). By the 1960s, a listener might hear more than 20 minutes of commercials in an hour, with lots of deejay chatter, station promos and news. The car made the perfect captive audience.

An odd species, humans are, as we live vicariously through the images of the road, be that commercials, movies, games, virtual worlds, and even Google Maps. Music is used in commercials to lead listeners and viewers to the next product point. It unifies the experience, and a good song or beat moves the ideas along. Car commercials done well make one feel like they are the driver. They can see and hear, and nearly feel the experience of being in the car; a good tune goes a long way toward helping to accomplish that mood. *CarJamTV* (2013) on its YouTube channel boasts more than 80 million views, and is listed as one of the top car channels of the world, having only officially launched in September 2013. Its channel hosts a series of commercials

targeting the future of automobiles, all feature an intimate experience for the driver, and the passenger at times. It underscores the romance and mystery of the road. German automaker Audi has been tapping into popular culture since the 1990s. Among its videos, one might find the 2012 AudiA3 commercial sporting a new entertainment system, in addition to other creature comforts. The commercial opens with a digital interface within the tuner, or where the car radio used to be traditionally. One push of the button, and a visual menu exhibits an assortment of album covers from which to select. The theme is a glimpse of the future now. CarJam.tv archives upscale commercials inviting viewers to take a peek into the ultimate driving experience, and to subscribe to them on YouTube, Facebook, and Twitter. A connected Tumblr additionally features a series of commercials launched in May 2013, including one for New Maserati Quattroporte (2013). The commercial is identified as its "first sexy commercial," especially when viewed in larger than life high definition resolution, on *Carjam.tv*. The plot plays out like a James Bond movie in the style of a music (https://www.youtube.com/watch?v=Squv4KI751w).

When you hit the road, you too can capture that feeling, with the right car and soundscape. The unfolding story of the road and radio entangle the past and present, with either hope or dismay for the future depending on one's vantage point. Car commercials interpret intimacy as fantasy, intertwined as a sort of role play. Looking upon the landscape that unfolds before one's eyes, it is on the road that the driver can both discover and escape himself or herself.

The Silence on the Virtual Highway

Imagine taking a trip on Route 66 via the Internet. That is something that was never conceivable during its early construction, nor its decommissioning in 1985. Some parts of the route are now off from the main thoroughfares. An extraordinary number of road enthusiasts document their expeditions along the highways, for much of the off-roads are not maintained. Online, increasingly, these trips are archived and serve as travel video logs, with some travelers sharing personal journeys along back roads. A couple of sites follow along the Western U.S. and Route 66 (Bandringa, 2013; Styxmahler, 2012). The Route 66 segments provide guided tours, pointing out landmarks along the way. Professional to amateurs alike document their journeys and post them online for virtual tourists, who refer to these videos when planning a similar trip or merely wishing to see the sights without leaving their home. Just browse the information highway with your destination in

mind, and one will surely find that someone else has chronicled that experience already. A big part of the video tour is the soundtrack added to the videos or the background music that was played in the car during the trip. There was a time when one could only imagine what it would be like to take a road trip across the country or across the world. In the past decade, the Internet has made many of those locations within one's reach via the computer. Simply browse YouTube.com—*Road Trips*.There's even a 3 minute time lapse of traveling Route 66 from Chicago to Los Angeles (Triplapser, 2012). One can view the videos, sometimes with narration and at other times only music accompanies the drive. Such trips are packaged online in short video segments, about the length of a song.

Google Earth (see https://www.google.com/earth/) increasingly promotes Internet Tourism. Think of a location, and zoom instantly there. Cruise the strip of Las Vegas in a moment for a quick mental escape during lunch hour or perhaps to map a summer vacation. The author of this chapter attempted to journey down Highway 66 via Google, but the trip was disjointed due to changes in the highway system over the decades. The rerouting of some of the early roads came, as the surrounding areas shifted in population, and more direct routes were constructed. For now, the only way to travel virtually across this historical road is to do so in sections along the highway. For instance, a number of landmarks serve as points of reference such as the Wigwam Motel along Route 66 in Holbrook, Arizona. Yet, the map stopped short of the street level view.

At other times, the author cruised long stretches of Route 66 through Arizona, New Mexico and California, encountering miles of beautiful desolation as the road curved through the magnificent desert and mountainous terrain. Following the course, the sparsely travelled miles would alternate with highly congested areas usually noted for one or two historical sites reminiscent of early days—diners, gas stations and motels. The soundtrack is silent, with no car radio to tune into on this virtual trip, only that provided by the computer user. There are no automobiles, only the point of reference of the person engaged in this mental exercise. The virtual road trip is a visual one, engaging only one sense.

Roadtrip Nation: Back to the Open Road

An interesting twist in road culture is an initiative now airing on Public Television. The show description for Season Ten of *Roadtrip Nation* (2018) reads like a modern-day Kerouac novel: "Three soul-searching young adults take

the *Roadtrip* of a lifetime to figure out where their lives are going!" It continues, and here is the twist in the plot: "Hopping about *Roadtrip Nation's* iconic green RV, Jackie, Megan and Zachariah travel the country to interview influential leaders in STEM (science, technology, engineering, and math) and learn the steps they took to get where they are today" (*Roadtrip Nation*/Season 10, 2018, para. 1). Now in its 13th season, the point of the show is, the road trip is about self-discovery or personal exploration; it is a metaphor for helping viewers to find and "define their own roads in life" (*Roadtrip Nation*/Season 10, 2018, para 1). Each episode follows similar themes, with titles like, "You Should Already Be Doing Something You Love," and "Make Yourself Happy." *Roadtrip Nation* began in 2001 as the inspiration of four college students (three of them, Nathan Gehbhard, Mike Marriner, and Brian McAllister, are still involved) who set out in pursuit of their own dreams. It evolved into an international movement, primarily between the U.S. and Australia.

Roadtrip Nation has also served as a non-profit organization that reaches out to empower young people through real life experiences, and that is, according to the group, done on the open road. In this series, the open road is the place to ask questions about life, and the various paths available. Online, at *Roadtrip.org*, you can watch the archived road trips, hear interviews with mentors, and even post your own road trip and/or apply to go along with one of the teams. The underlying theme is educating yourself about the choices in life.

A young woman's voice narrates the open for season ten, episode one: "Everywhere you turn, people try to tell you who to be, and what to do, but what about deciding for yourself?" She continues, defining the mission of *Roadtrip Nation*, as "a movement that empowers people to find their own roads in life. Ever since the original road trip in 2001, the keys to the Green RV have been passed down to a new generation of road trippers" (*Roadtrip Nation*/ Season 10, 2018, Episode 1). The trips take the travelers across the nation on road trips to connect them to inspirational people who enjoy their careers, and to find out how those people came to know what they wanted to do in life. The road trippers ask questions that their peers would like to know. The web site also supports independent musicians, archiving all the artists they feature on the shows along with 22 original songs featured in 2013. The tie between the open road and original music being played out by the producers of *Roadtrip Nation* is understated.

Roadtrip Nation connects the road to free spirited creativity of independent artists. With all the possible mobile technologies that promise to deliver

more content choices than ever before, audio books, news, sports and music to the dashboard, one might also contemplate a space for programming off the beaten track. Redefining what is heard in the car might be, in reality, a breaking free from mainstream content suppliers, and the car's soundtrack might be invented to be a future option that inspires originality and an appreciation of the road as a place of contemplation.

Of course, driverless cars have already begun to cruise the roads. Sebastian Thrun in a Ted Talk entitled "Google's Driverless Car" (2011) explained his goal in helping to design Google's driverless car, which for him began as a project for Stanford University. The motive was to save lives by offering safer alternative transportation (Thrun, 2011, 00:20). A sense of control might be arguably lost in the process. The road experience will be transformed in many ways, and among them will be how we will listen within the connected car, transitioning from driver to passenger. There will be plenty of time to pay attention to the sights surrounding. How will this scenario recreate the interior environment and the soundtrack within the car? Marshall McLuhan (1994), in *The Medium is the Message*, envisioned technology as an extension of humanity rather than a replacement of the human spirit (p. 107). That, of course might seem overly dramatic, given the number of lives speculated to be saved by new driverless automobiles. Yet what is the relationship between new generations and the open road? There is that impulse to control one's music playlist, but there is also a sense of freedom when one merely lets the music define the experience through the radio, as song and voice, as news, entertainment and information, with occasional impromptu interruptions from the live local deejay hailing from that particular part of the country that one is traveling through at the time. It helps to establish a sense of identify and local character for each region. It is a way to acknowledge self within society, and a means to occasionally escape for a while on the open road, making new friends and experiences in an unscripted adventure.

Gaming and Simulated Experiences

The Mitsubishi Live Drive project was promoted as the world's first virtual test drive and set a record in the Guinness World Records "for the furthest distance driven by an online controlled vehicle in 24 hours—91 miles" (Guinness World Records, 2010, para. 1). Virtual drivers would actually be controlling the car in real time, an Outlander, on a Southern California test

course (Swallow, 2010, para. 7). The marketing campaign was praised by the company and the national media as a success, especially given that the automobile company had trouble initially attracting consumers into their showrooms. Here, they brought the car to the consumer (Halvorson, 2010, para. 3). Some media outlets, like Fox News, compared the experience to those games some of the test drivers had grown up with as teenagers, i.e., the strategic action games like Knight Rider where players complete missions (Halvorson, 2010, para. 4). Outlander drivers became familiar with the various amenities of the automobile. No word on whether anyone turned on the radio, or was even asked to do so. Another virtual project—Connected Car Dashboards, co-sponsored by the software company Splunk Inc (SPLK) and Ford Motor Company, is designed to collect and analyze data on automobile performance. Test drives by employees were recorded and posted online (Business Wire, 2013, para. 1).

These test runs and experiments are indicative of how much the automobile industry is relying on performance data, and much of that will likely bleed over to how we listen to music, entertainment, and informational programming within the car. Technology assists in this sense of control over the road, and life in general. The Internet of Everything (IOE) will likely connect home to car, and maybe the home stereo to the car audio system. Even upon death, one can arrange for a signal to wipe their hard drive from any incriminating personal files on their computer.

Simultaneously, automobile companies, tech companies, road societies, and those wishing to share their travel experiences have looked toward the Internet to offer virtual journeys, for those who cannot afford to travel around the world let alone their home country. Other services offer adventures to those who have physical challenges that prevent them from taking their dream vacation or allow them visual access to popular (and sometimes off the beaten trail) destinations, that otherwise they would never experience, other than virtually.

In November 2013, the Mercedes AMG Vision GT6 sports car made its debut on the virtual racetrack as an integral component of Playstation 3's new racing game *Gran Turismo 6*. The visionary plan to release a series of cutting edge sleek vehicles designed as a simulated real world driving experience—a mixed reality road play (Carrion, 2013, para. 1). The engine sound of the virtual Mercedes was another aspect of the car design. The gaming world has typically measured driving performance as part of the experience. Just think of how those early road games in arcades computed the scores of its players,

demarcating the good drivers from the less skilled by a point system. It is more than the car meets the track. The latest games concentrate on creating an appropriate environment to draw in players. The ambience is a factor in the surroundings.

Grand Theft, Los Angeles, CA

DJ Pooh hosts the West Coast Classics station. He's a big personality, and he grew up with all these guys who are on the station. We were getting phone calls from Pooh saying, "I'm driving over to Dre's house, what you need from him?" And then 30 minutes later he's like, "I'm going to Snoop's house. ..."

—Shamoon (2013, para. 6)

Grand Theft Auto (1997) (GTA) of Rockstar Games offers a car radio soundtrack, taking the player into an interactive world where the car becomes part of the larger storyline. Game players tune into a selection of car radios offered, or they can customize their own station. Some forums list comments by game players who want to listen to these stations when they are not playing the game via their iPod. Several comments have to do with the popularity of these stations. So what's all the excitement about—a car radio in a game about cars? For a sample of the programming, *Los Angeles Times* Pop Music Writer Randall Roberts shares a narrative of his experience with the latest version (Roberts, 2013, para. 1): "Dusk had settled on virtual Los Angeles, and I'd just hit a few pedestrians and smashed my stolen roadster near City Hall. The sound of police sirens was getting closer ...," and he continues, "The nearest vehicle was an idling delivery truck. I pulled the driver out, kicked him a few times and jumped in the front seat. As I sped off, the car radio started playing." The setting is make-believe Los Santos, "a vividly— and darkly—crafted place" (Roberts, 2013, para. 1). Roberts is here for the joy ride: "I'm a novice, and certainly no gamer—while the rockabilly warbler strummed and sang about the sun going down and his love not being around." (Roberts, 2013, para. 3).

His car radio frequency in the car, on this occasion, is tuned to Rebel Radio, with songs by "Hasil Adkins, Hank Thompson and Johnny Cash" and many more. "With a flip of the controller, a whole curated catalog of stations delivered DJs including Big Boy of L. A. rap station Power 106, actress Pam Grier, beat producer Flying Lotus, indie rockers Wavves and Keith Morris, former screamer for Black Flag and the Circle Jerk," adds Roberts (2013, para. 4).

Grand Theft Auto V Soundtrack (2013) encompasses amazing city views, landscapes and soundscapes of Southern California. A fictitious city "and the open countryside of San Andreas provide the setting for a heist caper told through the perspectives of three protagonists. Its virtual world is the biggest to date for the game series, and all that drive time demands quite a bit of music," reports *Rolling Stones*' feature writer Evan Shamoon (2013, para. 1). Rockstar's soundtrack supervisor Ivan Pavlovich, told Shamoon, "We have 15 radio stations, two talk radio stations, 240 licensed songs, and somewhere in the proximity of 20 movies worth of score. It's the largest soundtrack that we've done, and the largest score that we've done" (Shamoon, 2013, para. 2). The setting is modern Los Angeles, with the idea behind the sound to "capture that feeling of L. A. and California. We approached the radio stations as the musical soundscape [you experience] as you fly into L. A. One of the things we've never done in a GTA game before is a pop station [which] made so much sense in the context of L. A" (para. 3).

Featured radio stations have included Radio Los Santos, a hip-hop urban Latino mix with all the teasers and deejay hype that makes radio great for cruisin' the streets and highways. The deep male voice begins, resonating the words dripped in bass, "Radio Los Santos. Big Boy in your neighborhood, you hear me, you hear me!" (GamerSpawn, 2013, 00:27)." After 30 seconds of music, a second male voice echoing a similar "street vibe" attitude interjects, "From East Los to the beach, all the way up Blaine County, we're the home of the hottest, freshest, newest and the best jams on the planet" (GamerSpawn, 2013, 00:51).

The sound of this and every station captures the style and formatics of the hip radio announcer, and offers a retro listen to larger than life radio personalities such as Wolfman Jack who set the tone for the music for *American Graffiti* (1973). The radio stations fit within the context game, often serving as parodies of real life counterparts. There is even a mock talk radio station, WCTR, with a sarcastic tone among the talk show hosts summoning radio personality stereotypes. Formats exist for nearly every programming genre, with radio personalities styled to the appropriate station. The auto is center stage in this game, but its companion—the car radio—has become par for the course in a well-produced role play game. A taste of the various formats are available on YouTube by simply searching for *Grand Theft Auto*—Radio. Sometimes the radio stations are built around a theme, like London in the 1960s, depending on the setting of the game. The volume of homemade YouTube videos extended conversations about the GTA experience attests to the

fan culture that has grown around these different radio formats; the GTA wiki lists the many variations possible on these embedded radio stations.

As a music reviewer, Roberts (2013) explains, "I find the car stereo is my sanctuary, my retreat, (mostly) my domain" (para. 7). It is the way he hears and reviews new music—"the claustrophobia of headphones be damned" (Roberts, 2013, para. 7). The car provides him sanctuary, where he receives some of his "least interrupted melodic messages" and it is there he "can boom, scream and (ahem) rap without fear of ridicule or repercussions" (Roberts, 2013, para. 7). Roberts pay homage to the car radio for its nostalgic significance and its relevance to American road culture that continues today. Reminiscent of American record producer Berry Gordy's famed "car test" for the Motown sound, the radio in the dashboard has defined popular music for generations. "No wonder some of music's greatest minds don't consider a mix complete until it passes the 'car test': a roll around town with the recording cranked on the stereo. If it doesn't sound good there, something needs fixing," notes Roberts (2013, para 9). Among all the millions of songs available and all the options for playing them back, car radio finds a place in one of the best-selling videos games in history. *Grand Theft Auto V* earned nearly one billion dollars in the first few days.

A *Second Life* Road Trip

Another adventure might be to travel the virtual highways in a virtual world. *Second Life* (2003) is an online 3D virtual world owned and operated by Linden Lab of San Francisco since 2003. As of March 9, 2018, Linden Research reports more than 53 million residents of which approximately 50,000 log onto Second Life daily (Linden Research, 2018, para. 1). Part of the virtual lifestyle involves buying homes, clothes and transportation. The road system within *Second Life* is fairly primitive with some excellent to good exceptions. Others create their own private roads and some create race tracks for personal use to share with friends. Some road associations organize car events. However, transportation across the virtual world is mainly by teleporting from one point to the next. Airplanes, boats, cars and motorcycles are all part of the virtual culture, or perhaps more accurately role play. A particular fondness for Route 66 is prevalent in *Second Life*. Some residents create landmarks—bars, diners, and gas stations—around a slice of the road, riffing off any point on its timeline from the 1930s to the eighties. "The Bagdad Cafe" on Route 66 is described by its founder Van Hoffman as a cafe on "a desert road from Vegas

to nowhere." He continues, "You're on Route 66 in the Mojave Desert when you pull in for coffee at a 50's rundown diner."

A summer tribute show dedicated to the history of Route 66 brought in people across the world, from London to America and beyond. All gathered at an old fashioned drive-in theater that served as a stage. The audience and the actors were represented by avatars, with computer puppetry by a cast of people from around the world. On this occasion, a dance company performed songs from those early days of the road. The audience watched the show in and on cars. The cars were animated props. The audio featured retro tunes. Inside *Second Life*, there are few roads, and plenty of cars. Vehicles are parked on virtual lawns outside virtual houses, and serve as status symbol rather than a necessity. Who needs a car when you can teleport from one place to the next in a moment? Yet there is a romantic spirit associated with cars even in the virtual world, and this extends to global consumers that participate in *Second Life* as members. There are even car associations. Car radios are silent accessories in dashboards, when they are present. The cars are silent with song, but not without engine sounds.

A thriving automobile industry exists in *Second Life*, from classic cars to modern vehicles, everything from Audi to Porsche, Toyota, Scion, Pontiac, Nissan, and so many other makes and models from across the world. For instance, one of the many dealers states, "We love cars. New cars, old cars, concept cars, race cars, flying cars … and mostly *Second Life* cars" (Johnson, 2010, p. 78). Other associations such as Friends of Virtual Highway, bring together game members globally who share like interests. The prominence of the car culture is missing one important element—the car radio. Vehicles are styled with radio tuners but the car radios are silent. Each resident provides their own soundscape, or tunes into the region's music provided for them, if they wish to listen to the stream. A car dealership can set its property to a certain radio or music, in keeping with the era of their cars.

A Nostalgic Future

The motion picture *The Internship* (2013) parodies modern technology when interns Vince Vaughn and Owen Wilson seek help from a driverless vehicle. Will consumers be willing to hand over control to a computerized car? Consider those movies where the main character is framed by police or some governmental agency, and their only recourse is to jump into a car and escape out of town. The plot might seem far-fetched from reality. Yet it is a provocative

idea to consider—what to do when there is no escape to an open road, or what it will mean for the car radio? What internal or external controls might there be for the car soundscape? Today, audio technology promises customization and personal control over the radio. Technology brings with it increased standardization, such as in mapping (GPS) and safety features that shape the driver and car relationship.

Imagine if local culture might be programmed into your soundscape, down to the last detail such as customizing a deejay sound with a lisp or a heavy accent. As the automobile soundscape evolves into a personal choice, and the driver becomes the passenger, how will we conceptualize the road experience? Like *Grand Theft Audio*, "will car dealerships create their own radio stations, or will we as passengers?" Maybe passengers can plug in *Grand Theft Audio*, select one of the virtual car radio stations, and immerse themselves into the game—and relive or experience that sense of nostalgia that is fading quickly from the road.

In *The Big Book of Car Culture* (2005), Jim Hinckley and Jon G. Robinson assert the bond created between road and driver through the car radio did not necessarily instill a spirit of individuality, but in reality created a social bond that transcended the road experience:

> The twenty-first century satellite radio brings in broadcasts from around the world on hundreds of specialized channels, but the very individuality takes it out of the collective mind. Decades from now, people won't share common sentimental memories about the music and shows they listened to on the radio. (p. 61)

Perhaps the unpredictability of what might play or be said over the car radio, what station one might hear on the open road, or how all these elements come together to create an experience, had offered a promise of adventure. Some of those moments were recreated for TV shows, and in recent years, with the ease of technology, drivers have captured these road trips for video tape. Alas, new adventures await the traveler.

Cruisin' Route 66, with the Radio Set to Yesterday

Now, one might explore the world through Google Earth, mapping out their destination there and perhaps never leaving the house. The adventure becomes one of the mind; a simulated road trip. It is limited by the available technology at this point. And when one jumps into a driverless car in the near future, will he or she jump in the passenger seat ready to control only their interior surroundings? Already, both driver and passenger increasingly opt to plug their

portable listening options into the dashboard. Those songs, audio books, or podcasts are likely those shared by the passenger's circle of family and friends. The radio in the car is becoming merely symbolic of our former relationship with the road, which continues to be redefined as new modes of transportation offer more practical solutions to traffic problems. However, there is a mystique embodied by and within the car, that calls forth sounds and images of past times that movies, games, and memories romanticize to younger generations.

McLuhan would tell us that invention is meant to extend our human capabilities, to serve, and to connect the human spirit rather than isolate us from each other. The car radio did that, and the idea came from drivers who wanted to fill the emptiness of the long roads with a voice or song. The future could hold increasingly interactive communication between the car listener and radio talk shows hosts and deejays, or other live programming, if the human driver becomes a thing of the past. Imagine a holographic talk show host sitting in the backseat. The car might truly become a home away from home, the ultimate environment to nurture social mobility. The future will be determined, not necessarily by the technological options, but by the willingness of the consumers to adapt them, and that will likely be an issue of affordability, meaning such realities may be postponed for a number of years for many people. That's the thing about the future, it's anyone's guess—even among the futurists.

A stable counter-movement acknowledges a fascination with the past, and for younger generations it is a curiosity about technologies and lost potential of the 19th and 20th centuries (Ginsburg, 2013, para. 2). As for music today, the trend is for some teens and young adults to find interest in listening to anything from Sinatra to Panic! at the Disco, in addition to talk shows, whether they listen from their AM/FM car radio or iPod. The situation dictates the listening. It is a convergence of culture, with new practices and technologies occasionally informed and redesigned by nostalgia and former road culture. Such trends like Steampunk or Dieselpunk literature, cinema, and fashion have intertwined the romantic elements of the past with modern technology. *The Hollywood Reporter*'s Merle Ginsberg (2013) pointed toward fashion trends over the past decade that call for "retro styling, creating numerous '60s-inspired looks skewed toward trendsetters and tastemakers of any age" (para. 3). NBC *Fashion Star* host Louise Roe, one of the style experts for the Disney Channel's *Teen Beach Movie* that aired Summer 2013, states, "Icons like Edie Sedgwick and Marilyn Monroe, movies like *Grease* and current fashion blogs—retro '60s looks are all over the runways and sidewalk ..." (Ginsberg, 2013, para. 3; Bjelic, 2018, para. 1).

It is not just the clothes; it is the music, art and cars, and the whole culture that is becoming of interest to a younger generation. The video game series *Fallout* (1997) from Bethesda Game Studios is now in its 4th edition and continues its long-running 1950s theme, playing off the atomic age, but set far into the future. As in the previous edition, the cars don't move, but they are an important aesthetic to the game. In *Fallout 3* (2008), the radios are worn as wristbands. Like GTA, there are so many radio stations, that a wiki was created as a station guide (Fallout 3 Radio Stations, 2018). Players have also created mods that allow for many more songs to be played via the radios. It is interesting that while cars are no longer functional, portable radios and broadcast towers still transmit across the desolation In Fallout 4 (Pemberton, 2015):

> [T]he game opens up, and we're plunged into its pre-war world. On a sunny autumnal morning, somewhere in the suburbs surrounding Boston, the player is finally witness to the world before the bombs fell. The house we find ourselves inhabiting, in both its exterior design and its interior decoration, resembles a brand new home of the suburban 1950s; shiny new cars lay dormant outside each bright new house … the culture of the Fallout world, in its music, its design and its fashion, is permanently stuck in the mid-20th century. (paras. 6–8)

This chapter has probably provoked more questions than it has answered about the future of the car radio and its meaning to society. For now, consider the popularity of a dashboard designed to emulate the style of car radios in their heyday, but fitted with modern technologies, and social capabilities that exploit the Internet to its fullest: the information highway within one's automobile at a touch. As a passenger, one might be able to plug in the GTA or Fallout radio playlist, and view their game on their windshield. The radio soundscape would be ideal, with the car's speaker system pre-programmed and designed for the space. Now wouldn't that be the ultimate mobile game— being enclosed in a gaming automobile set up for virtual, augmented and mixed reality, and a surround-scape.

It really not so far off at present, with higher-end graphics on the rise, computer processing becoming smaller and more powerful, and screens thinner, and consumer demand for in-car entertainment anticipated to dramatically increase with driverless cars (Fitzrpatrick, 2015). So you can bet that will include a killer car stereo system for whatever inside soundscape you want.

Moving toward the conclusion, the following is an excerpt from a *Time* interview with Danny Shapiro, NVIDA's senior automotive director who pointed out more than 8 million cars on the roads "already have NVIDIA technology inside, ranging from Audis to BMWs to Hondas and Minis," and

role-playing on virtual highways and that he predicts more than "25 million cars" by 2020 will have similar and even more advanced technologies:

> About a decade ago, we had some automotive customers who wanted to increase the level of visual fidelity and really improve the experience inside the car. That's when you started to see screens inside cars that displayed different kinds of graphics. And so we started taking graphics processors that were in laptop computers to drive the screens in the cars. Today, we have over 8 million cars on the road with NVIDIA technology inside, ranging from Audis to BMWs to Hondas and Minis. Tesla Motors is one of our flagship customers, with their 17-inch touchscreen. ... (Fitzpatrick, 2015, para. 4)

Time Spent Listening in the Connected Car

One of the benefits of in-car radio listening is that the drivers and passengers are captive listeners. Drive time listening, as noted in our introductory chapters, is fairly high compared to at-work or home. That often means more time spent listening in the car, and that matters to the radio industry. That also means that radio broadcasters have a strong interest in what listening options will be available in new automobiles.

In 2017, The National Association of Broadcasters established a partnership with members of the GENIVI Alliance, which has a specific interest in automotive radio technology. "The GENIVI Alliance is a non-profit organization that provides standards and an open connectivity platform for in-vehicle infotainment systems, or IVI" (Vernon, 2018, para. 3). The information systems can provide everything from GPS to Google Earth, traditional radio stations, satellite options, CD players, and Bluetooth plug-ins, and that's becoming fairly basic to many mid-range priced automobiles today. The GENIVI initiative is based on the belief that driverless cars are around the corner, and the broadcast industry must prepare itself. The "Connected Car" is a theme increasingly discussed at auto shows like AutoMobility LA 2017 and CES 2018 (Vernon, 2018, para. 1).

The alliance includes broadcast companies such as Cumulus, as well as manufacturers like BMW, Honda and Volvo, audio equipment manufacturers like Alpine and Pioneer, several service and software/hardware companies, and Intel and Analog Devices (Vernon, 2018, para. 2). Steve Crumb is the alliance's executive director who is tasked with this question: "How can radio best fit into the connected car?" The answer will be discovered only, according to Crumb, when broadcasters situate "themselves in the place of passengers and think of the experience being delivered" (Vernon, 2018, para. 9). Already, the automotive environment is becoming congested with all too

many options. Crumb recommends, all these options must be "integrated into a single experience; and radio is a part of that greater digital experience that a person has" (Vernon, 2018, para. 10).

The future of the in-car soundscape may be visual as well as an aural environment. The car might even serve as not only a listening space, but a mobile studio for recording. It might make being stuck in traffic pleasurable, for it could provide an enjoyable transition between the office and the home, and even while on long road trips. Internet radio stations might even take to the road, creating a whole new breed of pirate radio, streaming on the go.

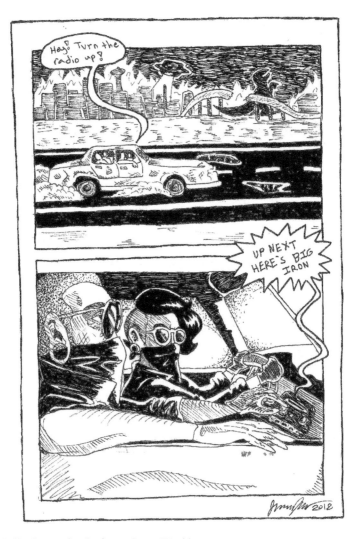

Figure 13.1. Big Iron—Car Radio in Game Worlds.

References

Bandringa, C., & Bandringa, I. (2013). Back roads West Trips. [Blog]. Retrieved from http://www.backroadswest.com/trips.

Bjelic, N. (2018, September 3). The comeback story. 60s, 70s, 80s, 90s Fashion trends that are back. Rebels Market. Retrieved from https://www.rebelsmarket.com/blog/posts/fashion-trends-from-other-decades-that-are-back-in-style

Business Wire. (2013, November 14). Splunk and Ford test drive open data development in connected cars: Ford's openXC platform and Splunk enterprise reveal insights into driving behavior. Business Wire. Retrieved from https://www.businesswire.com/news/home/20131114005474/en/Splunk-Ford-Test-Drive-Open-Data-Development

CarJamTV. (2013, November). Car video channel. Retrieved from https://www.youtube.com/user/CarjamRadio

Carrion, A. (2013, November 18). Mercedes-Benz AMG Vision Gran Turismo concept.European Car.

Fallout 3 Radio Stations Wiki. (2018). Station guide. Retrieved from http://fallout.wikia.com/wiki/Fallout_3_radio_stations

Fitzpatrick, A. (2015, October 21). The Unlikely Secret Making Cars Much Smarter. Time. Retrieved from http://time.com/4080008/nvidia-car-driving/

GamerSpawn. (2013, September 6).Grand Theft Auto V—Radio Los Santos (Radio Preview). Retrieved from https://www.youtube.com/watch?v=HeZRQi7YcNY.

Ginsberg, M. (2013, July 22). The Retro modern style of 'Teen Beach Movie.' The Hollywood Reporter. Retrieved from http://www.hollywoodreporter.com/news/retro-modern-style-teen-beach-589333

Grand Theft Auto V Soundtrack. (2013). Retrieved from http://en.wikipedia.org/wiki/Grand_Theft_Auto_V_soundtrack.

Grand Theft Auto Wiki. (2006–2018). Retrieved from http://www.grandtheftwiki.com/Radio_Stations.

Guinness World Records (2010, November 10). Greatest distance driven by an online controlled vehicle in 24 hours. Mitsubishi Motors North America. Retrieved from http://www.guinnessworldrecords.com/world-records/farthest-drive-by-an-online-controlled-vehicle-in-24-hours/

Halvorson, B. (2010, October 8). Mitsubishi to offer online test drives of actual car. Fox News. Retrieved from http://www.foxnews.com/tech/2010/10/08/mitsubishi-to-offer-online-test-drives-actual-car.html.

Hinckley, J., & Robinson, J. G. (2005). Radio theme songs for the road. In The Big Book of Car Culture: The Armchair Guide to Automotive Americana (pp. 60–61). St. Paul, MN: Motorbooks.

Hoffnung, V. (2013). Bagdad cafe. SecondLife.com. San Francisco: Linden Lab.

Johnson, P. (2010). Second life, media and the other society. New York, NY: Peter Lang.

Kerouac, J. (1957). On the road. New York, NY: Viking Press.

Krug, J., & Godar, D. (2013). Road trip radio.Retrieved from http://roadtripradiousa.com/

Levy, S. (2013). The Internship. [Motion picture]. United States: Regency Enterprises, Dune Entertainment, 20th Century Fox (Distributor).

Linden Research. (2018, March 9). Second Life grid survey. San Francisco, CA: Linden Lab. Retrieved from http://www.gridsurvey.com/.

McLuhan, M. (1964). The medium is the message. In M. G. Durham & D. M. Kellner (Eds.), *Media and Cultural Studies* (pp. 107–116). Malden, MA: Blackwell Publishing.

McLuhan, M. (1994). *Understanding Media: The extensions of man.* Cambridge, MA: MITPress.

New Maserati Quattroporte. (May 20, 2013). Commercial. [Tumblr blog]. Retrieved from http://carjamtv.tumblr.com/

Pemberton, T. (2015, December 8). Why Fallout 4's 1950s satire falls flat. *The Atlantic.* Retrieved from https://www.theatlantic.com/entertainment/archive/2015/12/why-fallout-4s-1950s-satire-falls-flat/418665/

Roadtrip Nation. (2013). Founded by Nathan Gehbhard, Mike Marriner, & Brian McAllister. Retrieved from *http://roadtripnation.com/watch/public-television/season-ten*

Roberts, R. (2013, November 23). The best place to hear music? Cruising in the car, speakers booming. Los Angeles Times. Retrieved from http://articles.latimes.com/2013/nov/23/entertainment/la-et-ms-driving-in-la-20131124.

Shamoon, E. (2013, August 28). Inside the 'Grand Theft Auto V' soundtrack. *Rolling Stone.* Retrieved from http://www.rollingstone.com/culture/news/inside-the-grand-theft-auto-v-soundtrack-20130828

Styxmahler. (2012, May 17). *Route 66 road trip! AZ, NM, TX, OK, KS, MO (plenty of 'Cars references).* Retrieved from http://www.youtube.com/watch?v=dqaVym_d04c

Swallow, E. (2010). Mitsubishi Breaks 5 Guinness World Records in 24 Hours. *Mashable.* Retrieved from https://mashable.com/2011/02/09/mitsubishi-guinness-records/#YowWUdo5QSqg

Triplapser. (2012, November 5). *Route 66 Timelapse from Chicago to LA in 3 minutes.* Retrieved from https://www.youtube.com/watch?v=ufx-_98fmCU

Thrun, S. (2011, March). Live Talk: Google's driverless car. [Recorded video]. *TED2011 Talks.* Retrieved from https://www.ted.com/talks/sebastian_thrun_google_s_driverless_car

Twenty One Pilots. (2013, January 4). *Car radio.* Vessel (Album). Fueled by Ramen/Produced by Greg Wells.

Valdes-Dapena, P. (2006, November 18). Real cars drive into Second Life. *CNN Money.* Retrieved from http://money.cnn.com/2006/11/17/autos/2nd_life_cars/index.htm

Vernon, T. (2018, February 2). GENIVI seeks open approach to IVI. *Radio World.* Retrieved from https://www.radioworld.com/tech-and-gear/genivi-seeks-open-approach-to-ivi

VirtualRoadTrip.net. (2013). Retrieved from http://virtualroadtrip.net.

APPENDIX

"BLACKTOP: THE RADIO PLAY"

Jay Needham

Introduction by Phylis Johnson

Professor Jay Needham's Blacktop sound piece reflects on how the road, car and radio intersected with the American dreams of successes, an expansive landscape and soundscape filled with new places to explore and conquer, in the hope of success or to escape convention, exiting through the prairie darkness toward the city lights, or vice versa. The car radio is a central aspect of Blacktop. In Professor Needham's script as transcribed for this book, and as can be heard via Sound Cloud (https://soundcloud.com/jay-needham-1/ blacktop), one begins to hear how the radio is both companion and interrogator on the road, and how the dialogue between one's radio and one's thoughts share the static of fading county lines and physical boundaries through the midwestern plains.

Blacktop was streamed in Drift: *Resonant Cities* (2004), New Media Scotland. Curated by Robert King. It was released as part of the *Deep Wireless 2: Radio Art Compilation* (cd, 2005) produced by Deep Wireless Festival of Radio & Transmission Art; New Adventures in Sound Art, Toronto, Canada. It has also been performed as a live broadcast in St. Louis, Missouri, during the Popular Culture/American Culture Association in 2014.

Introduction by the Author and Sound Artist Jay Needham

Out from the box of voltage, copper wire and mineral crystals, a woman's voice reads the newspaper, plain as day, just like that. Her slower cadence emphasizes the writer's words, a telling lilt adding something extra from the Missouri side. You are seated next to the wireless set and can hear the hollow room in which she is speaking, her voice reflected from the slash-sawn pine floor and plaster. Distant sensing, listening to that other place, another's voice: it centers you warmly, addictively. The music and voices on the radio, they have become your second weather and all of it has found ways of making you feel present and distant at once. Radio got into you like that. Falling ribbons, bright and otherworldly, curtains composed of static descending. Receiving these signals has become an elegant way to move across the land, to make and transport stories, to add a measured teaspoon. This ability to radio forecast frees you and so you have nailed a wire in the ground to make a receiving wire, grounded that certain place where waves will fall in your yard. These actions are inescapable, because at the very core of it, you adore listening.

Listen back in prairie time, tune in as the tractor's thumping fuses with the humid chorus of cicadas above the banks of the Mississippi, near Quincy. The sound of the Studebaker[1] joins that din in the open air of the plains and you are out wandering again, driving a silent road movie as it plays through the windshield during all those sluggish summer transects and winter hauls. Find a speed that fits the solitude of the moment, on back roads along the Canton Chute or down near Ghost Hollow. Motoring over that rich, arable loam, the passengers travelling in the realm of the spherics have found a place that might need music to carry them out over the river, to move the story to the other side, to ride and listen along the long line of blacktop.

Blacktop is a story that wanders, a sonic road trip that discards the map and favors a drift. It's partly based my own experiences climbing over rusty fences and also a celebration of car radio, especially the places we seem to go in our own heads as we drive and listen. When the interior of the car became a salon for listening, it changed how we perceive the present tense, it put it into motion and opened a space for us to rehearse our dreams and tally our losses. The once mundane act of driving shifted paradigmatically to the back seat and sound became an active partner in our journeys. Blacktop's structure is serpentine and purposefully through-composed with morsels of Lohengrin added. The story starts where most cars end, in heaps that are the thick layers of our future geology.

Blacktop: The Radio Play

[Ambient sounds, hum of machines.]

NARRATOR:
At the end of a long line of blacktop, a noted team of science filmmakers work into the night. Great care has been taken lighting the area of impact. An even bath of soft light cuts a circle shape into the night. Scaffolds, cherry pickers, and generator trucks, cables thick as eels. Fragile clusters of bulbs dangle overhead, a thousand mini suns. The aluminum streetlight pole, new and glinting silver-green, rough with sharpened highlights. The continental, the square-looking one from that decade of heavy looks, waits down a smooth, freshly-blacktopped lane. Grinding acceleration, wire rope torqued to attention by a spinning cable spool on a flatbed. Sweet diesel, deep in the nose. The car is reeled in fast, and it's obvious it's not under its own power. The same kind of technical anticipation was felt at the trade show the week before. Stress-responsive alloys, a popular topic. Break-aways were all the rage this season. We savor the view, examine the intricacies, the details of the experiment. The continental bucks a little in the rear end, tilts and wrinkles into the pole, just at the moment of impact. We slow our talent for viewing. Sparks from below, and then it's free, ejected up and now falling. High-speed cameras capture a wobble, as it migrates up the pole. The smash is silent. We might not hear it. Did we just see that—or ...? We slow our talent for viewing, because we adore time travel.

[Ambient sounds of insects chirping, dogs barking]

Beyond the test site, we're out of town. The real outskirts, on a flat country road in America, where the streetlights fade to prairie darkness. Night air pools in the darkest shadows. Climb over the rusted fence and we're in! We're in someone else's yard now. No lights to give you away. That's the one feeling you know, except right now, you're in a junkyard. Used soil underfoot, oil-thick ground, rust-powdered fine, tight, and transformed. Before us stand rows of Detroit's finest, half-crumpled and stacked. Walk among them. Enter the museum of dead transportation.

[Sound of a car door opening.]

Sit in the back of Peter Zandall's Buick 8. Not much rust for a '37. Turn on the radio.

[Sound of radio static.]

And crank the plastic ivory knob to find a station, one that fits the solitude of the moment.

[Ambient sounds continue.]

Four hundred and eight thousand miles of Midwest regional sales calls.

[Sounds of a running car.]

Mid-Ohio in the fall. Up and down Illinois in winter. Michigan in the spring. Peter worked for a company that produced a mint breath spray. The green liquid came in a small glass vile. In later years, the cap was modified with a pen clip. Peter dreamed on the highway. He dreamed of being a visiting lecturer. He desperately wanted to be a writer. And on those long road trips, he composed elaborate mysteries, plots that were steeped in history. He changed his driving habits, as he rolled through the small college towns,

[Instrumental orchestral music starts.]

taking it all in, slowing at the sight of ivy-covered buildings. Lecturer. Lecturer. Visiting Lecturer. The word was almost pornographic. Lecturer, it would say on the embossed business card. Visiting lecturer, with a trunk full of novels, not breath spray.

[Orchestral music crescendos and fades into radio static.]

RADIO VOICE-PETER:
Heading towards the university, where I'll be delivering a lecture, as a guest lecturer. Just left a roadside diner. It was kind of strange. There was a dog inside, an Airedale. It seemed, I don't know, out of place. It just seemed too regal for a diner. An Airedale ... something about it. Ah yes, that's it. The Airedale. The Airedale was missing. No one knew whether it was the fault of Mr. Broxley or that if the three-time Westminster champion Airedale Prince Gold Standard had just wandered off ...

Some two weeks back, details were discovered in Mr. Broxley's painting journal. Broxley described a sketch of Price Gold Standard:

RADIO VOICE-BROXLEY:
I was laboring mildly over Gold Standard's difficult knees, never realizing how like miniature tree trunks the front legs are--stiff, and straight, much like little redwoods. Being that I have an expediting, exacting detail as my commerce, and following such discretions as I work allows me to relax. The fur is dense, packed, all that curing hair, tight swirls to be rendered in fine line. Tedious, yes, but I'm the man for such tedium. My relation with this beast will end once I have completed this sketch of him. His outbursts upon my being will forever be contained by the cool stroke of my hand. He has a perfect, box-shaped head, Roman, regal, statuesque. The old masters had a vision when it came to dogs. The slightest nuances in expression were rendered, from the bold, aggressive stances of hounds, to the diminutive, to the impish half-faces of matronly lap dogs. True vision. Hmm.

[Ambient sounds of a running car.]

RADIO VOICE-PETER:
Heading towards the university, where I'll be delivering a lecture, as a guest lecturer, talking about the mysteries of mystery writing. Maybe … [chuckles]

I want to talk to you today about mystery writing, and let me wax solipsistic if I could. I have been driving about 20 hours now. I slept a little, but not much. Passing all the highways and byways of Ohio, passing each road as it's numbered. Like chapters in an unending book, the roads curve, like the turning of a page. We're just going nowhere, just driving. I don't know.

[More radio static, then the sound of dialing through frequencies, not quite tuned in.]

RADIO VOICE-PETER:
To see what can be seen … He just went off on that route.

[Ambient sounds change back to car driving sounds.]

NARRATOR:
There are still a few medium-point pens under the driver's seat. Look past the faded Coke-bottle windshield, out beyond the curved hood, across dead lanes of ancient traffic, under the alien noise of cicadas, there is static. There's static on the road, at the long line of blacktop.

[Ambient sounds mix with ethereal music]

Note

1. The reference is to the midwestern city 'Quincy' near the Mississippi River where Elmer H. Wavering and William Lear have been believed to come up with the idea of the car radio, prompted by a date in which their girlfriends suggested listening to the radio in the car would be romantic. They would eventually take their idea to Paul Gavin, who would take their prototype in his studebaker to the Radio Manufacturers Association convention in Atlantic City, NJ in 1930.

 See Hal Oakley (2014, January 9), Quincy native father of modern automotive electronics, Herald-Whig, retrieved from http://www.whig.com/story/24411717/quincy-native-father-of-modern-automotive-electronics#

 Also see, Agis Salpukas (1998, November. 27), Elmer Wavering, 91, Pioneer Of Auto Electronics, Is Dead *The New York Times*, https://www.nytimes.com/1998/11/27/business/elmer-wavering-91-pioneer-of-auto-electronics-is-dead.html

CONTRIBUTORS

Donna L. Halper, Ph.D. in Communication from the University of Massachusetts at Amherst, 0is Associate Professor of Communication and Media Studies at Lesley University in Cambridge MA, where she also advises Lesley's student-run newspaper, the Lesley Public Post. Prior to entering academia, Dr. Halper spent nearly four decades in broadcasting, first as a deejay and music director, and then as a radio and management consultant. She is also known for having discovered the classic rock band Rush, who dedicated two albums to her; she can be seen in a 2010 documentary about them, "Beyond the Lighted Stage." An experienced media historian, Dr. Halper is the author of six books, including a revised and expanded 2nd edition of "Invisible Stars: A Social History of Women in American Broadcasting" (Routledge 2014) and "Boston Radio 1920–2010" (Arcadia 2011). She has also written a number of book chapters, and her articles have appeared in both scholarly and mass appeal publications. In addition to doing ongoing research in media history, she also does research on early baseball, and has spoken at several historical conferences, including a 2017 symposium at Cooperstown NY, where she presented

a talk about five pioneering women baseball writers. For more informa-
tion visit http://www.donnahalper.com/aboutdonna.htm. Dr. Halper can
be contacted at DLH@donnahalper.com.

Tim Hendrick, Master of Arts, Brigham Young University, is a full professor
at San Jose State University in the Journalism & Mass Communication
where he specializes in advertising and promotions.

Philip Jeter, Ph.D., University of Wisconsin-Madison, is a Professor in the
Department of Communication and Media Studies at Winston-Salem
(NC) State University. He has taught in mass communications programs
at Bennett College, Edward Waters College, Florida A&M University,
Marshall University, Michigan State University, Middle Tennessee State
University, North Carolina A&T State University and the University
of South Carolina. For 10 years, he was general manager of the Florida
A&M University radio station that won the "Black College Radio Sta-
tion of the Year" Award in 1991.

Jenny Johnson, MFA, Media Arts, Southern Illinois University, Carbon-
dale, is a lecturer of Radio and Audio production at Southern Illinois
University in Carbondale, Illinois. Johnson is a musician and songwriter
performing throughout the Midwest as well as a sound artist producing
audio-based artworks such as music albums, audio documentaries, and
radio dramas. She has worked in commercial radio for five years as a radio
deejay. For more information, visit Professor Johnson's websites www.the-
realjennyjohnson.com and jennyjohnsonart.com. She can be contacted
at jennytutones@gmail.com.

Phylis Johnson, Ph.D., Southern Illinois University Carbondale, is Profes-
sor and Director of Journalism and Mass Communications at San Jose
State University, and Emeritus Professor of Sound & New Media in the
College of Mass Communication & Media Arts at Southern Illinois Uni-
versity, Carbondale. She is the outgoing editor of *Soundscape: The Journal
of Acoustic Ecology* and the past managing editor of *The Journal of Radio
and Audio Media.* She has authored four books in media studies, numerous
research chapters and journal articles, as well as arts reviews and magazine
features on gaming, sound and new media, particularly virtual and mixed
reality. She has presented internationally, and has more than 20 years of
professional radio experience.

Jay Needham, MFA, California Institute of Arts, is Professor of Radio and
Audio Production at Southern Illinois University, Carbondale. He is a
sound artist, electro-acoustic composer, teacher and scholar. He utilizes

multiple creative platforms and his works often have a focus on recorded sound, archives and the interpretation of artifacts. His sound art, works for radio and visual art have appeared at museums, festivals and on the airwaves worldwide. Through applied aspects of his research, Needham strives to affect positive change and bridge the gap between the arts and the sciences. His latest sound installation is on permanent display in the new BioMuseo in Panama. He has been invited to speak at many noted programs including the Amsterdam School for Cultural Analysis, University of Amsterdam, Netherlands, the Department of Techno-Cultural Studies, University of California, Davis, California, and Institute of the Arts the School of the Art Institute, Chicago. His research is published in the journals, *Exposure, Soundscape: The Journal of Acoustic Ecology, Leonardo Music Journal*, and in the book *Hearing Places: Sound, Place, Time, Culture*. Needham is also the past Director of the Global Media Research Center at SIUC. For more information, visit jayneedham.net. Dr. Needham can be contacted at jneedham63@gmail.com.

Jonathan Pluskota, Ph.D., Southern Illinois University, Carbondale, is Assistant Professor of Sound and Media Production, in the School of Mass Communication and Journalism at The University of Southern Mississippi, Hattiesburg, MS. Dr. Pluskota has creative interests in sound and media processes and ethnographical research. He is currently a Fulbright scholar in Estonia (2017–2018) working on sound research. Dr. Pluskota can be contacted at jonpluskota@gmail.com.

Ian Punnett, Ph.D. Arizona State University, is a former nationally syndicated radio personality, morning show host, media personality, and author of such books as *Toward a Theory of True Crime Narratives*. He is the past managing editor of the *Journal of Radio and Audio Media*.

Wafa Unus, Ph.D., Arizona State University, is a new professor at Fitchburg State University, Fitchburg, Massachusetts, where she also advises student media. Among her publishing accomplishments, Dr. Unus has written a biography of Herb Klein, former White House Communications Director under Richard Nixon and Carr Van Anda, the managing editor of the *New York Times* under Adolph Ochs and considered the "father of science journalism."

Justin A. Williams (Ph.D. in musicology, University of Nottingham) is Senior Lecturer in Music at the University of Bristol, UK. He is the author of *Rhymin' and Stealin': Musical Borrowing in Hip-Hop* (University of Michigan Press, 2013), editor of the Cambridge Companion to Hip- Hop

(CUP, 2015), and co-editor (with Katherine Williams) of the *Cambridge Companion to the Singer-Songwriter* (CUP, 2016) and *The Singer-Songwriter Handbook* (Bloomsbury Academic, 2017). In 2017, he was awarded a Leadership Fellowship from the Arts and Humanities Research Council (UK) for a project on Regional Rap in the United Kingdom. Dr. Williams can be contacted at jwilli7@gmail.com and justin.williams@bristol.ac.uk.

Lady Dhyana Ziegler, Ph.D., DCJ, is interim dean of the Florida Agricultural and Mechanical University (FAMU) School of Journalism & Graphic Communication and the Garth C. Reeves Eminent Scholar in Journalism Chair at FAMU. She previously served as the Assistant Vice President for Instructional Technology and Academic Affairs at FAMU where she supervised the Division of Instructional Technology and Distance Learning Programs and Activities, the Faculty Development Lab, and the Student Computer Lab from 1998–2007.

Dr. Ziegler came to FAMU in 1997 after she was selected as the Garth C. Reeves Eminent Scholar Chair. Prior to that appointment, she served as professor of broadcasting at the University of Tennessee-Knoxville (UTK) as well as the Associate Director for Diversity Resources and Educational Services supervising research and technology under the Office of the Chancellor. She worked for the University of Tennessee-Knoxville for 14 years during which she was awarded tenure and promotion to full professor. Dr. Ziegler is the first and only African-American to be elected President of the Faculty Senate to date at (UTK) and is a charter inductee into the University's African-American Hall of Fame.

Dr. Ziegler has received many awards and honors, including international acclaim. In April 2008, she was knighted as a Dame of Justice by the Chivalric Order of the Knights of Justice at the University of Cambridge, England. She is a five-time Governor of Florida Appointee to the Florida Virtual School where she is currently the Chair of the Board of Trustees and a two-time Appointee to the Florida Commission on the Status of Women and is Vice Chair. She is also a Fulbright-Hays Scholar and was recently honored by *ONYX Magazine* as one of the 2017 "Women on the Move."

Besides teaching and research, Dr. Ziegler is a television producer and on-air personality and has produced several documentaries, commercials and other audio/visual works. She was a political panelist on "The Tennessee Report" airing on WATE-TV in Knoxville, Tennessee and also did commentaries on the news. She is the author of three books, more than 60

scholarly publications and has produced more than 100 videos and other multimedia productions. She has made presentations at more than 100 national and international conferences and has been awarded nearly 6.5 million dollars in grants.

Prior to her work in higher education, Dr. Ziegler worked for media entities in New York City including *Essence Magazine*. She was Executive Vice President for Patten and Guest Productions supervising all operations including marketing, advertising, manufacturing, and record production, as well as a copywriter/producer for Rosenfeld, Sirowitz & Lawson Advertising Agency. Dr Ziegler can be contacted at ladydhyanaziegler@gmail.com.

INDEX